Bushido

Legacies of the Japanese Tattoo

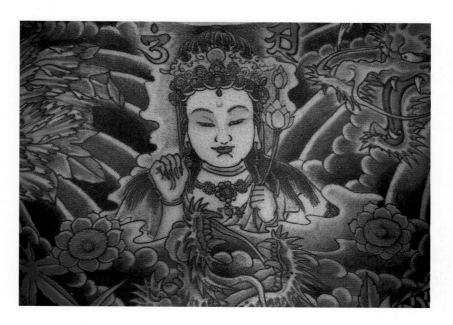

Takahiro Kitamura &
Katie M. Kitamura

Schiffer Publishing Ltd

4880 Lower Valley Road • Atglen, PA 19310

Acknowledgements

I would like to thank Horiyoshi III, without whom this book would not have been possible. I would also like to thank the Horiyoshi III and Horihito families, as well as the individuals who allowed themselves to be photographed for this book.

I am also infinitely grateful to Pinky Yun and Chuck Eldridge for their mentorship and support of my project this side of the Pacific. Also many thanks to Molly Higgins, Nancy Schiffer, Peter Schiffer and Schiffer Publishing for their guidance and encouragement. Finally, for help and inspiration, I would like to acknowledge those individuals who navigate by heart.

Kitamura, Takahiro.
 Bushido: legacies of the Japanese tattoo / Takahiro Kitamura & Katie M. Kitamura.
 p. cm.
 ISBN 978-0-7643-1201-4 (pb.)
I. Tattooing--Japan. 2. Japan--social life and customs.
I. Kitamura, Katie M. II. Title.
 GT2346.J3 K58 2000
 391.6'5'0952--dc21
 00-009478

Book Design by Anne Davidsen
Type set in Slogan D / Humanist

ISBN 978-0-7643-1201-4
Printed in China

Published by Schiffer Publishing, Ltd.
4880 Lower Valley Road
Atglen, PA 19310
Phone: (610) 593-1777; Fax: (610) 593-2002
E-mail: Info@schifferbooks.com
Web: www.schifferbooks.com

For our complete selection of fine books on this and related subjects, please visit our website at www.schifferbooks.com. You may also write for a free catalog.

Schiffer Publishing's titles are available at special discounts for bulk purchases for sales promotions or premiums. Special editions, including personalized covers, corporate imprints, and excerpts, can be created in large quantities for special needs. For more information, contact the publisher.

We are always looking for people to write books on new and related subjects. If you have an idea for a book, please contact us at proposals@schifferbooks.com.

Table of Contents

Introduction

The word *Bushido* is written with three characters, *bu* ('military'), *shi* ('man'), and *do* ('way'). Hence, *Bushido*, the way of the warrior; otherwise known as the samurai code of chivalry. This term describes the principles of honor and loyalty followed by the *bushi*, members of the military class that ruled feudal Japan...

The ideal samurai, in preachment if not always in fact, was loyal until death to one master in whose service he was always willing to sacrifice his life without a moment's hesitation, 'like the cherry sheds its blossoms'...Bushido emphasized constant physical training to maintain and improve techniques of swordsmanship and austere, Zen-like discipline to develop the character, the confidence, and inner self-control needed by the samurai to face an opponent's blade in battle to the death, without flinching.

Bushido is a philosophy that teaches patience...the kind of patience demonstrated by the samurai trained in Bushido can still be found in modern Japan.

In his introduction to Eiji Yoshikawa's[1] epic Samurai novel, *Musashi*, Edwin Reischauer writes: "The age of the samurai is still very much alive in Japanese minds. Contrary to the picture of the modern Japanese as merely group-oriented 'economic animals,' many Japanese prefer to see themselves as fiercely individualistic, high-principled, self-disciplined and aesthetically sensitive modern-day Musashis...Its emphasis on the cultivation of self-control and inner personal strength through austere Zen-like self-discipline is a major feature of Japanese personality today."[2]

In Japan, the persistent influence of an age-old code of ethics manifests itself in numerous ways. This "idealized self-image," as Reischauer phrases it, expresses itself in a particularly pure form in the world of tattoo art. It is no surprise that many of the warriors and gods emblazoned across the backs of the tattooed center around tales of righteousness and valor, while popular images such as tigers and dragons represent classic warrior values such as fortitude and courage. The imagery of the skin, whether historical or fictional, springs to life in the interpersonal relations characterizing the world of Japanese tattooing.

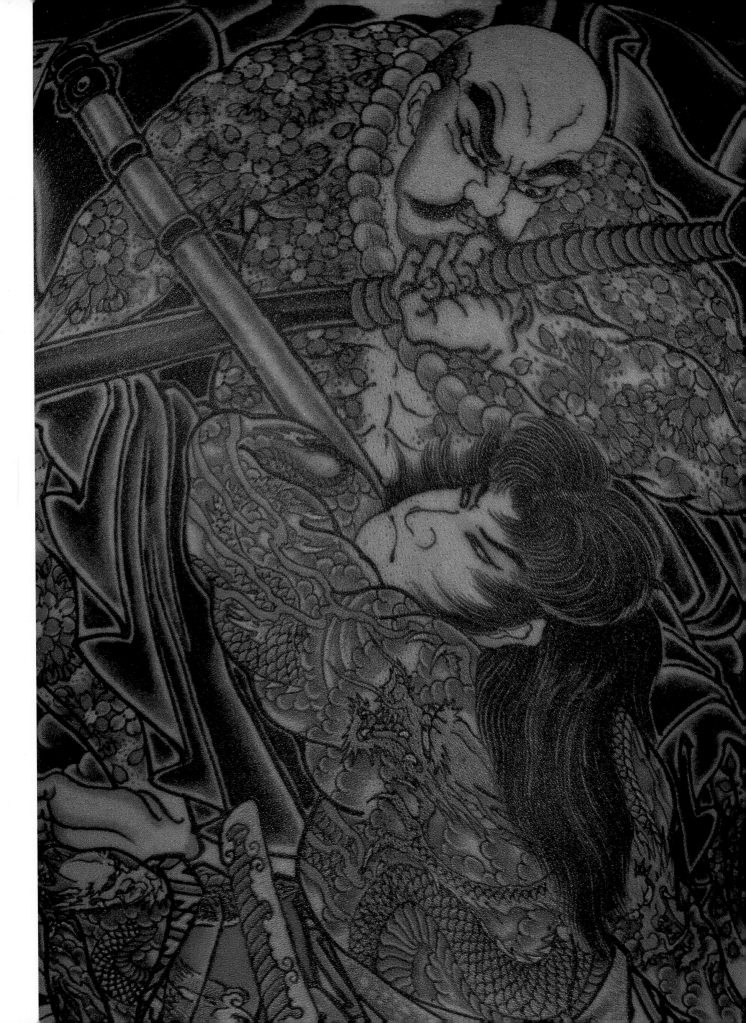

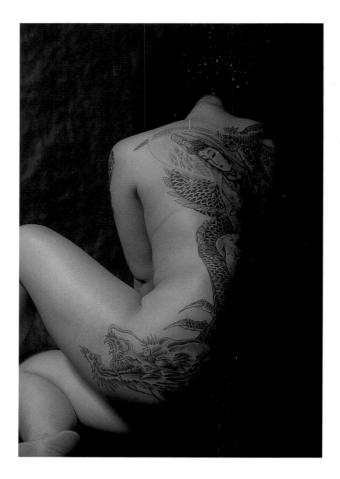

At its best, Japanese tattooing transcends art to embody an honor code. This honor code is what I would call the samurai spirit. Necessarily being a relatively nebulous and intangible notion, it is difficult to detail the specific components of this spirit. On the simplest level, the samurai spirit is often defined by a fierce devotion to the master and a strong self-imposed sense of honor, loyalty, and justice. But of equal importance are the nuances that accompany this spirit. There is, for instance, the samurai warrior's willingness to devote himself to a lifelong goal—for example, the avenging of a master's honor—the fulfillment of which he may not observe for years. The samurai must maintain his faith in his beliefs, even as the social or political climate shifts and alters. He must be patient, must act in a manner that may at times seem irrational or illogical, must resist the temptations of instant gratification, and must work towards fulfilling what may seem to be an impossible ideal. As a result, the samurai is often something of an outsider, a rebellious figure because he refuses to conform to the habits of the day. At the same time, the samurai is often the bulwark of tradition not because he is incapable of thinking in innovative or rebellious ways, but because he refuses to alter his beliefs in the face of temporary changes, and stands by the traditions of the past.

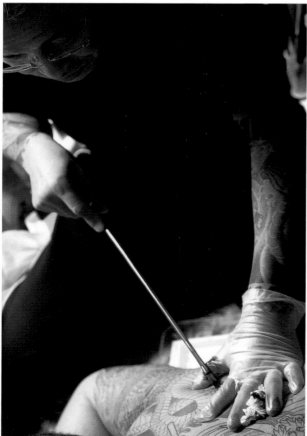

There are various historical reasons for the association between tattoo arts and samurai ethics. The links between the samurai and the artistic influences of tattoo art are self-evident; these warriors often acted as the subjects of *ukiyo-e* woodblock prints, which in turn served as the chief source of inspiration for tattoo artists both of that era and today. During the Edo period, many samurai actually tried their hand at artistic practices. The reasons for this association are historically based (during the Edo period, the income of these samurai was waning, and they were often thus forced to find alternative forms of employment), but the ramifications of this past association have remained strongly imprinted on the nature of Japanese tattooing today.

The similitude between tattooing and the samurai life also runs on a moral and ethical level. There are many similarities between the purely technical nature of tattoo art and the martial artistry perfected by the samurai; the processes used by both these schools of thought are concerned with training both the mind and the spirit. The spirit of the individuals in these two parallel worlds is also strikingly similar; there are many parallels between the paradoxically rebellious and tradition-upholding nature shared by both the tattoo master and the samurai.

Because the Japanese tattoo embodies so many qualities of the samurai spirit, it is able to reflect many aspects of modern Japanese culture. The analogies that can be drawn between the tattoo and the greater Japanese culture reveal the manner in which the social practices of this nation have retained elements of this moral code. For example, the imagery of the Japanese tattoo is one that is heavily symbolic, reflecting the aspect of Japanese culture that is centered around elaborate social codes. Both the Japanese tattoo and the Japanese social system turn around a form of coded communication. By the phrase "coded communication" I refer to the way in which a discreet gesture or glance can communicate a number of meanings; I refer to the subtle and discreet manner in which deep meanings and an extensive symbolism are contained within the subtlest nuances of each image. This practice of subtle expression, hidden meaning and coded communication is symptomatic of Japanese culture, both historically and today, effectively linking the tattoo, the samurai ethic, and mainstream Japanese culture as a whole. Tattoo images and their meanings often root back in ancient folklore, some tracing back as far as Chinese culture from centuries ago, thus emphasizing the importance of respect for tradition and heritage in tattoo art. The Japanese tattoo is cryptic, based on an elaborate, tradition-based code of significance,

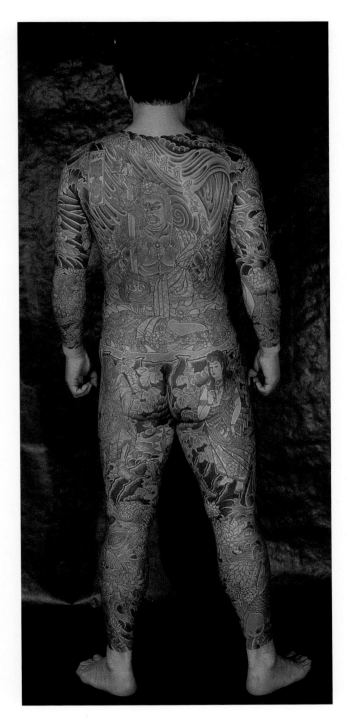

so that meaning is linked to maintaining legacies and respecting tradition.

The Japanese tattoo is also one that requires years of commitment and severe discipline; a Japanese tattoo is not something one can complete on a drunken night on the town, but requires the repeated endurance of severe pain in the form of an extended series of appointments and sessions that can last as long as ten years. This commitment and discipline are central to the samurai ethic; furthermore, whether or not it is accurately reflective of

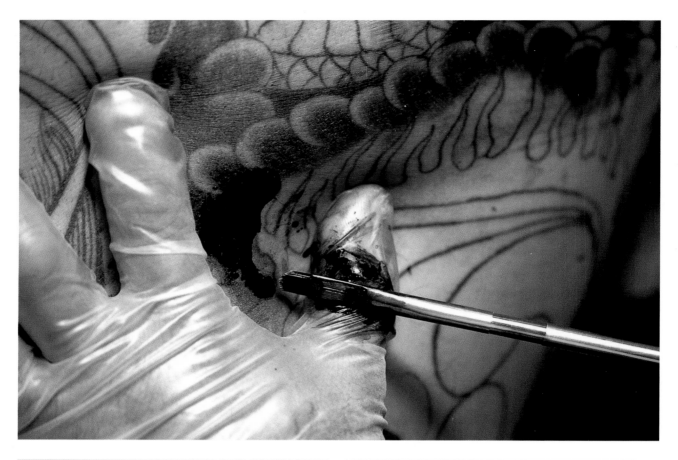

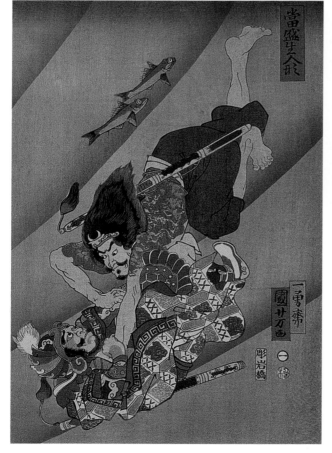

Suikoden-Battle in the Water by Kuniyoshi Utagawa. Courtesy of the Yokohama Tattoo Museum.

the nation's actual identity, the global perception of the Japanese is one which characterizes the culture with patience and diligence. The Japanese tattooing process reflects these very same characteristics, and is an extreme trial of skill and patience for both artist and client. It is a true test of will, finances, and pain. Not surprisingly, the word for tattoo in some parts of Japan is *gaman*, or perseverance.

In order to effectively explore the ways in which the tattoo reflects both the samurai ethic and the manner in which this moral code persists in today's culture, this book will attempt to contextualize the tattoo within both the social and art historical background of *ukiyo-e* art during the Edo period. The Edo period association between *ukiyo-e* art and the samurai is complex and manifold, and by considering this association, I hope to reveal some of the ways in which the face of the tattoo has been shaped by the repercussions of this historical association.

The book will then go on to consider the social implications of some of the more recent liaisons between the samurai ethic and tattoo arts by closely examining the relationship between the client and tattoo master, and finally, between the master and apprentice. I thus hope to establish the relevance

of this association between tattoo art and samurai spirit both historically and today. The conclusion will consider the future of this association, and the manner in which it might act as a force preserving tradition into the new millennium.

Japan is in many ways a nation juxtaposing the technology of the modern era against fragments of the past. The tattoo world strongly tilts the balance toward the latter influence, not partially because of this connection with the samurai warrior ethic. In this world, the word "master" remains miraculously untarnished by the passage of time, and connotes a weight that is perhaps difficult for a foreigner to immediately comprehend. The cultural environment of Japan is one wherein it is a privilege to receive instruction from an individual possessing years of diligent study and practice. Here, it is a welcome honor to refer to this person as "master." And it is in this culture that the samurai spirit lives on.

[1] Unless otherwise specified, all names in this book are in Western format, first name then last name.
[2] Edwin O. Reischauer, Foreword to *Musashi*, by Eiji Yoshikawa, trans. Charles S. Terry (Tokyo and New York: Kodansha International, 1981)

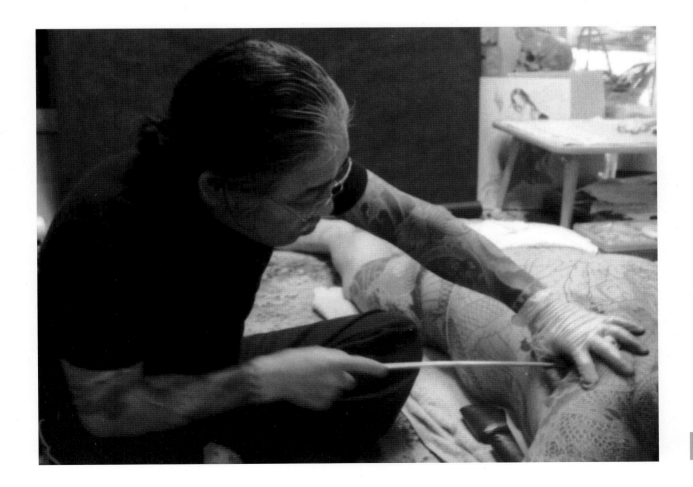

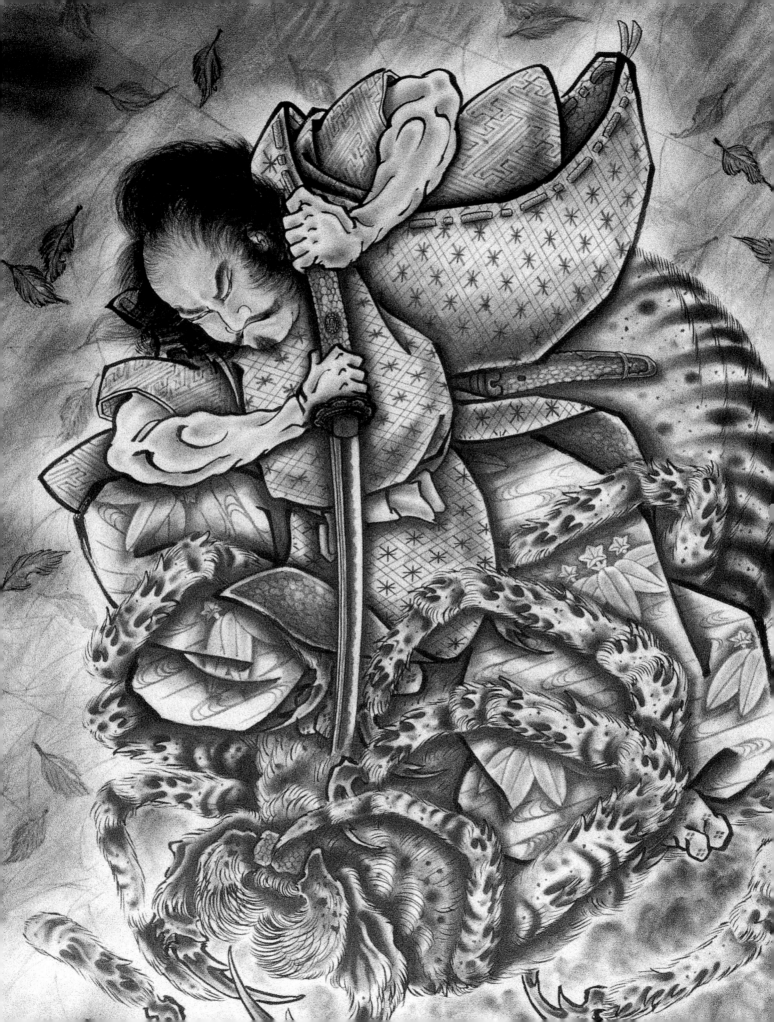

Chapter One

I.

Though the practice of tattooing is generally considered to have had a place in Japanese culture from as early as pre-historic times[1], it was only during the Edo period that the "Japanese tattoo" as such truly came into being. During this culturally and politically unique time in Japanese history, the social conditions were such that the basis of the Japanese tattoo was formed. Many of the images and techniques developed during these centuries persist in the modern tattoos of today. In this section, I will pay especially close attention to the development of the samurai imagery, and hope to locate the social reasons for the success and popularity of these images.

The "Period of the Warring Provinces" during the Japanese Middle Ages began with the Onin War (1466-1467) and continued into the early sixteenth century. This era was characterized by continuous civil war, and during this period the notion of the heroic samurai was a central figure in the imagination of the people. Finally, under the leadership of the charismatic shoguns Nobunaga Oda and Hideyoshi Toyotomi, a scheme for national reunification was successfully completed, leading to the establishment of the Tokugawa shogunate military government that ruled throughout the Edo period. The Edo period in Japan, from the early 1600s to 1868, represented an époque of remarkable political stability, and a corresponding economic prosperity. Under this firmly established government, the fine arts flourished, and the Edo period is now considered one of the most fruitful areas of study for Japanese art historians. Most importantly, during this period, the possession of both wealth and art was no longer restricted to the ruling class, but spread to the lower classes as well: "In Edo Japan, wealth shifted away from castles and temples in unforeseeable ways, and so did artistic expression.

Tenpo Suikoden Kogata Hanga by Yoshitoshi Tsukioka. Courtesy of the Yokohama Tattoo Museum.

This transformation is such that, over the course of the Tokugawa period, one is increasingly justified for the first time in Japanese history in speaking not of art and its patron but of the people and their art."[2]

This period in Japanese art history was, as suggested above, one in which the tastes of the people strongly directed the production of art. It is therefore perhaps natural that the roots of modern day Japanese tattoo imagery emerged during this period. *Ukiyo-e*, the art of Japanese wood block printing from which Japanese tattooing draws its images, was established during this period. Because of the cheap costs of producing prints (as opposed to paintings, for example), *ukiyo-e* was ensured its status as a form of art accessible to the working classes; the price of an average print would run no higher than the cost of a bowl of noodles. Unlike traditional court artists, *Ukiyo-e* artists were themselves working-class individuals and their art depicted the world with which they were familiar. Popular subjects included depictions of daily life, political satires, landscape, and erotica (*shunga*). Perhaps of greatest pertinence to the art of the tattoo is the *ukiyo-e* interest in creating visual images to accompany folklore, ghost stories, and historical figures and heroes. The artwork produced in this vein was uniformly concerned with capturing the spirit behind the imagination of the average citizen, while simultaneously maintaining a high aesthetic standard.

Warrior portraits (*musha-e*) were also enormously popular, and ranked among the earliest prints, dating from the 1660s.[3] Among the earliest artists developing this particular form of *ukiyo-e* were Masanobu Okumura (1686-1764) and Shun'ei Katsukawa (1770-1820). However, it was not until the emergence of Kuniyoshi Utagawa, born in 1797 and one of the most famed and influential *ukiyo-e* artists, that *musha-e* attained a truly global popularity.

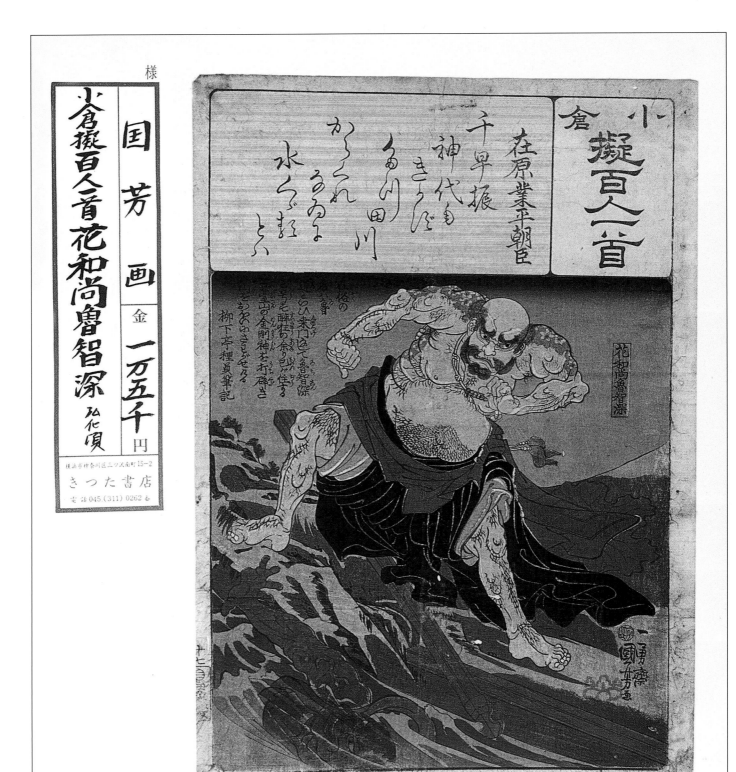

Suikoden Kaosho Rochishin by Kuniyoshi Utagawa. Courtesy of the Yokohama Tattoo Museum.

The young Kuniyoshi was heavily influenced by the work of Shun'ei Katsukawa's work. Apprenticing with *ukiyo-e* artist Kuninao Utagawa, Kuniyoshi received a thorough education and acquaintance with many different genres and artists; today his work is acclaimed for its range and diversity. Though Kuniyoshi designed a number of prints without great critical success, with the publication of *Tsuzoku Suikoden goketsu hyakuhachinin no hitori ('The 108 heroes of the popular Suikoden all told')* he achieved his first artistic breakthrough. The publication of these color, full-sheet prints created a veritable vogue for the *Suikoden* stories. With this success, Kuniyoshi gained respectability as a print artist, and though his art encompassed a wide range of subjects, his name is almost always associated with his *musha-e*.

Tattooing, which had been quietly gaining popularity within the culture, was now flourishing as a practice. Though the images chosen often varied, the most popular images were those of the samurai warriors, dragons, and tigers. The *Suikoden* prints fueled not only the popularity of the warrior figure, but also that of the tattoo itself. The prints cemented the link between the two, as many of the prints depicted warriors with full-body tattoos, and the overt masculinity of these warriors served as an inspiration for young men desirous of an extensive tattoo.

Many tattoo designs were copied directly from the *ukiyo-e* prints, and several prominent *ukiyo-e* artists were heavily involved in tattoo art. In his article "The History and Technique of Tattooing in Japan," Horiyoshi III writes: "Kuniyoshi, who went by the nickname 'scarlet skin,' had a tattoo extending from his shoulders to his entire back...he designed a tattoo of a Kikujido, a Chinese court page, to decorate his student Yoshiyuki's back...It goes without saying that this popularity spurred a diversification of designs and greater artistic complexity. The natural outgrowth of this trend was the collaboration between *ukiyo-e* print artist, tattooists, and tattoo aficionados. Not only Kuniyoshi, but his students Yoshitsuya and Yoshitora, and even the eminent Hokusai Katsushika designed tattoo *dessein*."[4] As the popularity of the tattoo heightened, *ukiyo-e* artists began designing prints that would simultaneously function as tattoo designs, and many prints designed without this double utility in mind were nonetheless well suited for use as tattoo designs.

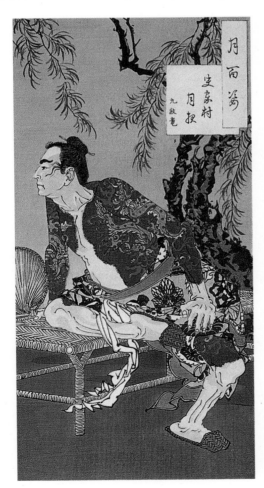

Suikoden Kumonryu Shi Shin by Yoshitoshi Tsukioka. Courtesy of the Yokohama Tattoo Museum.

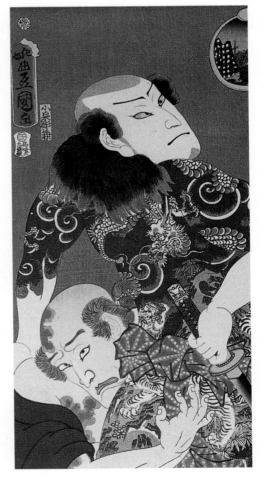

Danshichi Kurobee by Toyokuni Utagawa. Courtesy of the Yokohama Tattoo Museum.

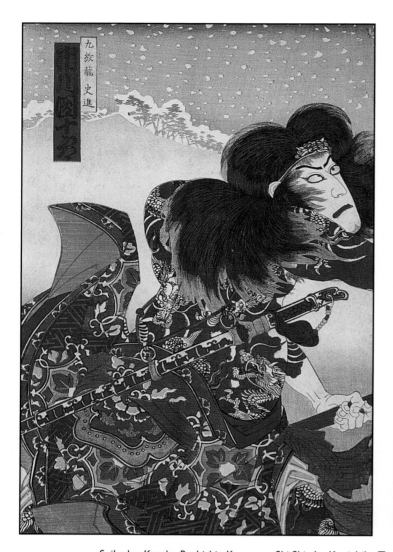
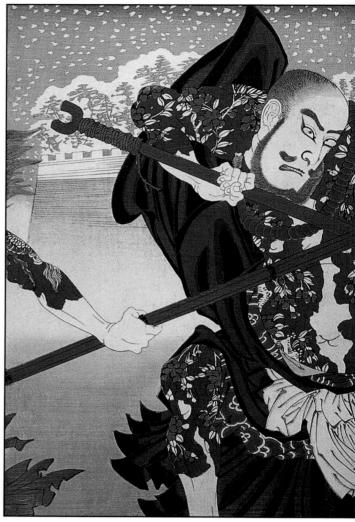

Suikoden Kaosho Rochishin Kumonryu Shi Shin by Kunichika Toyohara. Courtesy of the Yokohama Tattoo Museum.

Besides the remarkable success of Kuniyoshi's *Suikoden* prints, the popularity of the *musha-e* was bolstered by the sociological emergence of the *otokodate*, a new "common-man" hero figure who appealed to the sentiments of the average working-class Japanese man of the time. The *otokodate* replaced the samurai as the figures of national heroism; because of the peaceful nature of the Edo period, the samurai slowly faded into the background as dashing heroic figures and emerged instead as potentially oppressive figures. No longer the heroes of the people, the samurai became the emblem of a morally rigid government as well as hypocritical figures of excess and decadence.

With the spread of economic prosperity from the upper to the middle class, the social class of the hero figure was simultaneously adjusted. It was the working-class *otokodate* who now captured the imagination and admiration of the people: "the equiv-

alent of a knight or chivalrous commoner... referring to noble-minded men who supported the 'people.' The gallant behavior of these street-knights made them extremely popular with the townspeople, who viewed them as true heroes, heroes with whom they were able to identify because the *otokodate* were of the same social class."[5]

The imagery of the *Suikoden* in many ways inspired the emergence of the *otokodate*. These artistic and social phenomena were expressive of a general sense of unrest and dissatisfaction with the government. But more importantly, they expressed a profound nostalgia for the now outdated samurai persona; the people continued to worship the semi-historical, semi-mythical figures of samurai and *Suikoden* fame, even as they daily witnessed the corruption and decadence of the samurai ruling class. The many reforms of this period were in part instigated in order to reform the samurai class, but

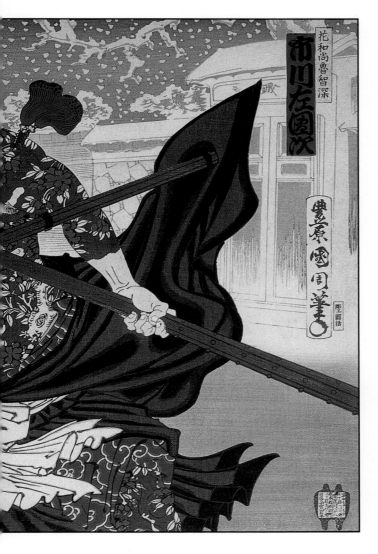

and skilled in the arts of war and peace, ideals few actually achieved."[6]

By tattooing the images of these warriors on their back, these men were able to appropriate fragments of the warrior identity for themselves. Firefighting brigades, since their establishment in 1720, were composed of heavily tattooed men. Initially, many of these tattoos were simple designs (such as Chinese characters, for example); however, following the success of Kuniyoshi's *Suikoden* warriors a century later in 1827, these tattoos were often replaced by those representing a fighting warrior. And indeed, these warrior images were in many ways representative of the effect these men hoped to create with their tattoos. Don Ed Hardy, in *Pierced Hearts and True Love: A Century of Drawings for Tattoos* writes: "firefighting brigades...would strip before approaching the conflagration. The intent, besides ease of movement, was to strike a dashing pose and 'outcool' the rival brigades fighting the blaze."[7] Imagining themselves to possess the characteristics of bravery, honor, and strength they perceived in their warrior heroes, these men were eager to display these emblems of "machismo." And not too unlike today, the immense pain involved in the tattooing process provided indisputable testimony to the bearer's ability to endure pain. This visual advertisement of strength and machismo received, in turn, a sort of living advertisement for the tattoo in the shape of these firefighters.

The government of this era, which modeled its ideals on a system of Chinese Confucianist ethics, often espoused moral and aesthetics standards that did not match those of their people: "In theory, the Confucian ethic espoused by the feudal authorities held participation in pastimes without morally uplifting or didactic value to be frivolous, and the shogunate periodically admonished the populace about indulgence in leisure pursuits."[8] The government's efforts to control the cultural activities and interests of the people led to a series of reform moments, including the famous reforms of the Kyoho Era (1716-36) and the Kansei Era (1789-1801). In *The Art of the Japanese Print*, Nigel Cawthorne writes: "The government tried to impose austere Confucianism on every aspect of Japanese life...the government restricted the size of prints and colors used. *Shunga* prints were outlawed altogether, on the grounds that they were a threat to public morality. Also outlawed were prints that depicted current events or sought to show the shogunate in a bad light. Punishments ranged from jail to exile and confiscation of property."[9]

in fact finally did little to dispel the over-arching sense that the shogunate were morally corrupt, and only strengthened the conviction that a return to the moral codes of the past was not only highly desirable, but necessary. Many of the men seeking tattoos chose the warrior figures of the past.

The vast majority of tattooed individuals during the Edo period were part of the working class, including firefighters, carpenters, and laborers. The men receiving these warrior tattoos were themselves estranged from any literal experience of the "heroics" of these warriors, and in some sense they were free to idealize the exploits of their heroes. It is the *romanticized* vision of these men that formed the identity the *otokodate* of the Edo period sought to impersonate, and it is the legend of these warriors that remains in modern days. As Guth writes, "Regardless of circumstance, they were expected to be paragons of virtue, rectitude, and dedication,

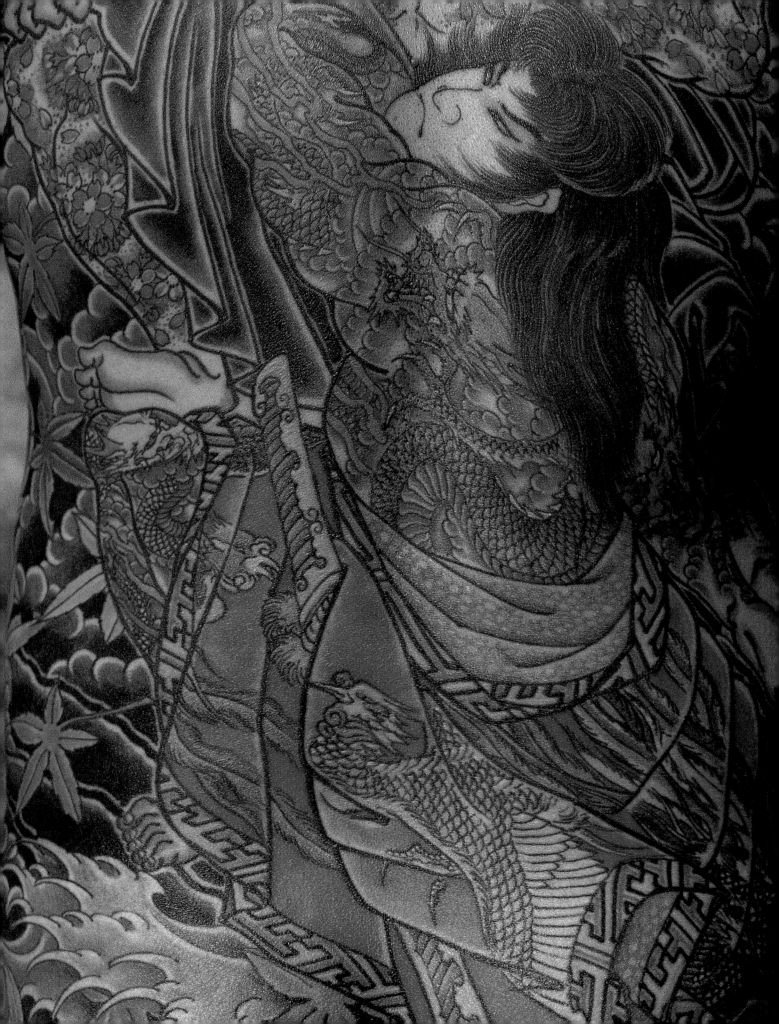

The effect of Chinese influence also fell upon the artistic aspirations of Japanese art of that time. The sophisticated culture of China and the artistic developments within that country held a profound effect on Japanese artists, who Guth describes as "both curious about and respectful of all aspects of Chinese culture."[10] The Chinese influence could be seen in the court art produced during this period, which often featured "Chinese cultural heroes, sages, political role models . . ."[11]

The ethics of *ukiyo-e* art, which sought to capture 'the floating world,' the ephemeral, transitory pleasure of life, ran in direct contrast to the stricter Confucianist ethics espoused by the government. *Ukiyo-e* art was more linked to the Japanese Buddhist philosophy: "nothing was more fundamental to Edo cultural developments than the Buddhist tenet that all phenomena are impermanent. A preoccupation with transience, in both nature and human affairs...a keen awareness of the brevity of human life and its fleeting pleasures . . ."[12] Ukiyo-e art thus becomes linked, however subtly, to a more nationalistic conception of both spiritual and artistic identity.

Crucially, religion and politics became intertwined in this struggle. Various nationalistic efforts were made within the art world of this time. In the late 18th century, three artists, Jokuchu Ito, Shohaku Soga, and Rosetsu Nagasawa, all profound individualists, rebelled against the Confucianist art of their time, and each did so in disparate, individualistic manners. Although "the link between eccentricity and artistic creativity had deep roots in Zen Buddhism...from the late eighteenth century onwards it became emblematic of resistance to Confucian rationality and the state's control of the individual."[13]

In the mid-nineteenth century, a more organized and widespread revivalist nationalist movement was established, now known as the Yamatoe Revival. During this period, artists such as Totsugen Tanaka (1760-1823), Ukkei Ukita (1795-1859) and Tamechika Reizei (1823-64) headed a movement to acknowledge and revive the beauty of classical Japanese themes, styles, and emblems, in direct opposition to the heavy Chinese influence that had dominated the art up until then.

These efforts nonetheless met with great opposition, both intentional and nonintentional. Because the government restricted the depiction of actors, courtesans, and current events—all the mainstay of *ukiyo-e* art matter—many artists turned to Chinese tales of a more 'moral' heroism for their inspiration, the *Suikoden* prints being a prime example of this phenomenon.

Ironically, the Confucianist government's efforts to curb the freedom of *ukiyo-e* art could on occasion severely backfire. For example, in 1842, the administration, fearful of any overt or covert criticisms, outlawed the depiction of current political or military figures. If an artist wished to portray a Japanese warrior, they could use only ancient figures of national valor. Kuniyoshi, in another famous set of prints, "took advantage of this mandate by issuing prints devoted to [Japanese] heroes of the twelfth-century wars between rival Taira and Minamoto clans. However, in the eyes of a public accustomed to looking for secret meanings, his portrayals of these paragons of feudal loyalty and self-sacrifice were often interpreted as censorious references to the existing political order."[14]

Nostalgia became a central force in this nationalist sentiment, and it was the fall of the samurai as a paragon of loyalty and honor that the public seemed to mourn most deeply. Because the government forced artists to portray warriors of the distant past, these figures were thus subjected to increased idealization and romanticization. Kuniyoshi in some ways acts as an emblem of this nostalgia, particularly as his subject matter draws from "warriors, legendary monks and monsters from the depths of Japan's mythical past."[15]

II.

The spirit of the *ukiyo-e* artists in many ways captured parts of the spirit associated with the myth of the samurai. Though the samurai code of ethics is based on a morale of absolute discipline and devotion, the romanticized conception of the samurai includes more rebellious, unconventional characteristics. Whether in a manner that is historically accurate or not, the samurai are often depicted as figures who defy public convention or authority in order to remain loyal to their own personal convictions.

Devoted to their art, these *ukiyo-e* masters also possessed something of a rebellious nature. Because of the governmental regulation of their art, many of these artists were forced to redirect their artistic energies, and form new (and often even more revolutionary) forms of expression. For example, Kuniyoshi, who also was a prolific political satirist, would create prints employing animals and plants

Facing Page: Tattoo rendition of *Kumonryu* by Horiyoshi III.

allegorizing the politicians of his day. In this manner, Kuniyoshi skillfully undermined the censorship of the Tenpo reforms of the early 1840s.

Artistically, the effects of this rebellious, boundary-crossing nature went even deeper. The range of Kuniyoshi's art included different forms and mediums; he is often cited for his own experience not only as a creator of tattoo designs, but also as a tattooer and as a tattooed man. Kuniyoshi's art, constantly concerned with breaking the bounds of conventionality, reveals a fundamentally rebellious nature combined with a highly trained and disciplined artistry, just as the warrior spirit combines a certain rebellious, even wild, quality, with a strong sense of tradition and honor.

Kuniyoshi is an ideal template for drawing the comparison of the artist and the samurai. Kuniyoshi's personal comportment also showed this sense of will and artistic integrity. In his book on Kuniyoshi, *Of Brigands and Bravery*, Inge Klompmakers writes: "Kuniyoshi was reputed to be a strong-willed character: when he did not like a publisher, for example, he simply refused a commission regardless of how lucrative it might be."[16]

His forceful and individualistic identity led him to be described as something of an ideal individualist: "Bluff, honest, good-natured and an individualist; a man of strong character who was not afraid to speak his mind...a generous friend, a good teacher, and a kind master."[17]

The above description of Kuniyoshi might easily be applied to the ideal tattoo master of today, and indeed, the similarities between the essential character of the tattoo master and the *ukiyo-e* master runs beyond merely the imagic similarities. Tattoo artists, particularly in Japan, often direct a remarkable artistic talent toward a less traditional—and all too often less respected—form of art. Horiyoshi III, in the Afterword to his book of prints, *One Hundred Demons*, writes: "Tattooing reached its peak of popularity among the masses at the end of the Edo period but even then with the exception of a limited number of dedicated supporters it was often scorned and despised...Behind the development of tattoo art as popular culture is the determination of outstanding tattooists who refused to bow to authority and convention."[18]

At the same time, this choice and the subsequent investment pushes the boundaries defining the world of "art" in the manner that *ukiyo-e* art did, and indeed, can throw into question the very definition of such a word. For example, some tattoo artists place greater emphasis on the craftsmanship of the tattoo, as opposed to the sheer artistry. Horiyoshi III

writes: "I take pride in my work and always will. I'd like to make it clear that this 'Hyakki-zu' is one tattoo craftsman's compilation of sketches for tattooing and that they are not works of art."[19] Though many would immediately beg to differ with Horiyoshi III's declaration, it is hardly simply a case of false modesty. For Horiyoshi III, whose appreciation for the value of heritage parallels the samurai valuation of tradition, the core of the tattoo rests upon its status as a craft, just as the essence of *ukiyo-e* art may be said to be that of a printer's craft. However, the remarkable artistry of the work of these "craftsmen" alters the rigid definition of "art," stretching its terms to include "craft."

Perhaps Horiyoshi III's repeated stress on the status of the tattoo as craft lies partially in his own desire to create an artistic expression indicative

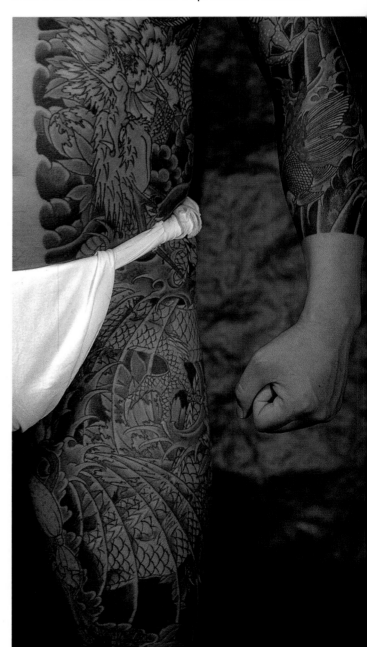

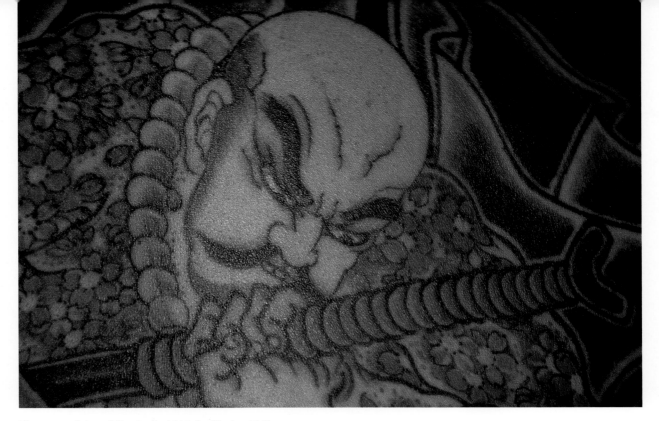

Tattoo rendition of *Kaosho Rochishin* by Horiyoshi III.

of the lives of common people, of "craftsmen." In the fantasy of the samurai, the warrior is similarly concerned with the status of the common people. If Kuniyoshi and his contemporaries succeeded in first creating a "people's" art, thereby broadening the manner in which art was to be regarded in the years that follow, tattooers today are active participants in the "opening-outward" of the modern art world. The tattoo has increasingly drawn attention, both socially and commercially; alongside this development is the increasing acclaim the *art* of the tattoo has recently garnered.

III.

Naturally specific thematic elements from the imagery employed by these *ukiyo-e* artists tide over to the modern tattoo images. It is often possible to draw direct visual correspondences between a tattoo design and an *ukiyo-e* print, whether in terms of the layout of the image, the symbols and motifs placed in the design, or the overall sentiment of the piece.

Both the tattoo and *ukiyo-e* arts feature the shared obsession with highly macabre elements, including remarkably graphic skulls and severed heads. The basis of these images, both in the work of *ukiyo-e* artists and in tattoos, lies in the basic identity of the samurai, that of the warrior and fighter. From feudal times, the samurai were by definition forced to prove

their ability to fight and kill, while simultaneously, and in a manner that might seem paradoxical, following a strong moral code. The ethics of the particular moral code more or less depended heavily upon the samurai's willingness to kill; the defense of a lord's honor could often be achieved only through acts that present-day morality would quickly condemn. Despite the glorification of the samurai in art, literature and legend, the profession of these men was at the most basic level that of the soldier.

It is the unique juxtaposition of the remarkable moral code of the samurai against openly violent displays of the soldier that has long fascinated the imagination of the public. This juxtaposition is evident in the tattoo images, which often contain images of a severed head, or a bloodied corpse, alongside an exquisite rendering of a samurai figure, one capturing the nobility and spirit of this warrior. This juxtaposition leads to an aesthetic of the sublime; the delicate lines and shadings of the tattoo, when combined with a frank and unshirking depiction of death, creates a remarkable work of art, one whose image can at times invoke a powerfully visceral response.

The role of the body is very much at the center of all of this; the transient nature of the art of the tattoo (after all, the work of art exists only as long as the wearer is alive) is reflected in the tattoo's depiction of the delicate, ephemeral nature of life. Hardy links this aesthetic to the larger culture of the nation: "In some ways the tattoo epitomizes a

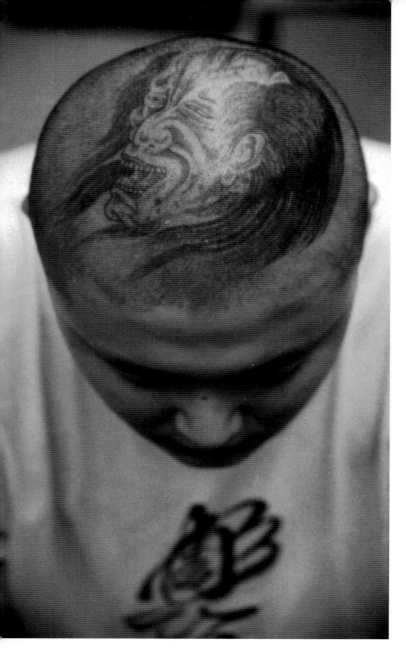

Horitaro's head, tattooed by his master: Horihito.

past. As a result, these images seem tinged with a wistful, uncanny beauty.

The mortal nature of the body of art in the form of the tattoo is reflected in the imagery of these samurai tattoos, which in turn is reflected in the mortality of the very men who bear these works of art. The mortality of the body here signifies not only human mortality, but artistic mortality, a relationship that is undoubtedly unique to the tattoo. While the trope dictates that the artist achieves immortality through his works of art, in tattoo art, if anything, the tattooer's art confirms his own humanity. Therefore, these images are infused with a heavy awareness of death—even when it is the samurai who delivers the blow of death. Other mortality images abound both in tattoo and *ukiyo-e* art; chief among these is the image of the cherry blossom. Blooming for only an extremely brief time, the flower evokes the brevity of the warrior's life, as well as the immense beauty and vibrancy contained within this short span.

Even when the images themselves are not immediately concerned with depicting the fragile state of humanity, the greater composition emerging out of the compilation of both wearer and tattoo image often refers to the tattoo bearer's own humanity. For example, one of the most popular images during the Edo period was that of the dragon, a mythical, all-powerful creature. As aforementioned, for members of the firefighting brigades, the dragon held special significance; because the dragon is said to live both in air and in water, it symbolically protected the wearer from fire. Thus despite the fact that the image of the dragon in and of itself has little to do with representing the fragility of life (rather, it would seem to represent a supernatural vitality), the choice to use the dragon as the subject of a tattoo reveals a poignant awareness of the fragile nature of life—particularly for the "warrior-like" firebrigade members.

While the warrior tattoo designs provide the most literal example of the infusion of the samurai spirit into the art of the tattoo, the symbolic nature of Japanese art images assigns the same traits and meanings of the warrior tattoo to animals as well. It is also not difficult to speculate that one who thought of himself as possessing the traits of a warrior would align himself with fierce beasts, real or imagined. But there is a more specific association between the meanings ascribed to these animal images and the *bushido* of the Japanese samurai.

The symbolic significance of the dragon is an example of the "coded communication" omnipresent in Japanese tattooing. Much like Japanese culture,

particularly Japanese aesthetic: that of *mono no aware*—the deep appreciation of an object's beauty, coupled with a sense of longing or sadness at the transience of that beauty. Accepting the ephemeral nature of all existence and understanding that its very transience renders a moment or creation more precious is a core concept of the culture."[20] It might be added that this sense of longing is in essence of forward-projecting nostalgia; that is to say, this sadness looks forward to the time when the object, or moment of beauty, has passed. However, perhaps most crucially of all, this sense of a "nostalgic present" allows for an idealization and romanticization of a present moment, in contrast to the more traditional form of nostalgia, which projects this idealization only onto moments in the

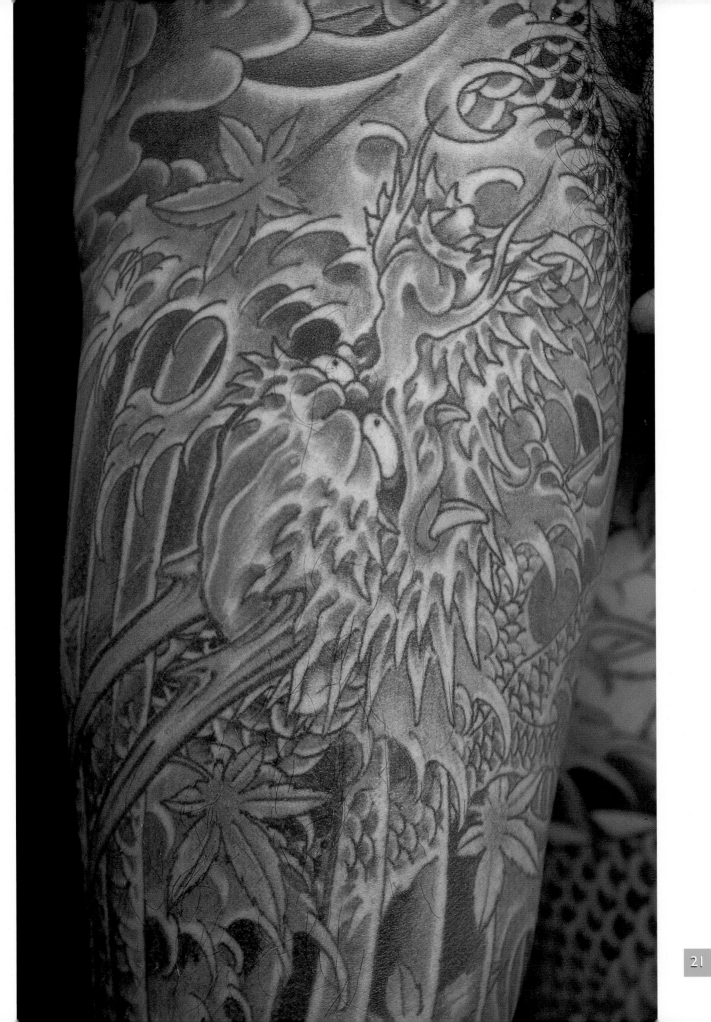

these codes are complex and multi-faceted; it is thus difficult to give a comprehensive, glossary-like definition the imagery that forms Japanese tattoos. Meanings will vary by era, artistic school, and artist—nor should one be too quick to disregard the personal meanings the bearer of the tattoo will ascribe to the image he or she chooses. For example, for the fireman who chooses a dragon design, the emphasis falls on the belief that the dragon will protect him from fire. But the dragon has many meanings connoted to its image. The dragon can immediately be linked to the samurai spirit by the manner in which it represents strength and the wisdom of restraint. There are other ways in which the dragon is linked to the samurai spirit; the dragon is central to the mythology of Japan, and is often connected with various gods and goddesses. As a being possessing and revered for supernatural powers, the symbolism of the dragon tattoo still

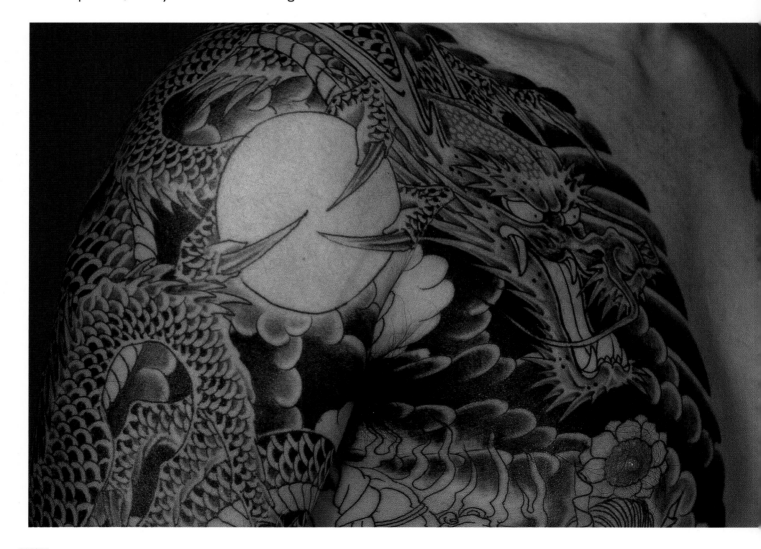

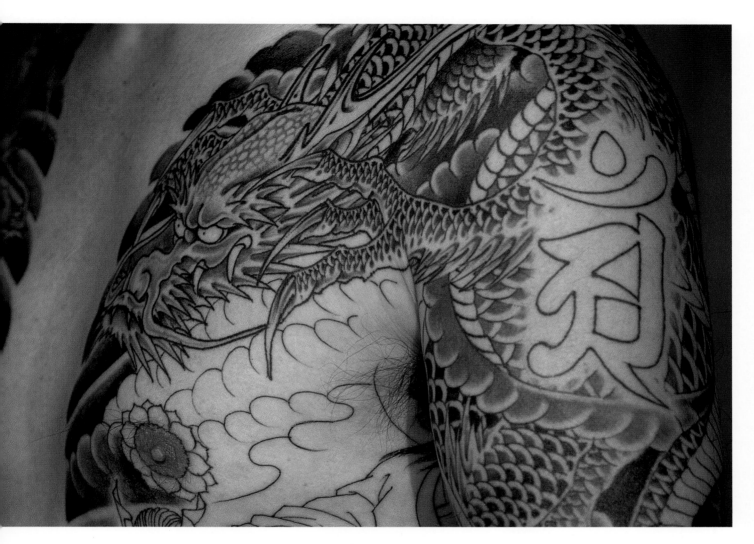

retains its protective qualities as well as a more blatant image of strength.

The tiger is another image which figures highly in tattoo and *ukiyo-e* art. From ancient Chinese thought, the tiger had power over the other beasts, best exemplified in the Japanese saying "*senri o hashiru.*" The literal translation means "runs 4000 kilometers," and the ability of the tiger to do so on a daily basis made it a warrior of the animal kingdom, respected by those who valued strength as an asset. The tiger thus represents not only speed and strength, but also endurance, qualities all central to the warrior.

Finally, perhaps, it is the crucial link of Kuniyoshi's *Suikoden* prints that ratifies all these connections. Many of the warriors of this highly influential print series were tattooed; thus when clients were inspired to obtain a tattoo in the style of the *horimono* that decorated these warriors, they did so out of

the desire to reference the indomitable samurai spirit represented by these images. Kuniyoshi's warriors wore images of dragons (*Kumonryu*), cherry blossoms (*Kaosho*), fire breathing foxes (*Kanchi-kotsuritsu*), fish (*Sotoki Sosei*) and tigers (*Tanmeijiro Genshogo*), to name only a few of the images that were to become standard repertoire for Japanese tattooers. It is also interesting to note that some of the aforementioned tattoos of the *Suikoden* are Japanese additions. Kuniyoshi chose to decorate some of his warriors with tattoos, though in the Chinese text upon which the series is based, they are not described as having tattoos. Because of the explosive power of Kuniyoshi's work and the influence these prints held on the imaginations of the tattoo community and the community at large, even without the indirect link of hidden meanings, the tattoo imagery worn by these bandit warriors came to directly represent the warrior spirit.

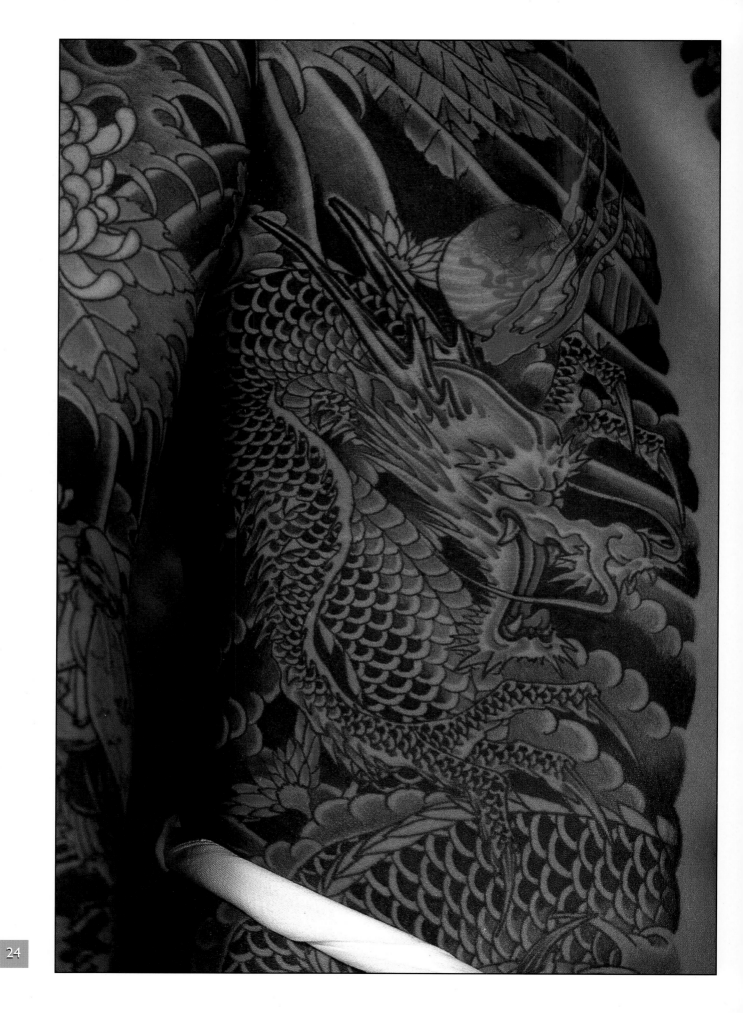

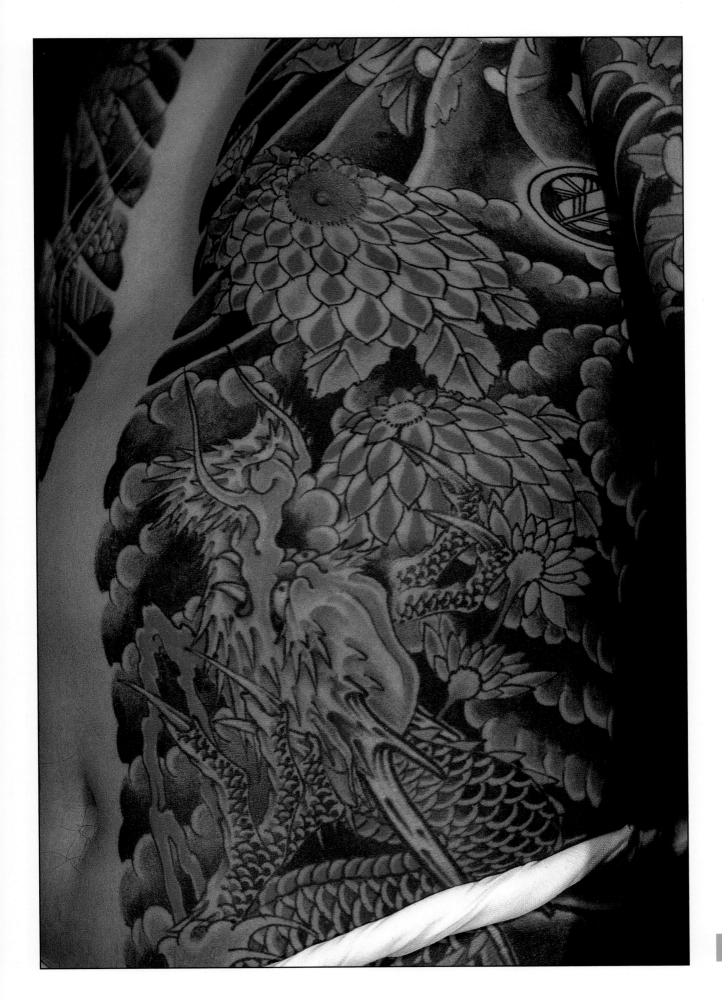

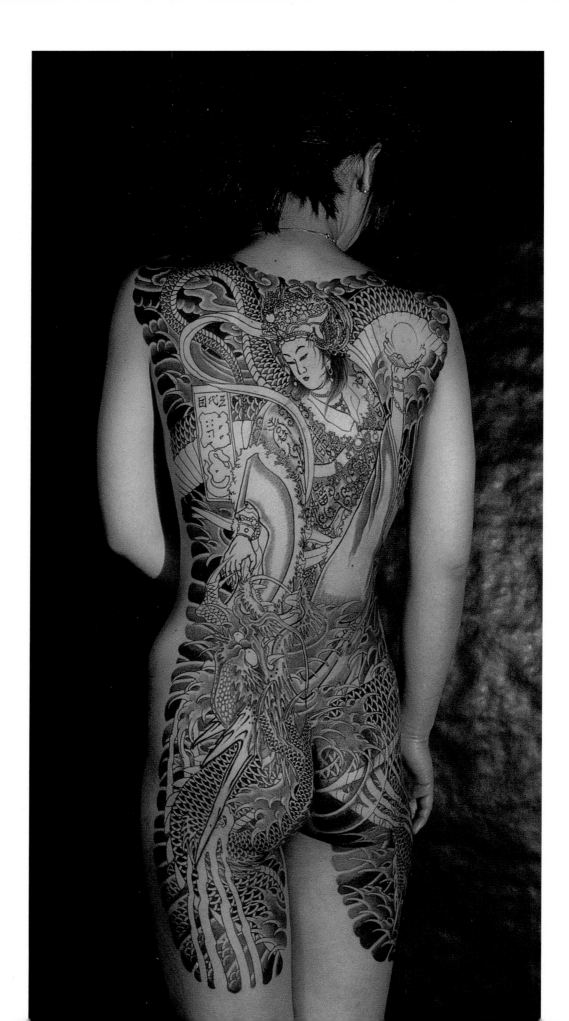

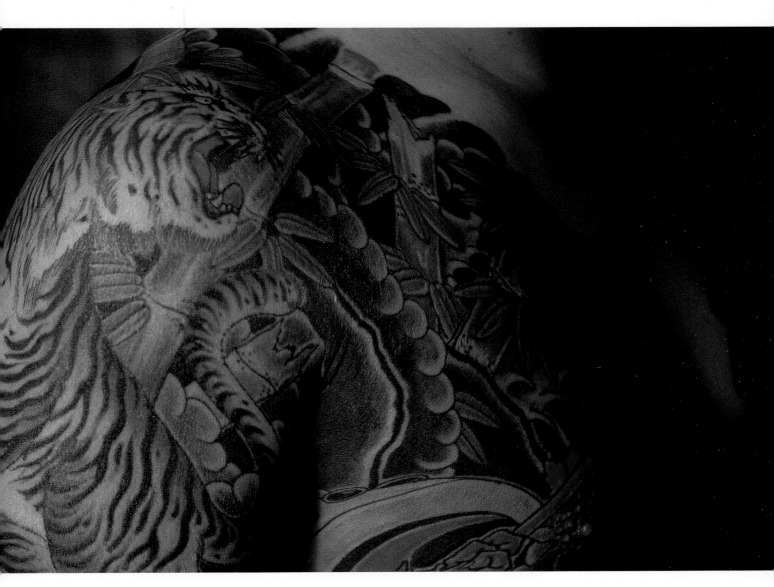

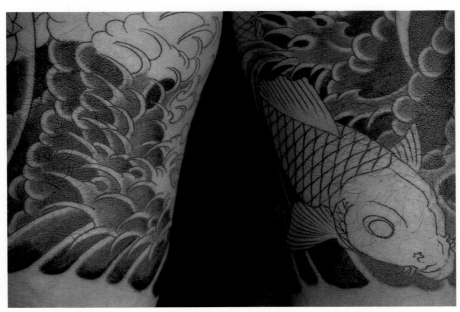

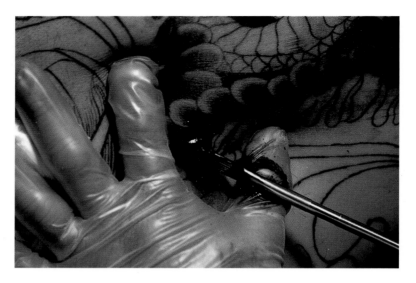

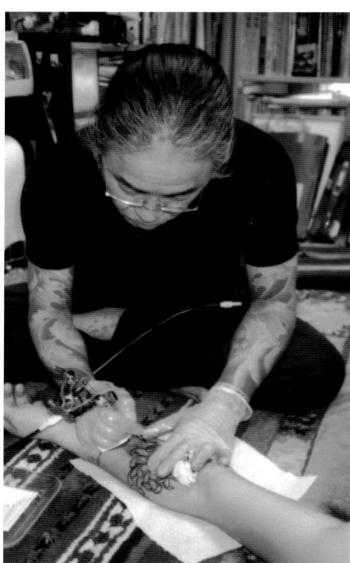

[1] In his article, "The History and Techniques of Tattooing in Japan," Horiyoshi III writes: "It is presumed that the inlaid lines and colorful designs engraved on the clay figures which have been excavated from ancient tumulus remains are intended to represent tattoos.

[2] Robert T. Singer et al. Edo: Art in Japan 1615-1868(New Haven and London: Yale University Press, 1998)14.

[3] Inge Klompmakers, Of Brigands and Bravery: Kuniyoshi's Heroes of the Suikoden (Leiden: Hotei Publishing, 1998)14.

[4] Horiyoshi III (Yoshihito Nakano), "The History and Techniques of Tattooing in Japan," IN Woman in Tattoo, Ed. Kaname Ozuma (Tokyo: Tatsuma Publishing Co.,1995)5.

[5] Klompmakers, 16.

[6] Christine Guth, The Japanese Art of the Edo Period (London: Orion, 1996) 47.

[7] Don Ed Hardy Ed. Pierced Hearts and True Love (Honolulu: Hardymarks Publications, 1995)

[8] Guth, 28.

[9] Nigel Cawthorne, The Art of Japanese Prints (London: Hamlyn, 1996) 17.

[10] Guth, 141.

[11] Guth, 27.

[12] Guth, 34.

[13] Guth, 81-2.

[14] Guth, 118.

[15] Nelly Delay, Japan: The Fleeting Spirit (London: Thames & Hudson Ltd., 1999) 127.

[16] Klompmakers, 10.

[17] Basil W. Robinson, Kuniyoshi (London: Victoria & Albert Museum, 1961)24.

[18] Horiyoshi III, One Hundred Demons of Horiyoshi III (Tokyo: Japan Publishing Co., 1998).

[19] Horiyoshi III, One Hundred Demons of Horiyoshi III.

[20] Hardy, 69.

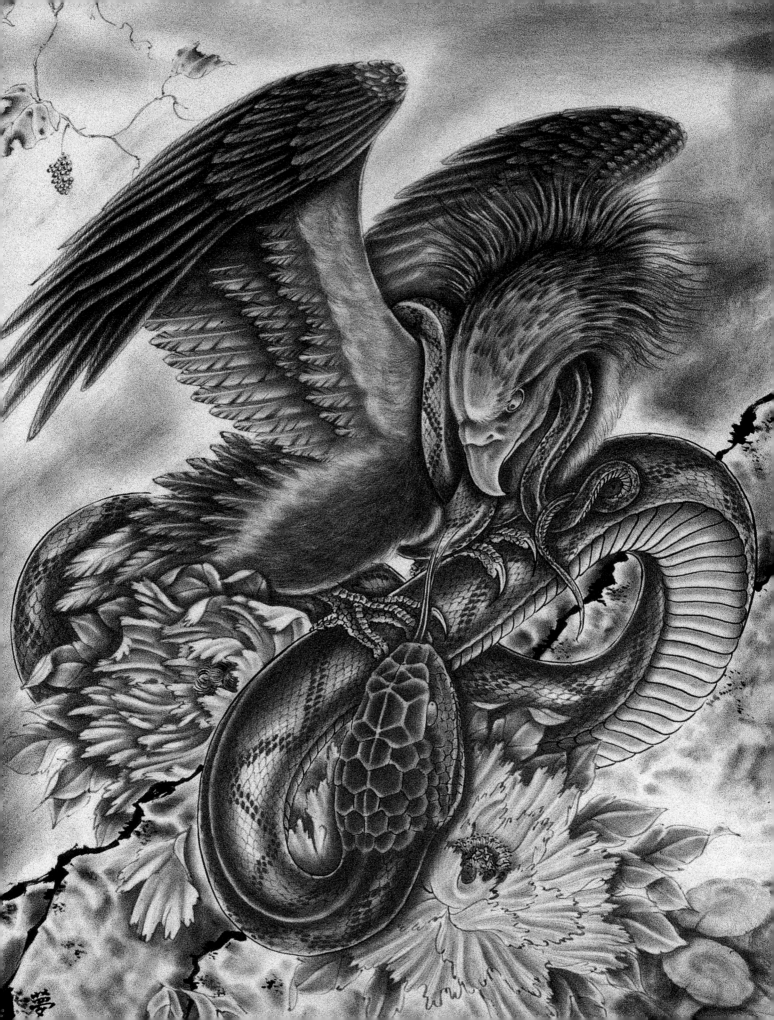

Chapter Two

Selecting the design for one's back could well be the second most important decision the client makes, surpassed only by the selection of the tattoo master. The tattooed back, stretching from the neck, encompassing and utilizing buttocks, and ending at mid-thigh is the largest unbroken space on the body on which to view a single image. The back offers the ideal canvas for the tattoo artists, and often the most exquisite works of art produced by tattooers will employ this space.

My tattoos, a mix of memories and impulse decisions, would undoubtedly appear both errant and artistically questionable by Japanese standards.

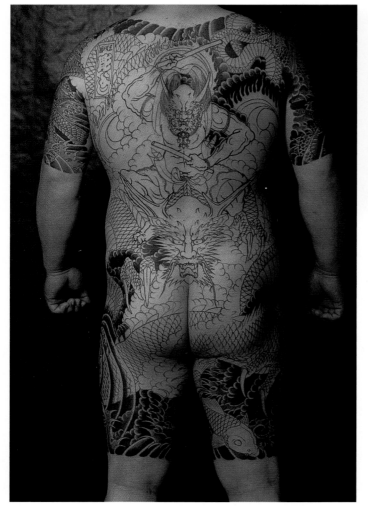

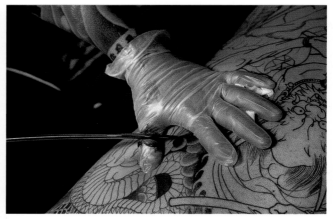

In truth, my one-point tattoos form a record of life experiences, even life phases, and for better or worse this is a central part of the character and charm of the American tattoo.

Fortunately, my back remained bare for 24 years. In part this was by chance, but as my understanding and appreciation of tattooing as an art increased, it was also in the anticipation of a full size backpiece. The process of choosing my "dream" master was not difficult. I was first exposed to the work of Horiyoshi III in Ed Hardy's *Tattootime* series while I was still in high school, and vigilantly watched for the many photos that were published in following years. The personal interviews I read with Horiyoshi only sharpened my admiration—even adoration—for the artist. When he published *One Hundred Demons*, a volume of

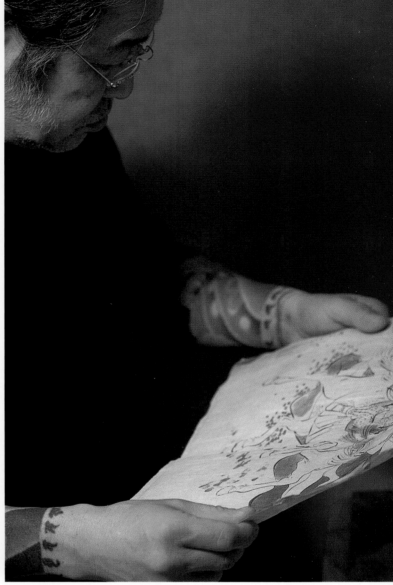

his artwork which took many great strides toward legitimizing tattoo art, I was literally stunned by its visually astonishing and artistically rich quality. I knew he was the artist for me—yet had no idea how to proceed from there.

Being Japanese born and American raised, my understanding of Japanese culture is characterized by my own distance and sense of alienation from what is finally my own country. But perhaps it is also due to this distance that I am familiar with the basic elements and ideals of this culture. Though I freely admit that I can be prone to romanticizing or idealizing certain elements of my native country, I also believe that my purported "innocence" also permits me to isolate the essential spirit of this nation, and in some sense recover what may've been displaced in recent times.

Several years ago, I read Eiji Yoshikawa's epic novel *Musashi*, which has been heralded by some as the *Gone with the Wind* of Japan. I was mesmerized, not only by the actual story (one falling into the genre of historical fiction), but also by the keen insights it provides into Japanese culture and patterns of thought. Upon finishing *Musashi* I promptly turned to another of Yoshikawa's historical novels, *Taiko*, the story of Hideyoshi Toyotomi. I fell in love with the story, and found myself enraptured by the tale of his dramatic rise from the status of sandal bearer to a position as one of the most powerful men in Japan. At the height of his career, Hideyoshi was one of the highest-ranking generals of Nobunaga Oda, a ruler who held as his primary objective the unification of Japan. When Nobunaga was assassinated, in true samurai fashion, Hideyoshi swiftly

(and violently) meted out justice by eliminating the "guilty" parties and continuing the mission of his dead lord. Though his lineage eventually fell to the Tokugawa Shogunate, Hideyoshi did complete the monolithic task of unifying Japan. The effect the story had on me was such that Hideyoshi became the center of the design I envisioned.

Having located both my ideal design and ideal artist, I became increasingly eager to realize what was beginning to look suspiciously like a highly un-realistic dream. At the suggestion of my friend, Jason Kundell, I wrote to Horiyoshi III, and in my crude and simple Japanese, explained the subject matter. I even went so far as to enclose a color copy of a Yoshitoshi rendition of the Taiko, which, while a beautiful print, was completely unsuitable for the Japanese tattoo format; at the time, its unsuitability was unknown to my then entirely untrained eye. Horiyoshi III seemed to be intrigued by my request; as he later told me, in nearly 30 years of tattooing, this was the first request for a tattoo of Hideyoshi. At our first meeting, his sketch surpassed the already lofty expectations I held and the tattoo was started. Over a two-week period, Horiyoshi completed the main image of Hideyoshi Toyotomi, sword raised on horseback in pitched battle, an image which gave life to every notion I had had of the Taiko. Since then, on subsequent trips, Horiyoshi has continued the tattoo, which is as of now still in progress.

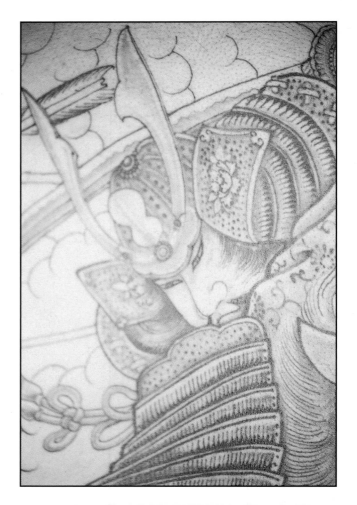

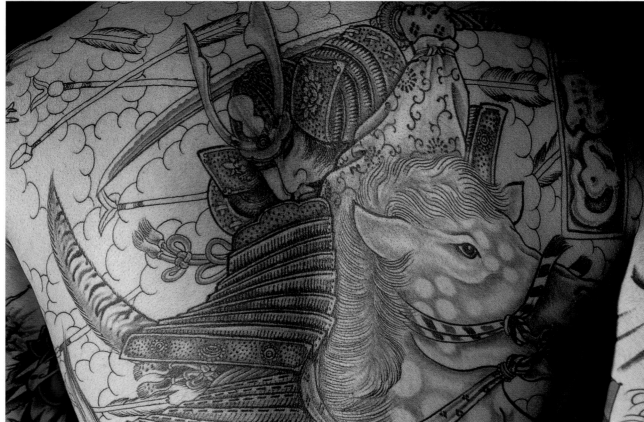

Genichiro Katori

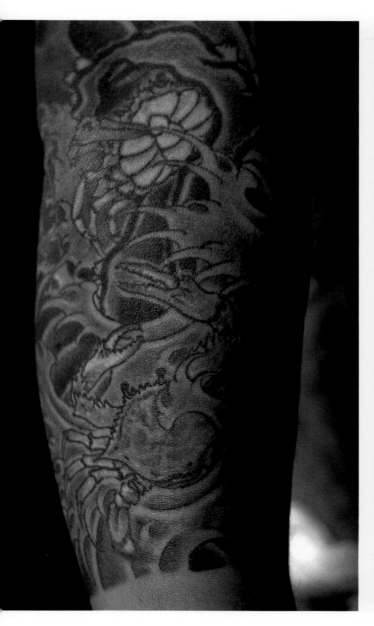

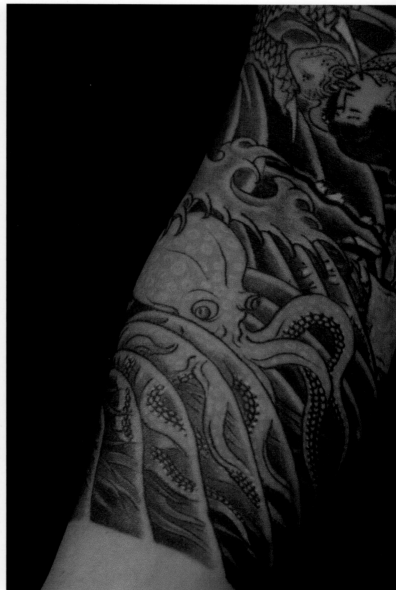

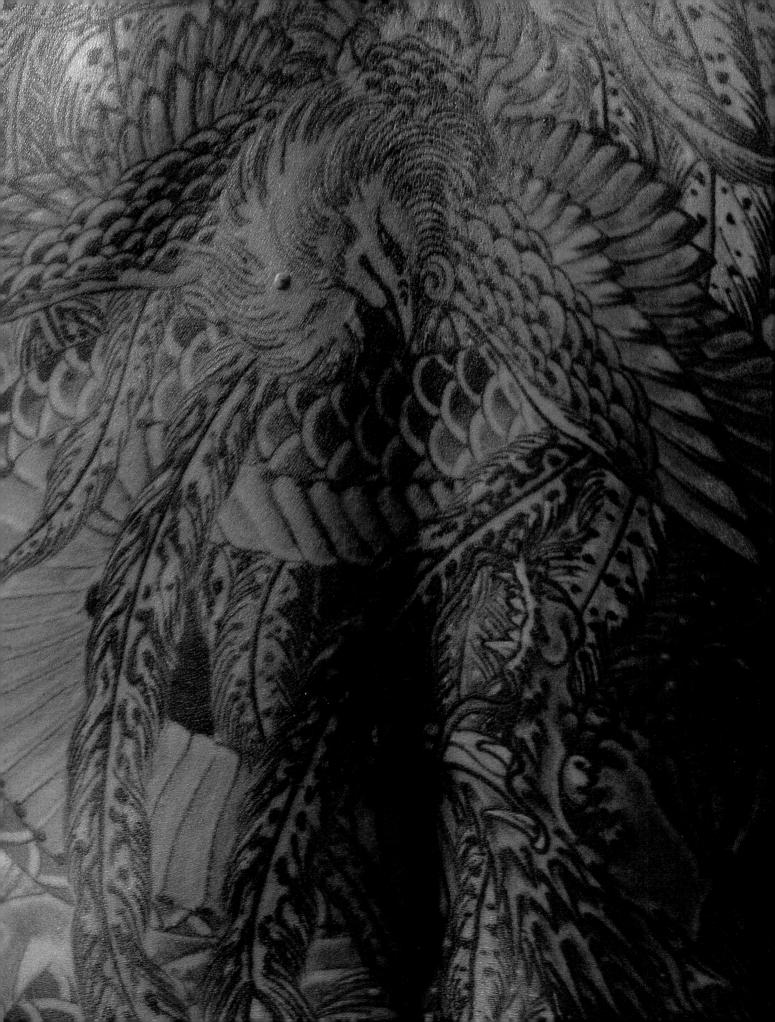

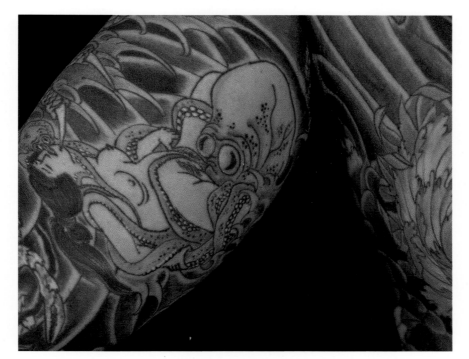

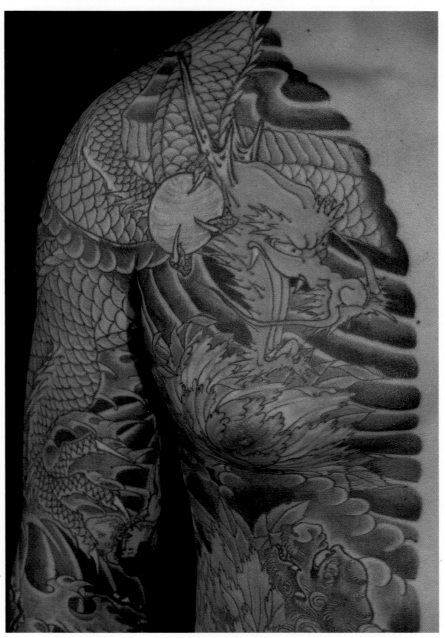

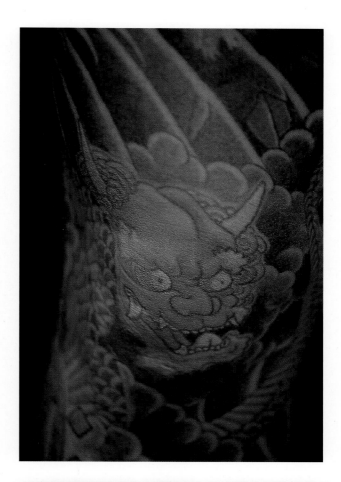

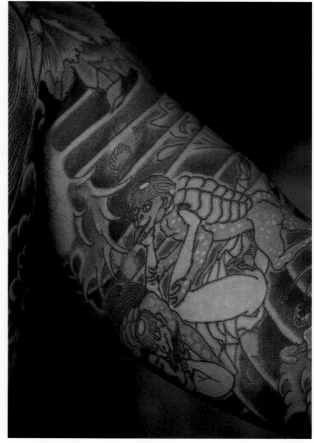

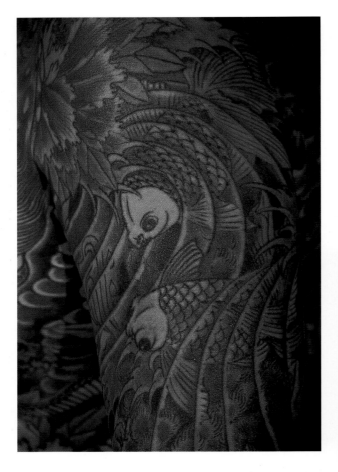

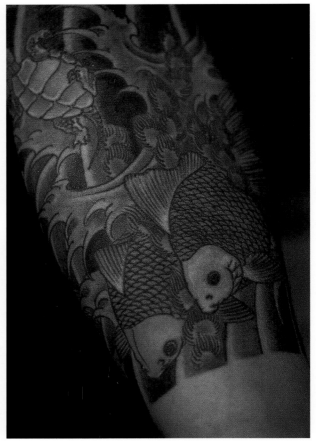

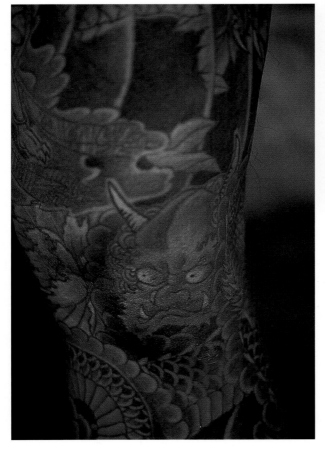

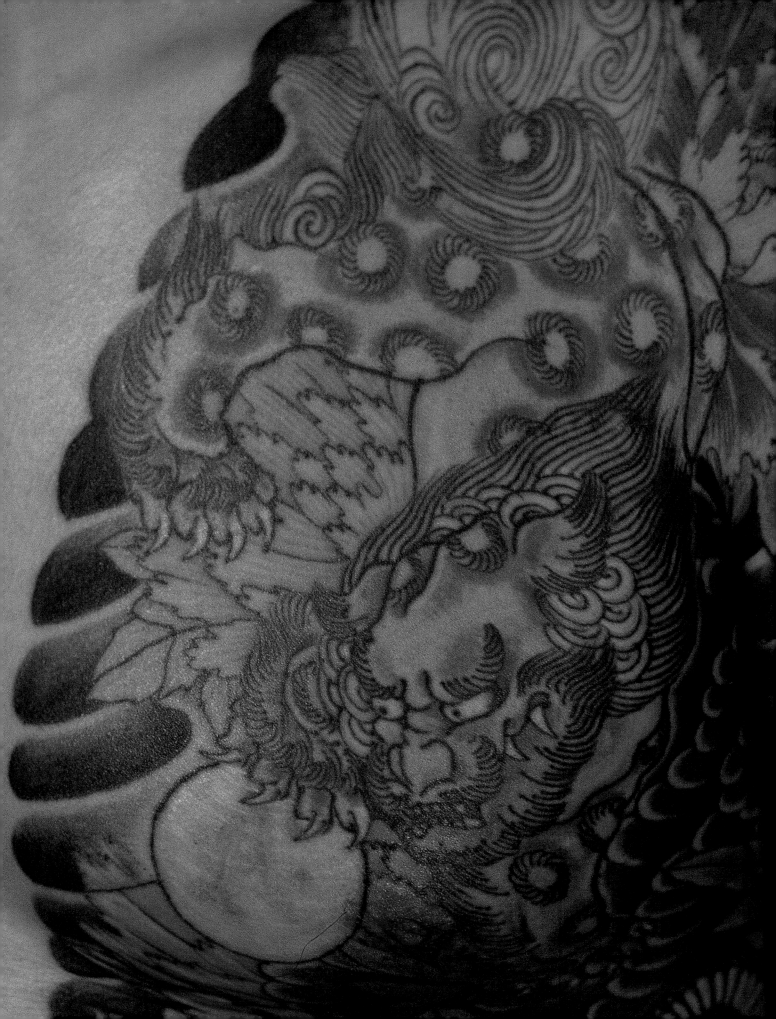

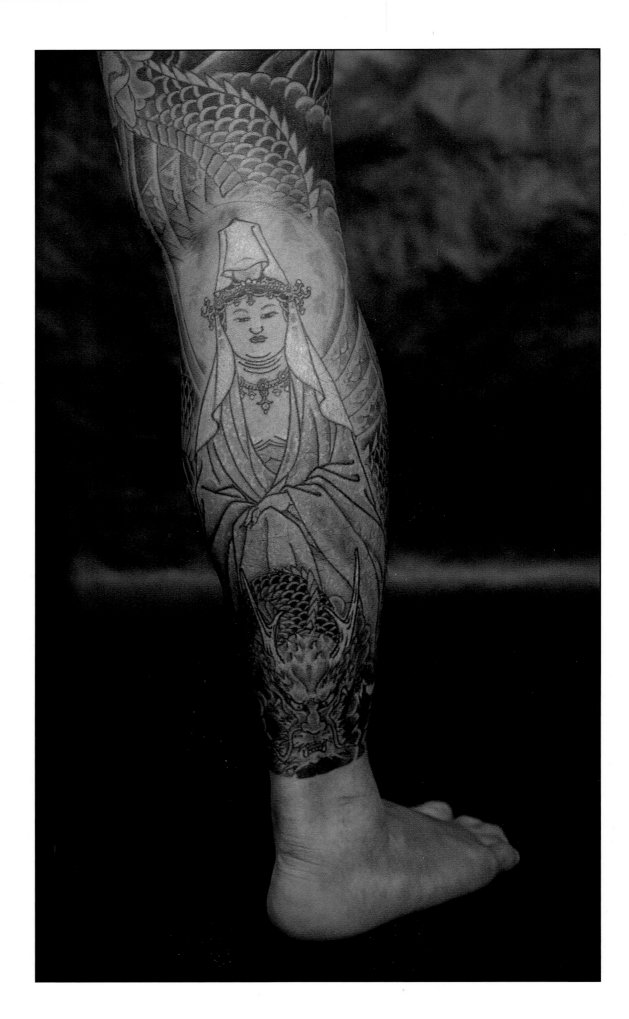

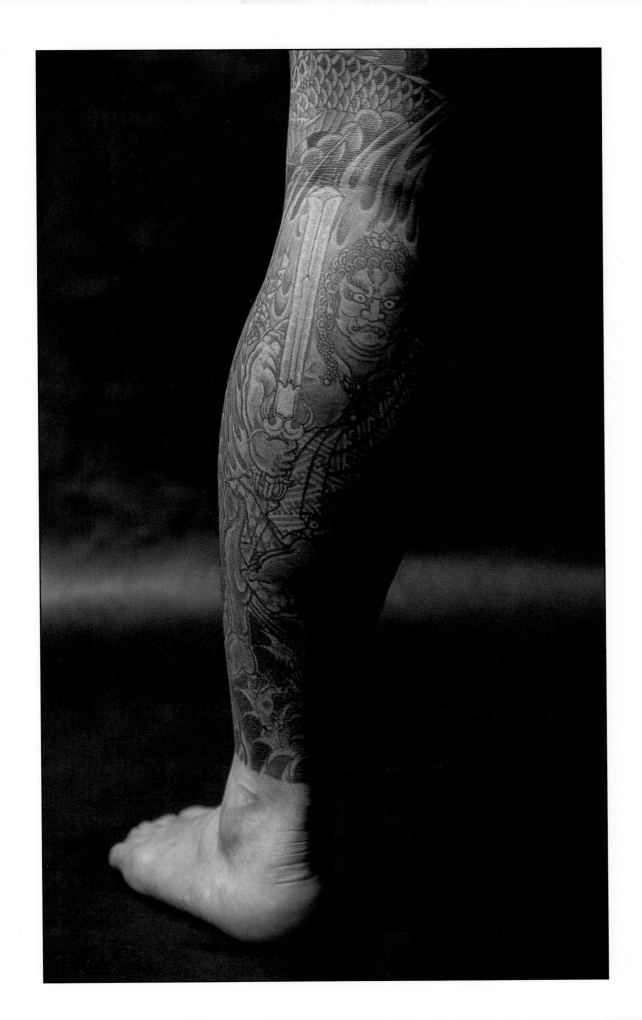

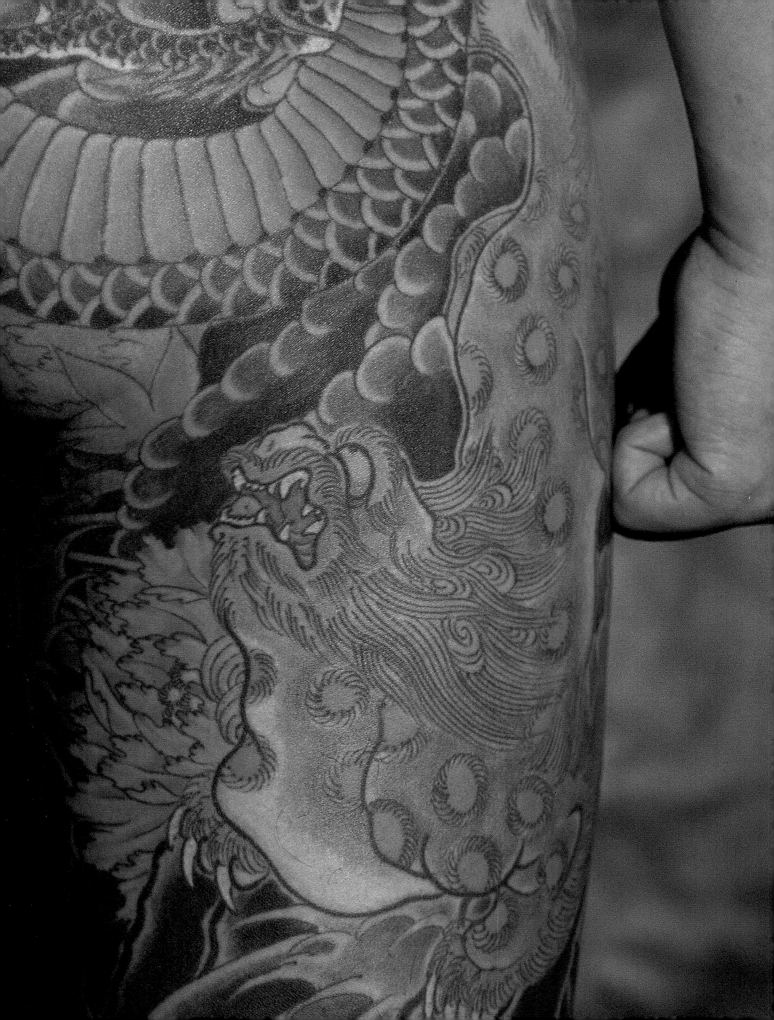

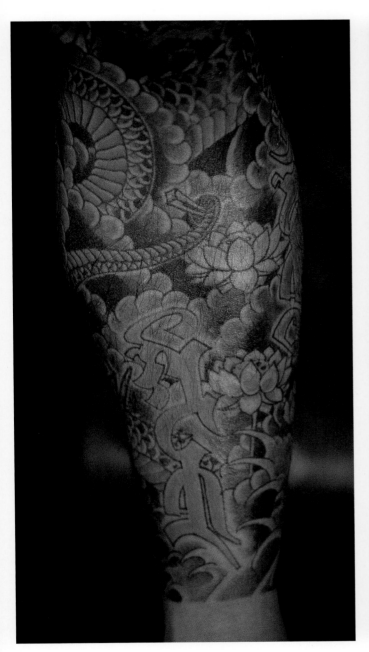
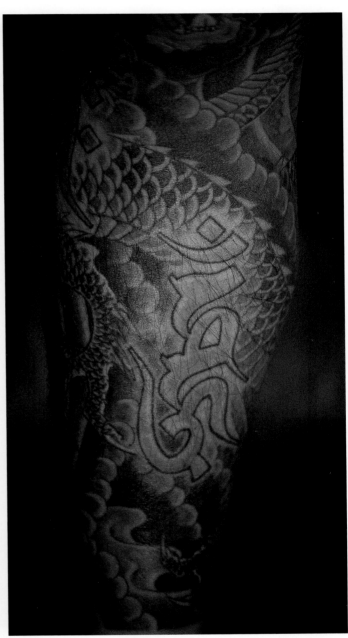

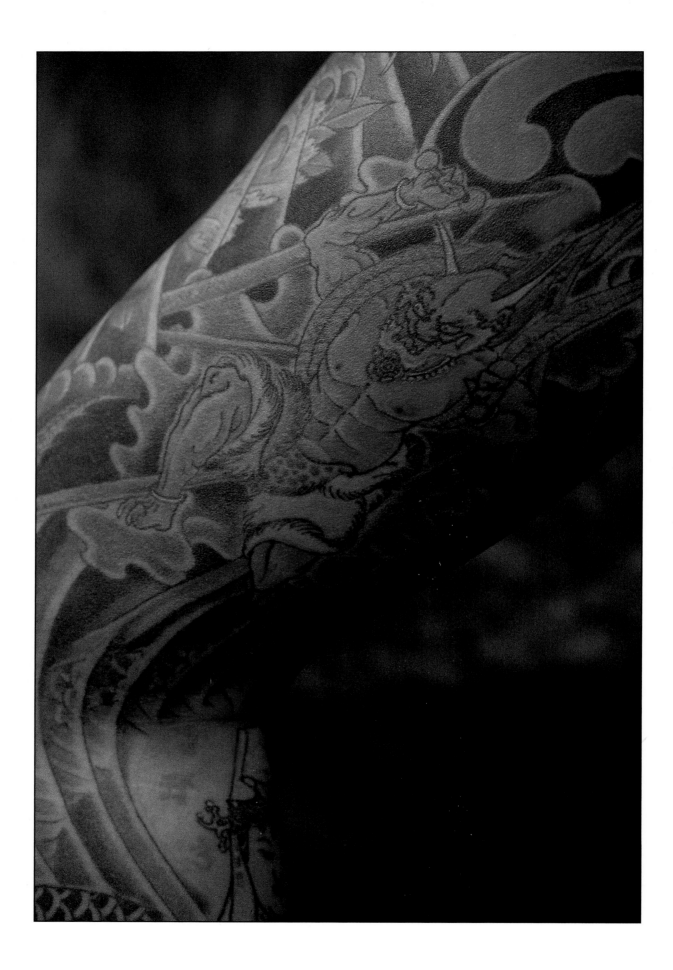

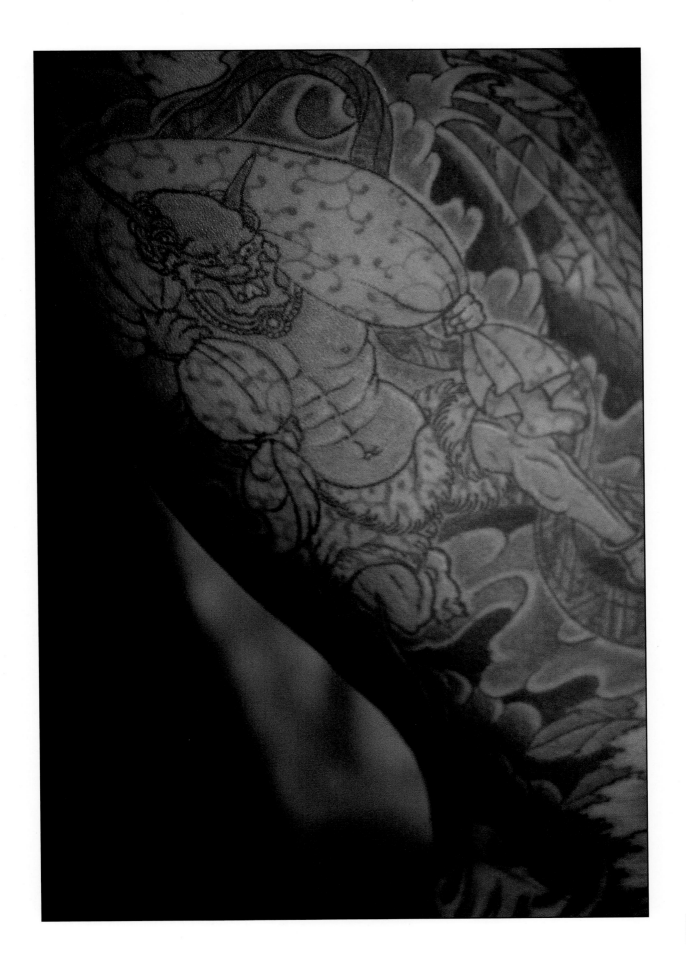

Motohiko Handa

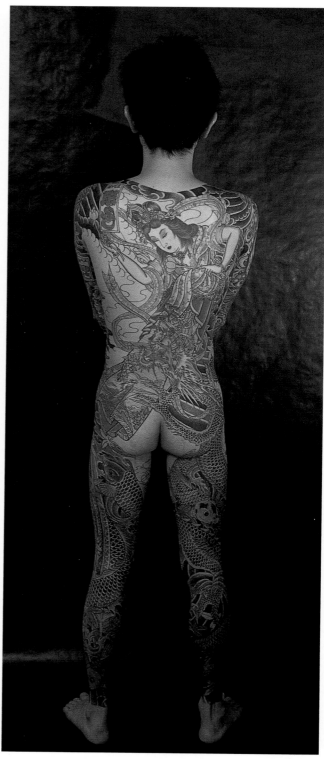

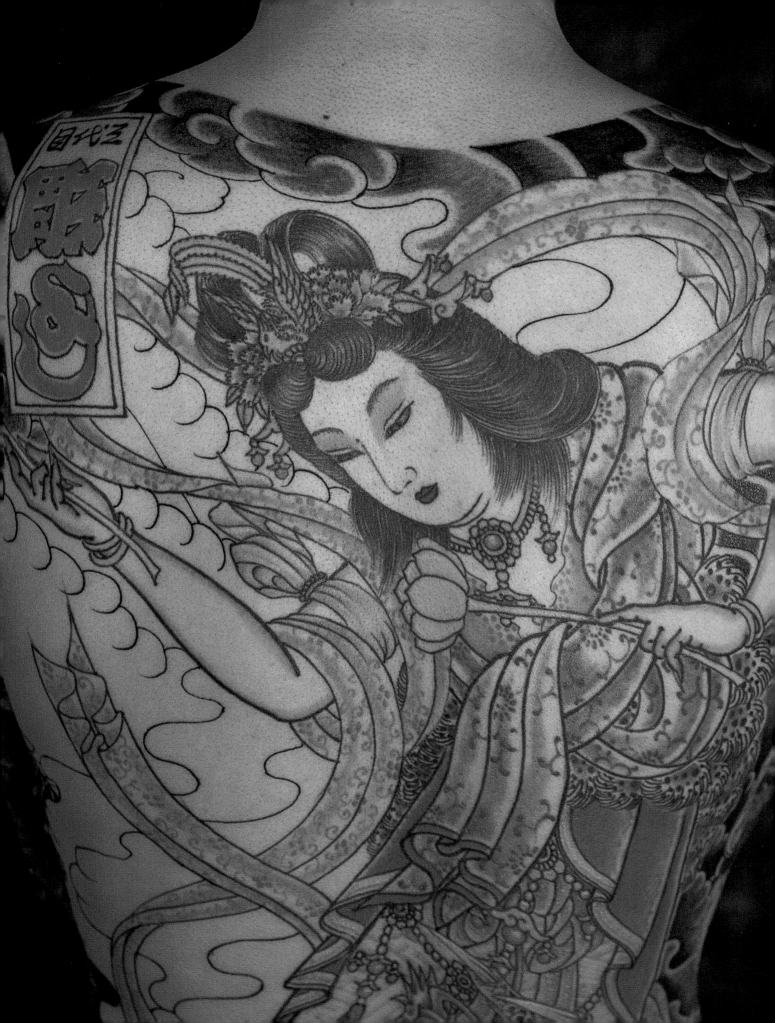

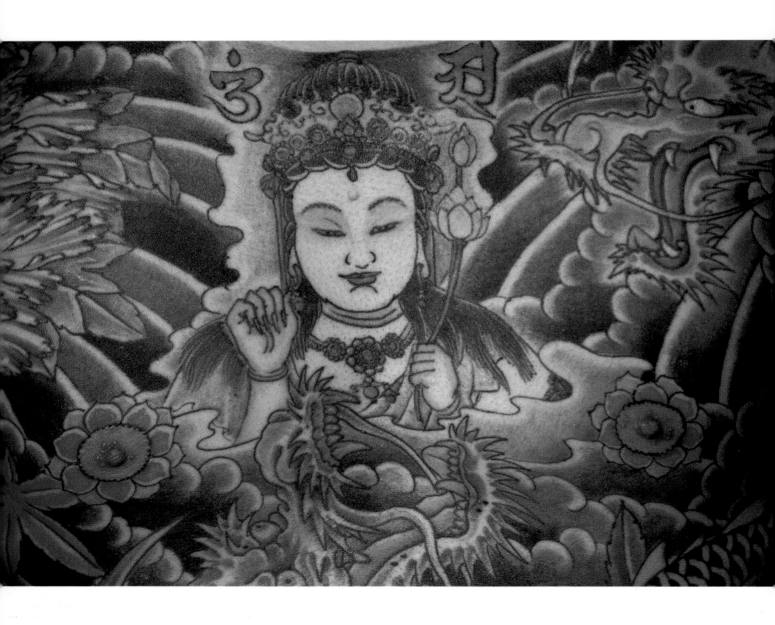

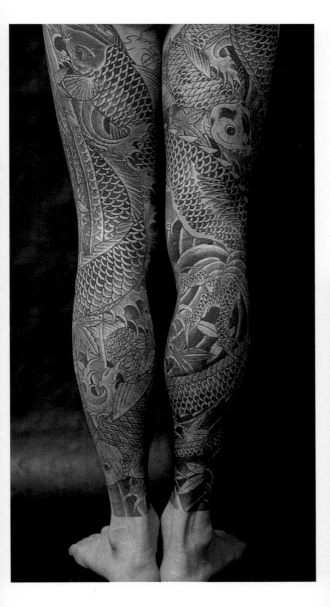

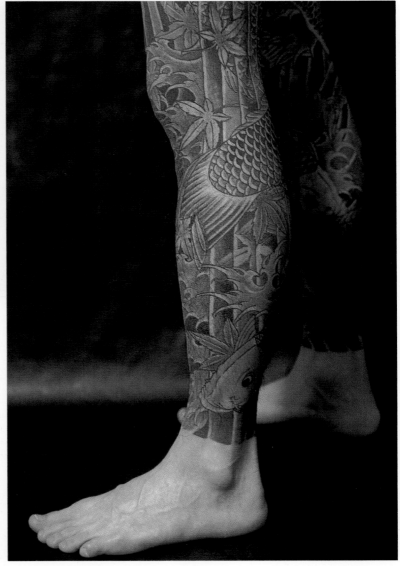

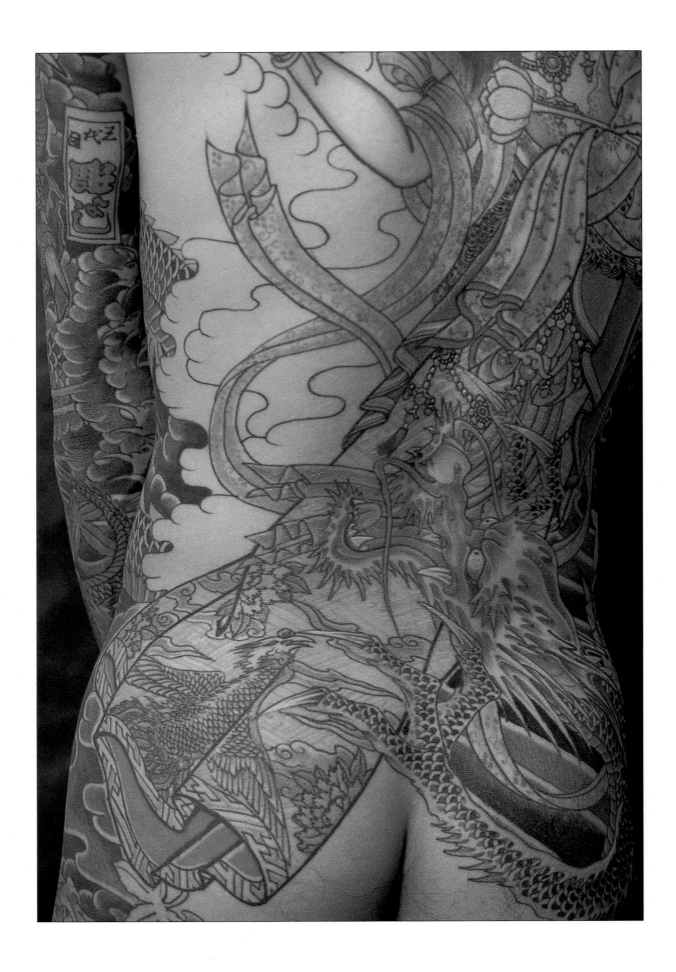

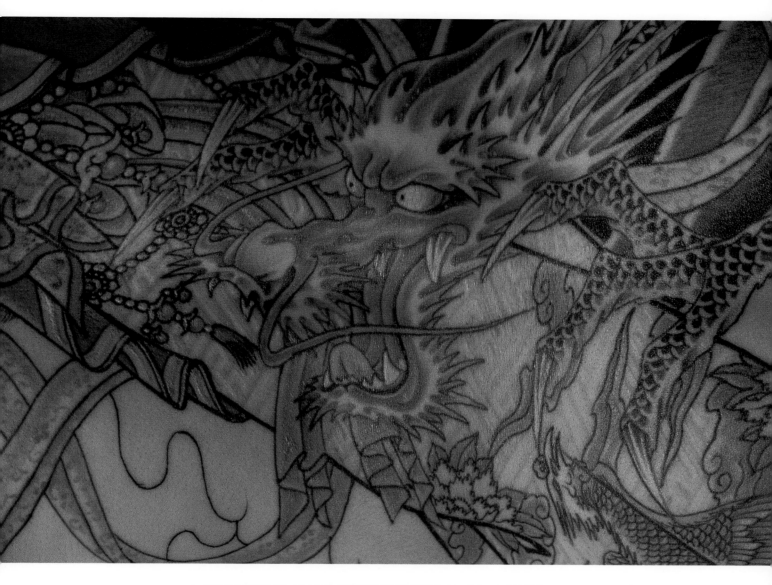

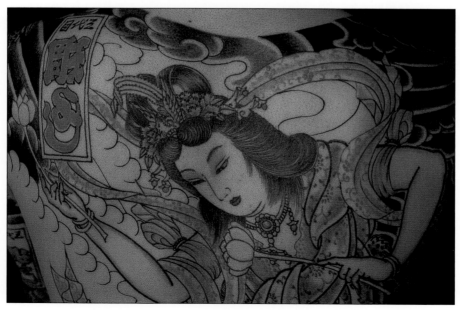

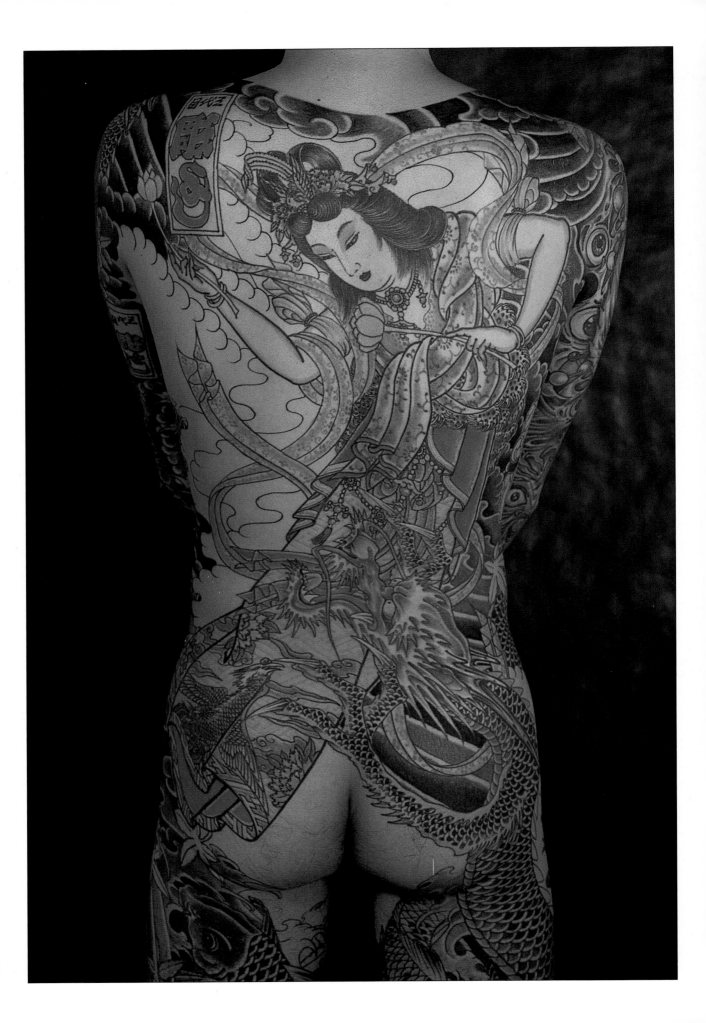

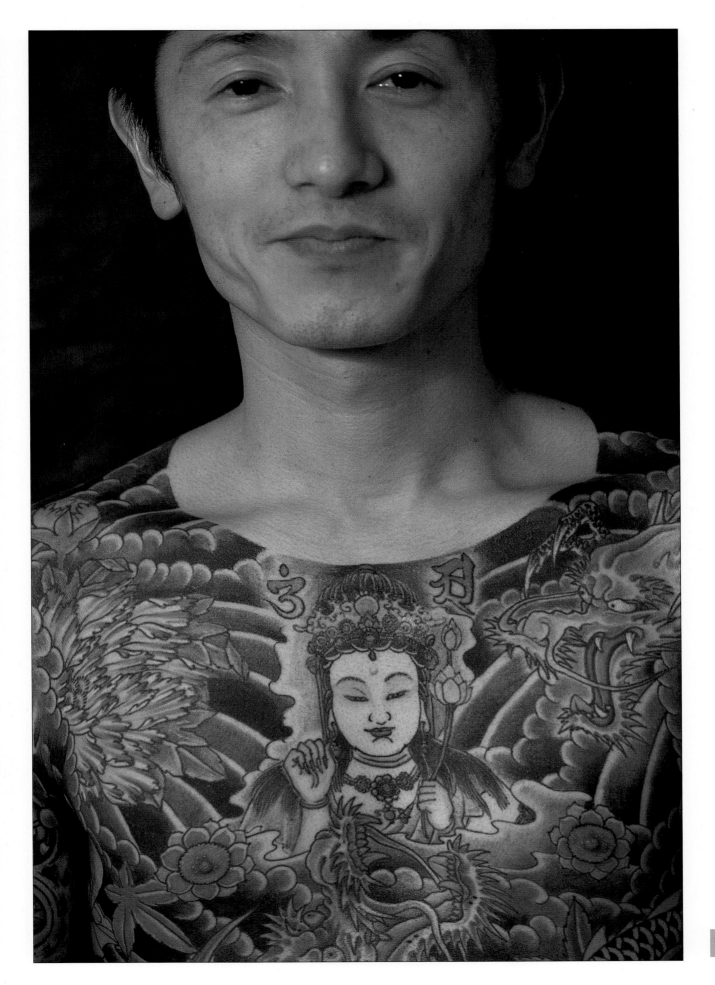

Naomi Ashida

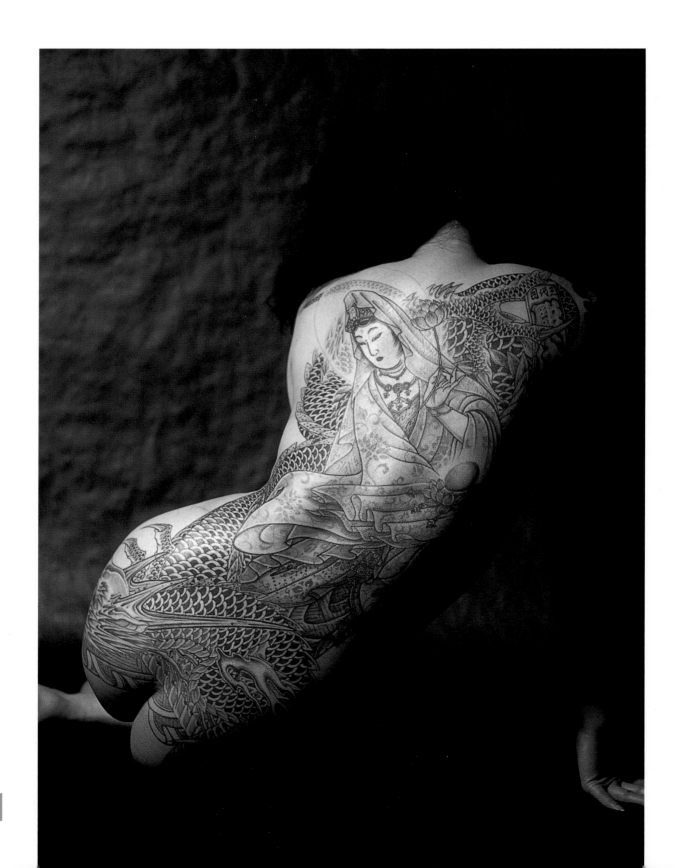

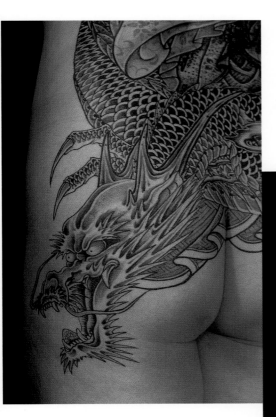
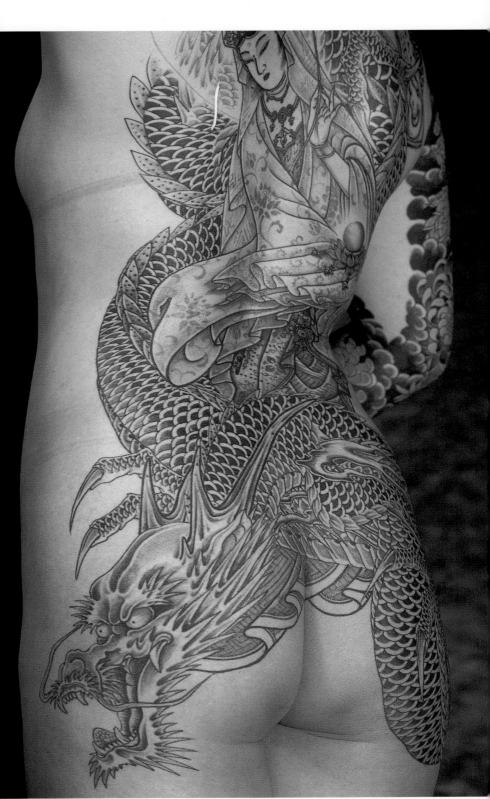

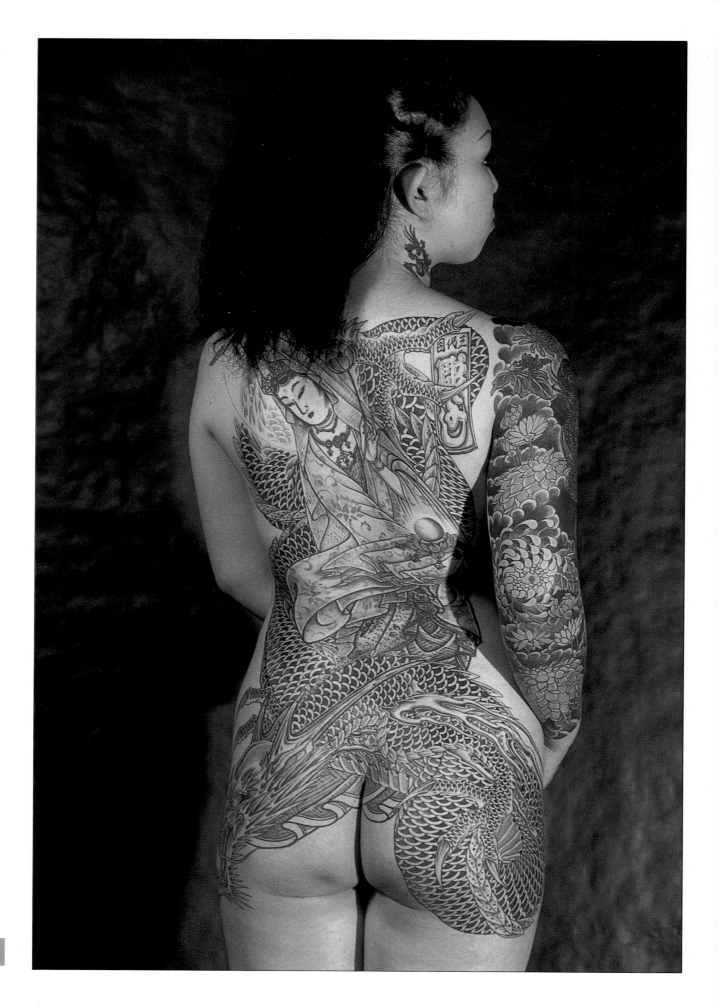

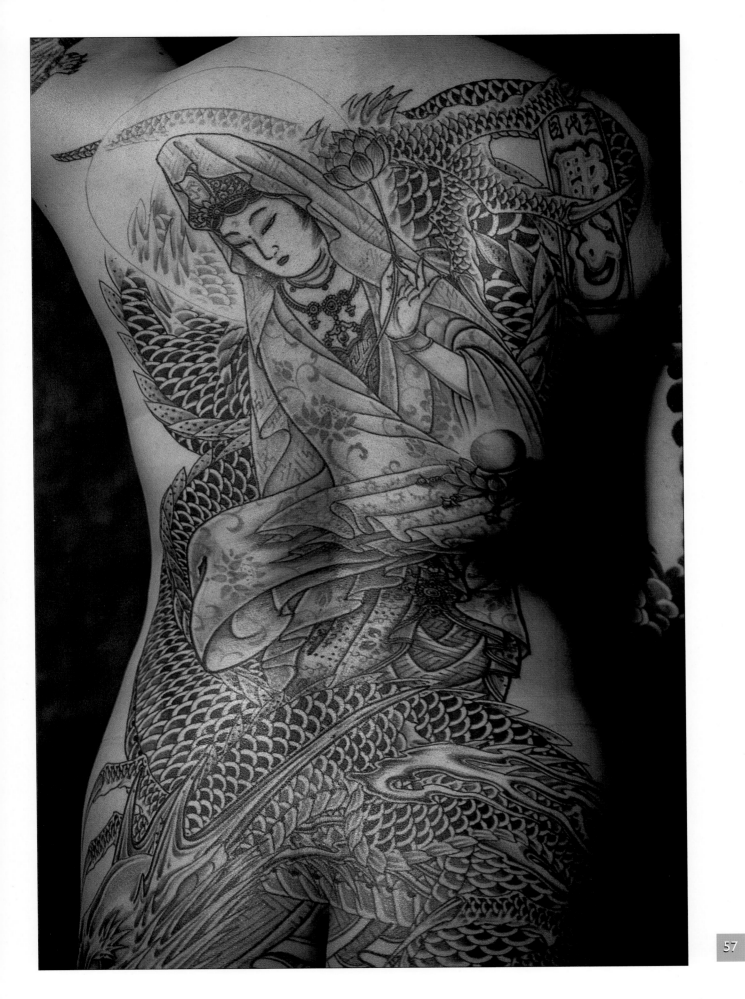

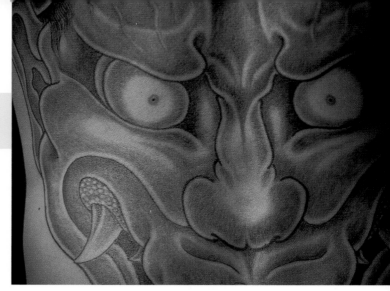

Syuichi Kawagoe

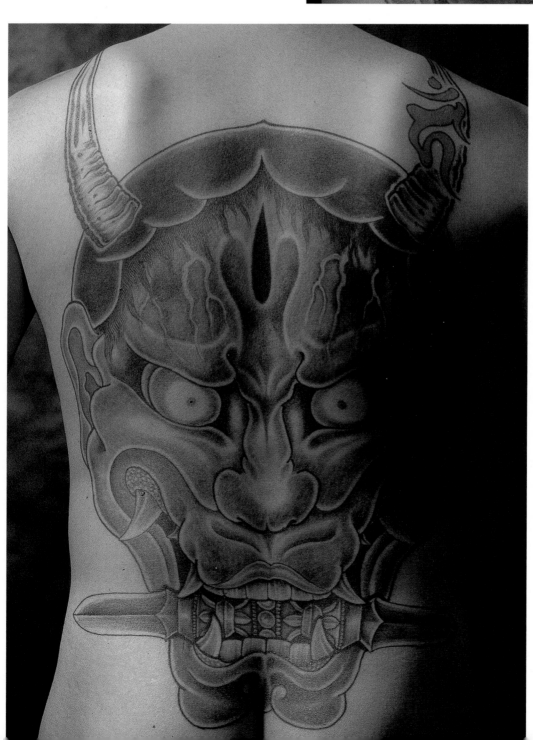

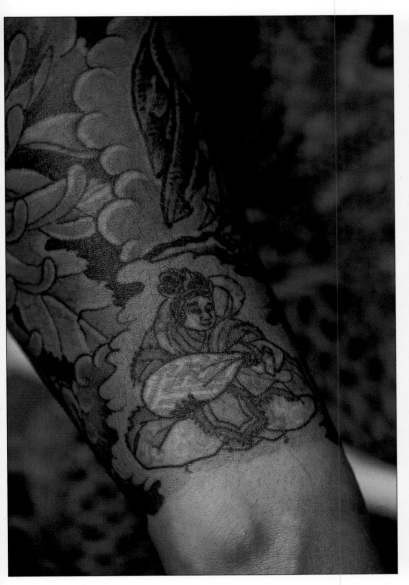

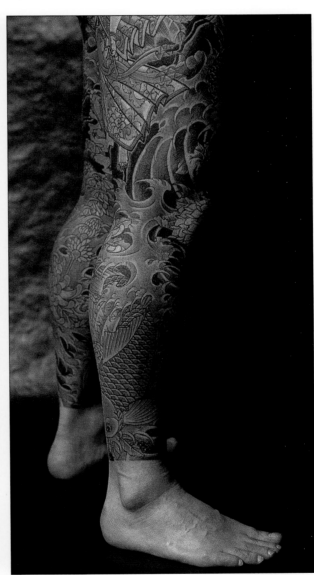

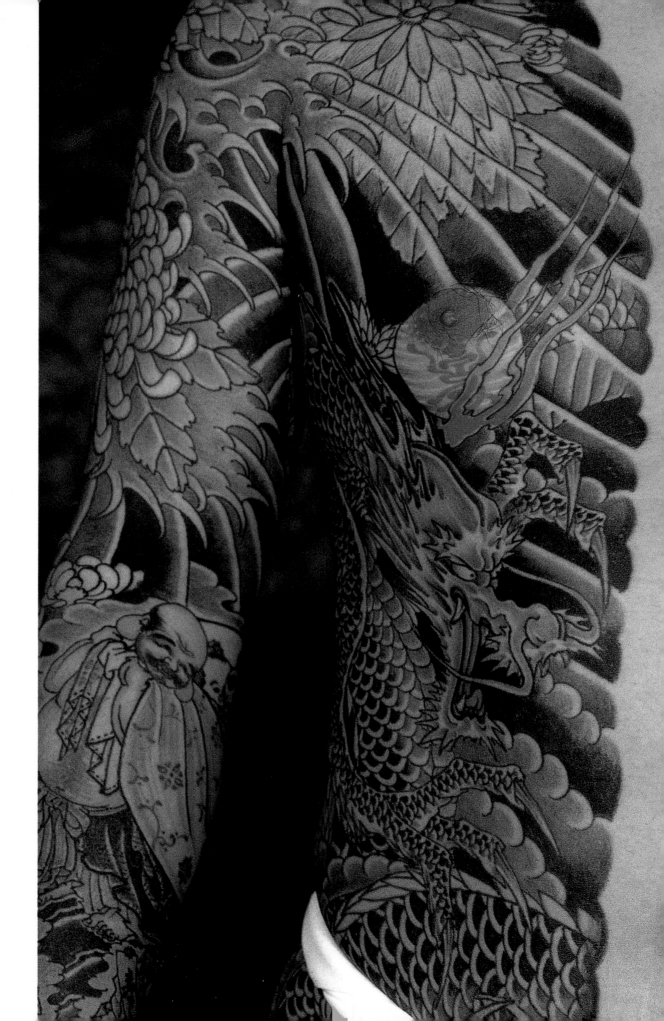

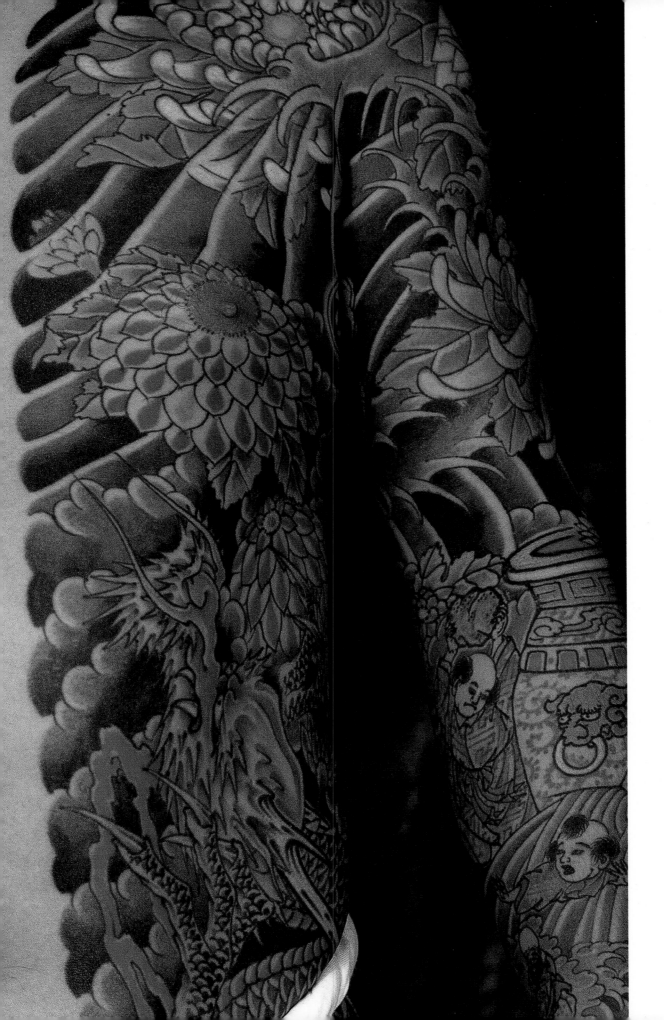

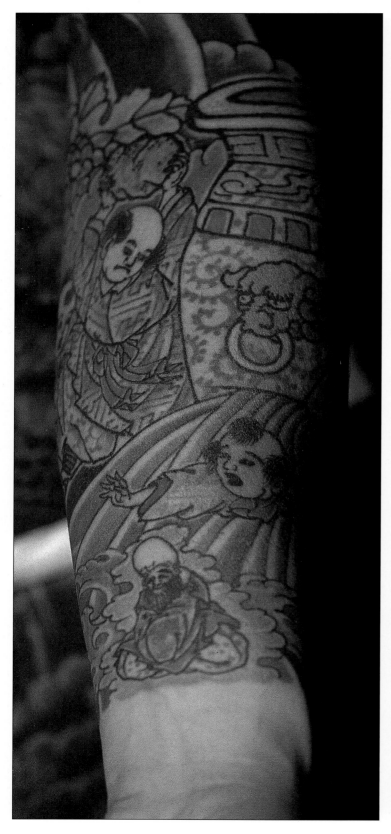

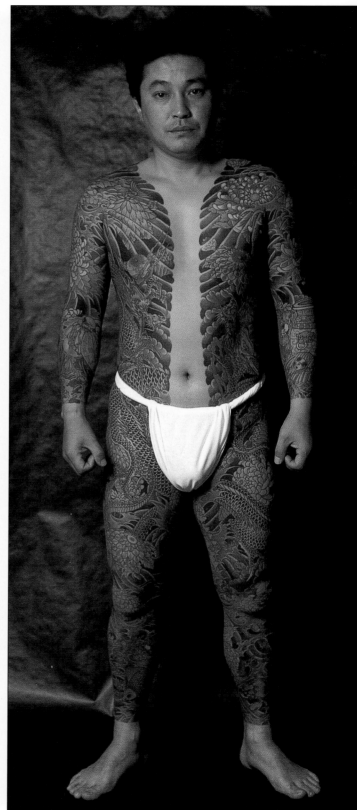

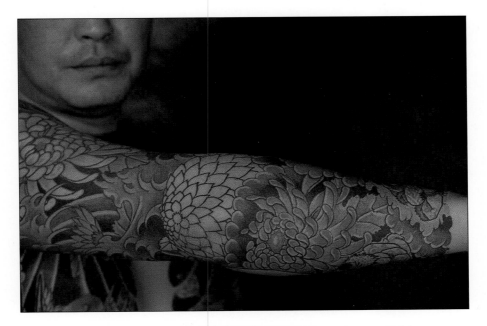

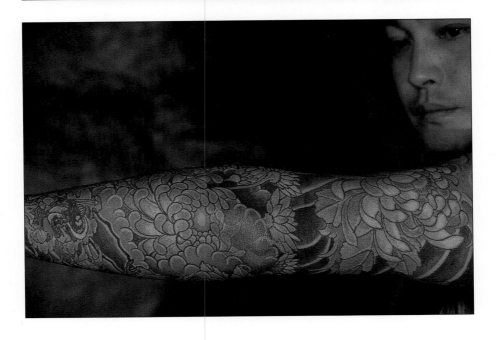

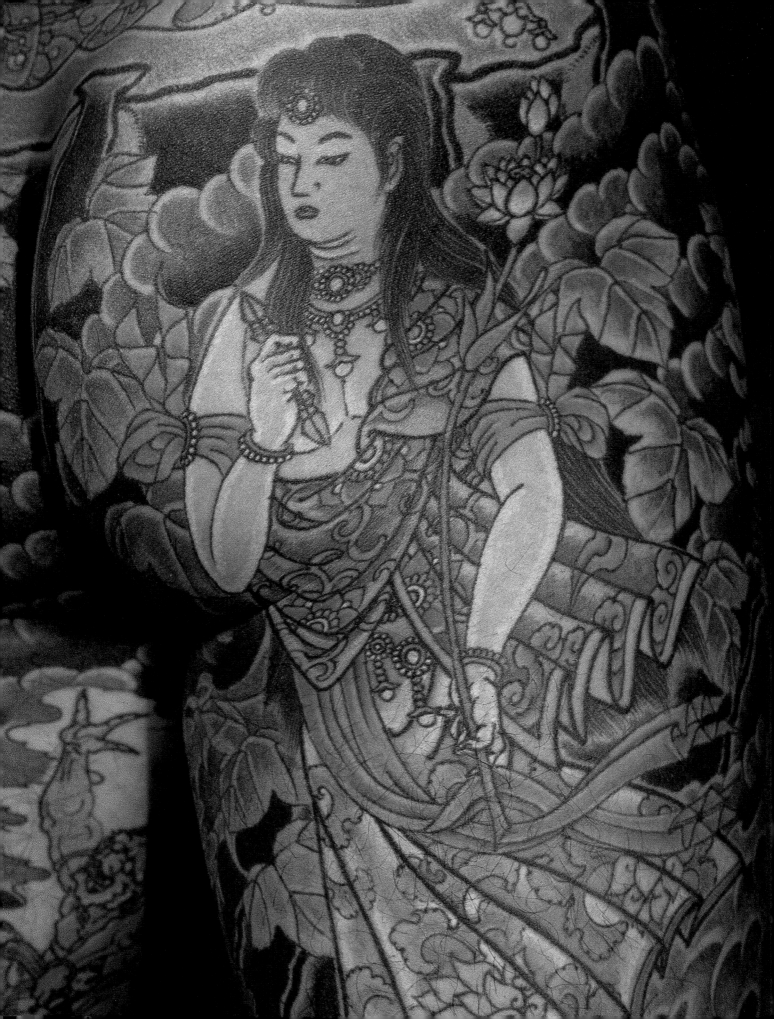

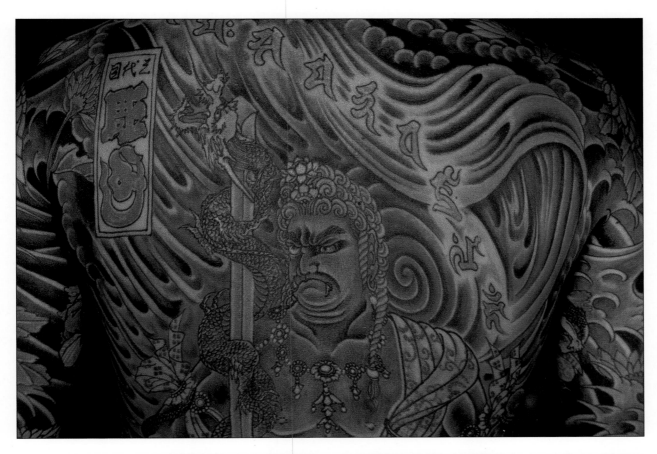

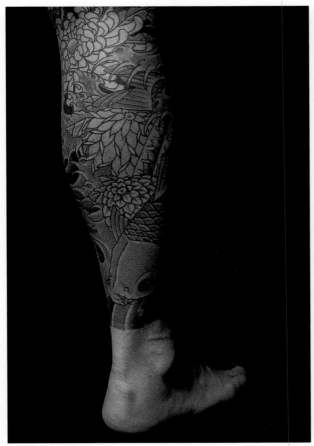

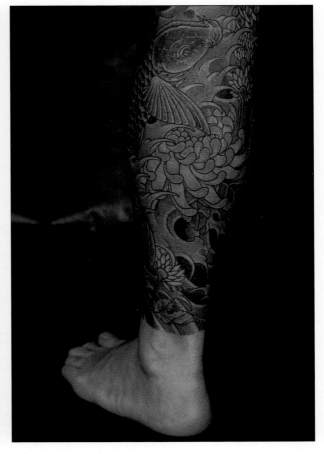

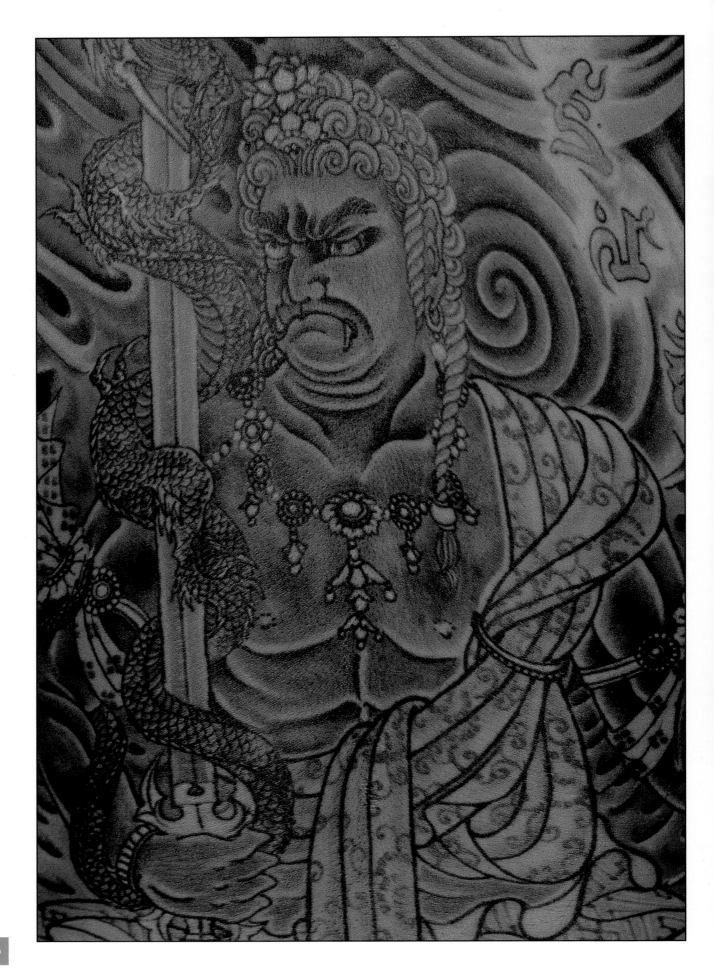

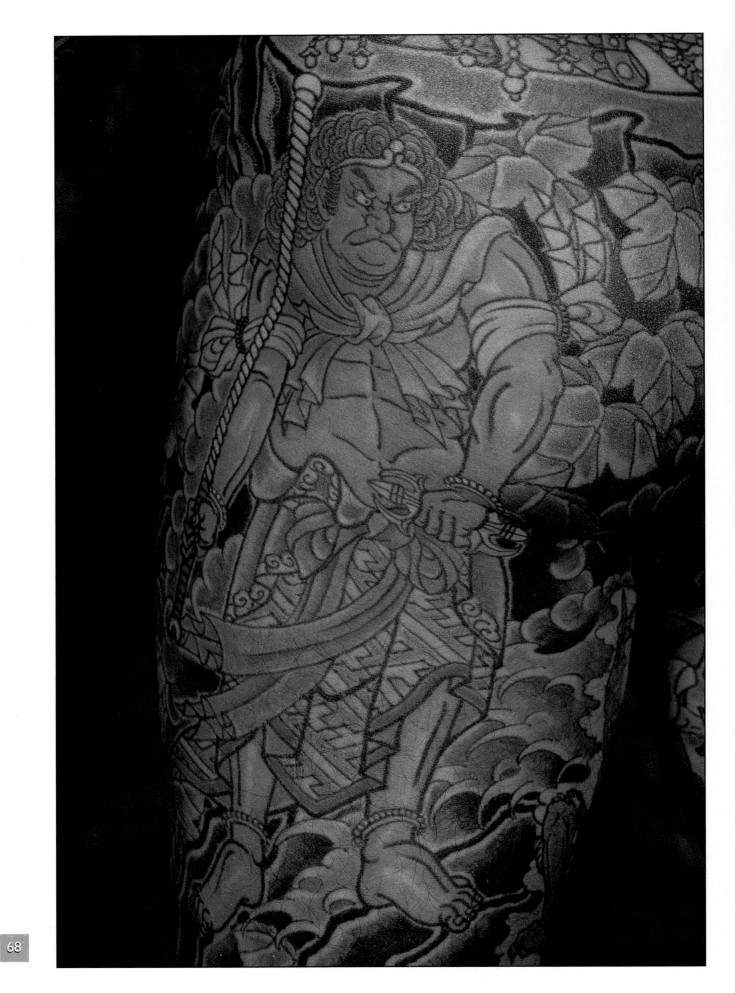

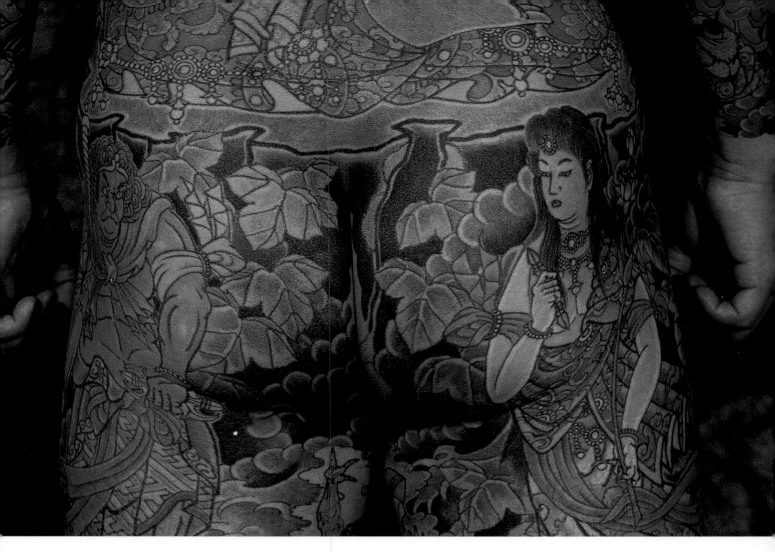

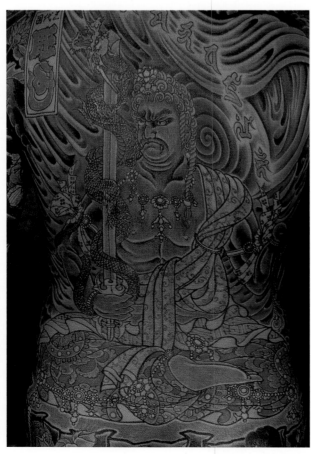

Miho Ito

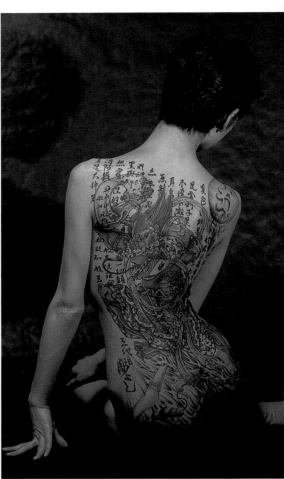

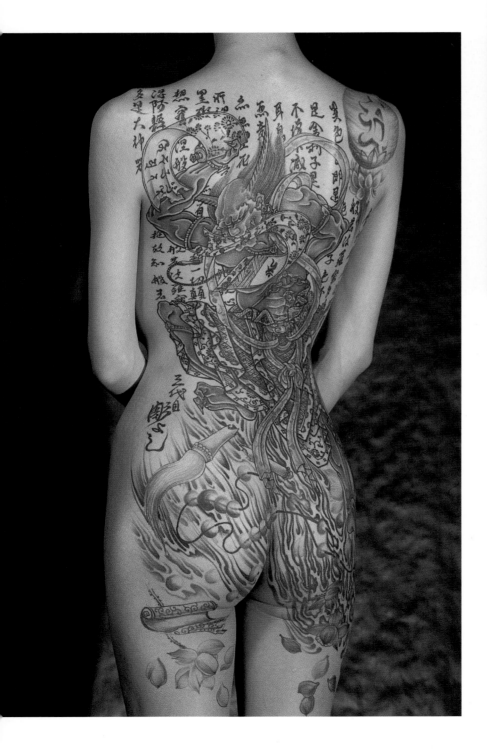

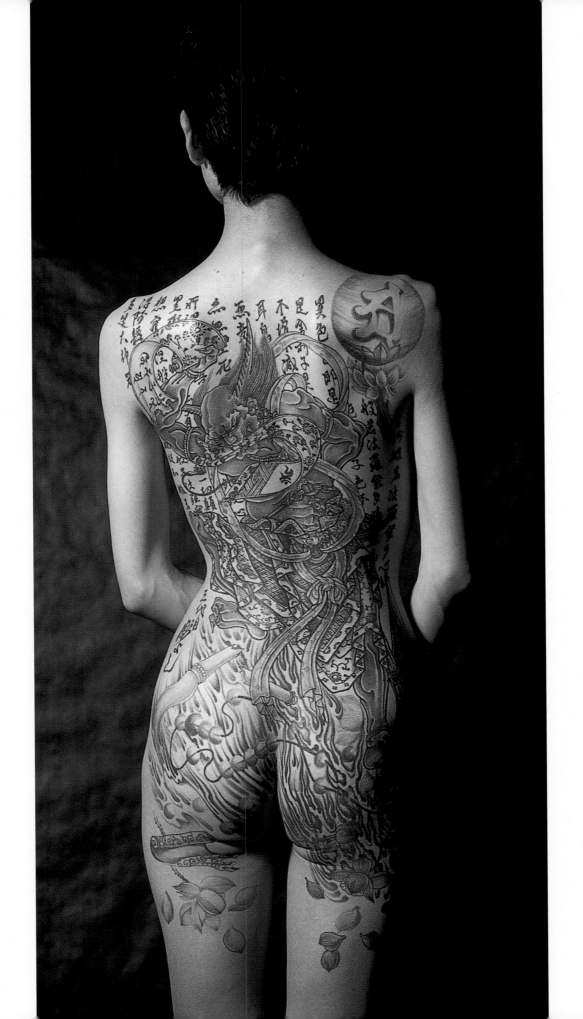

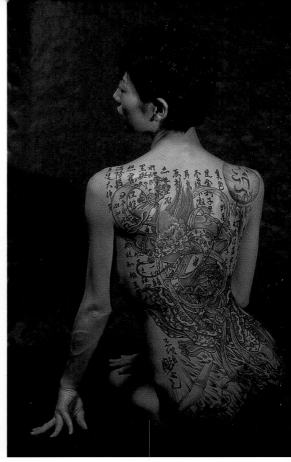

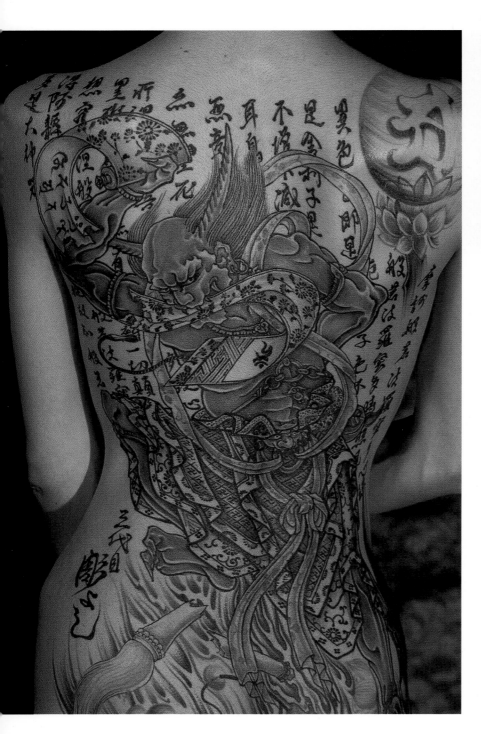

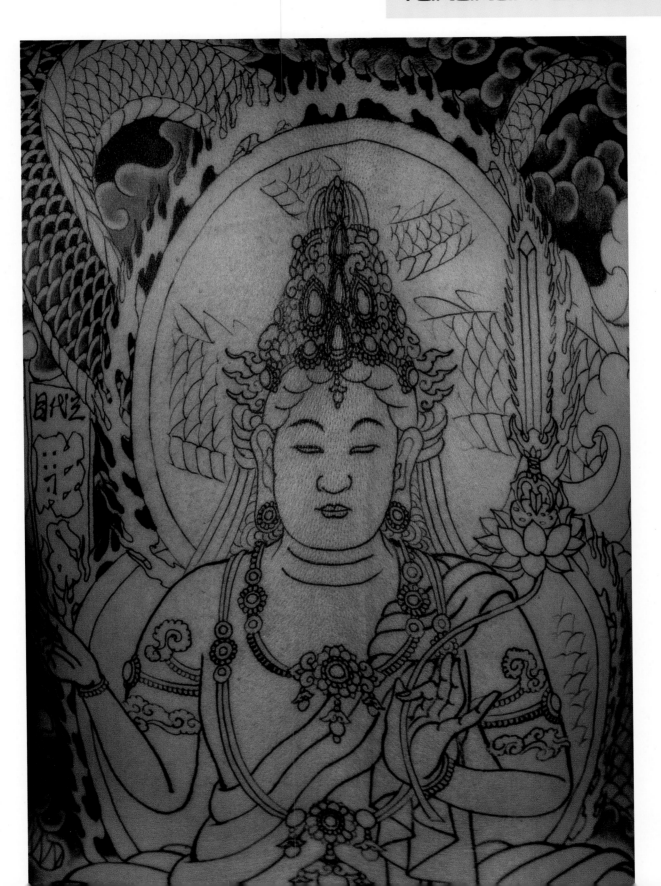

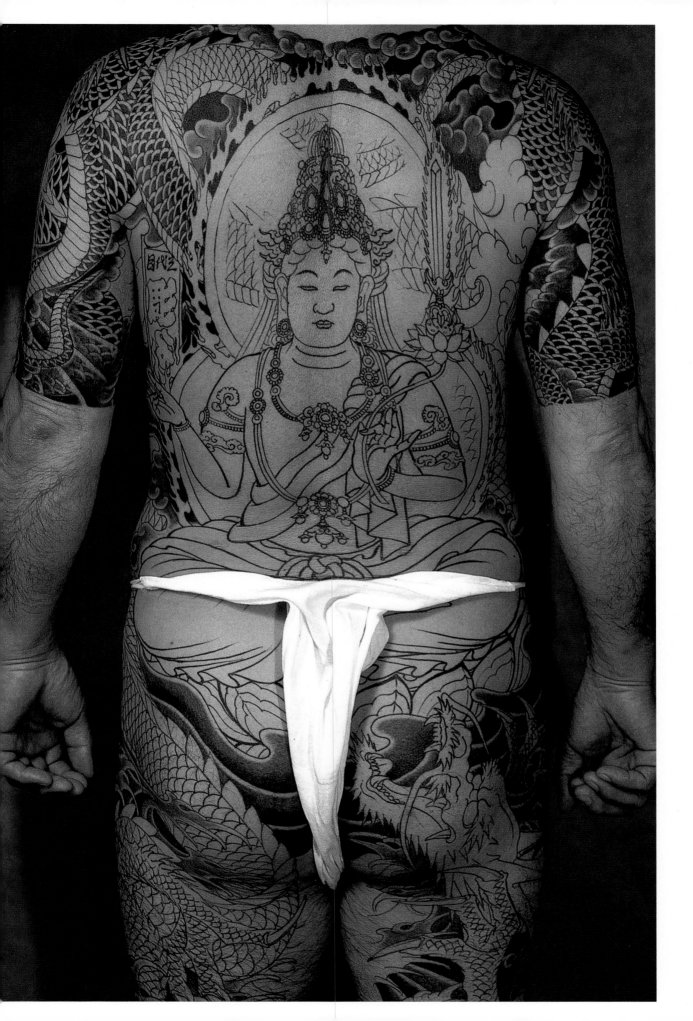

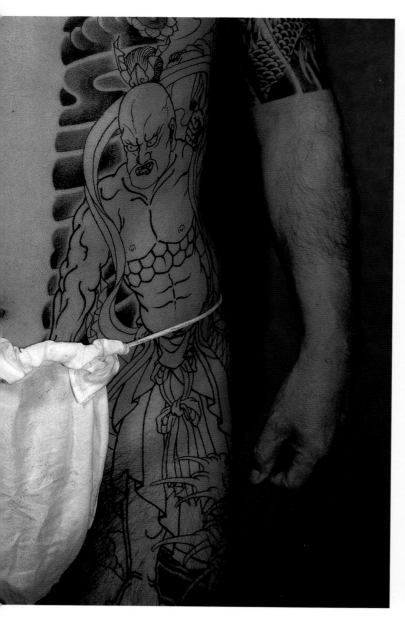
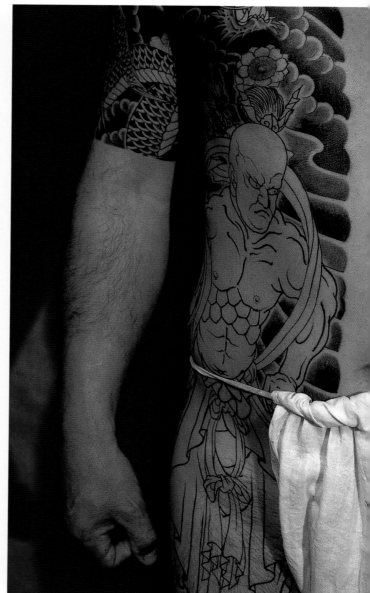

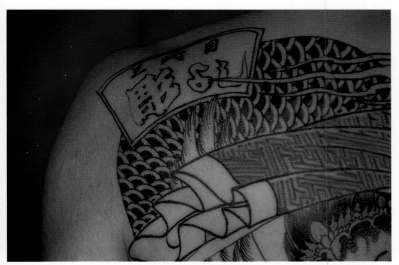

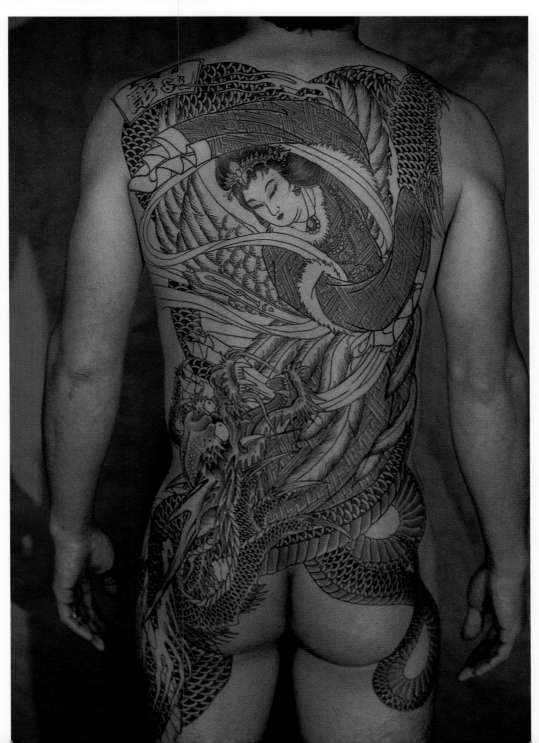

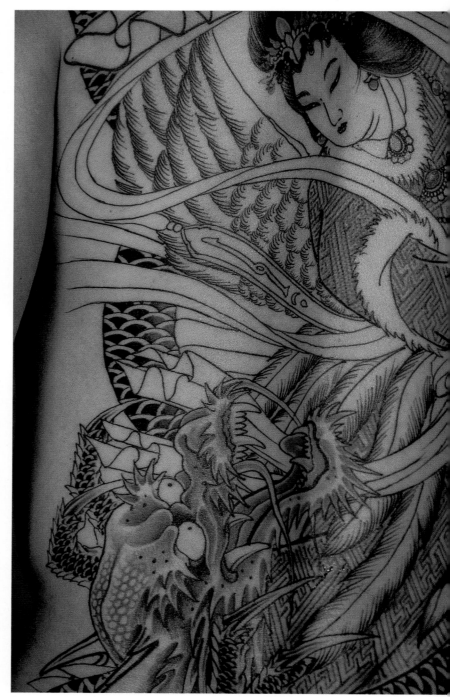

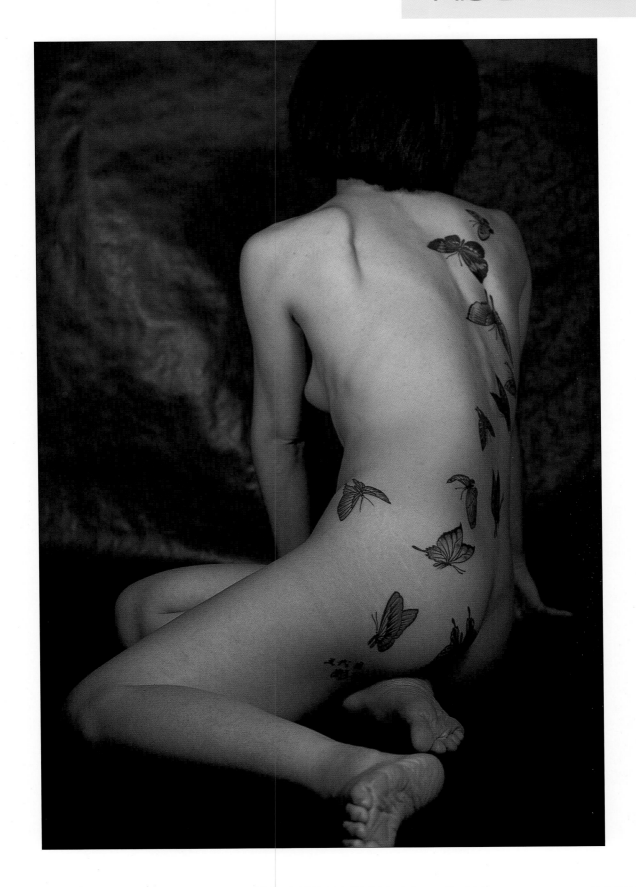

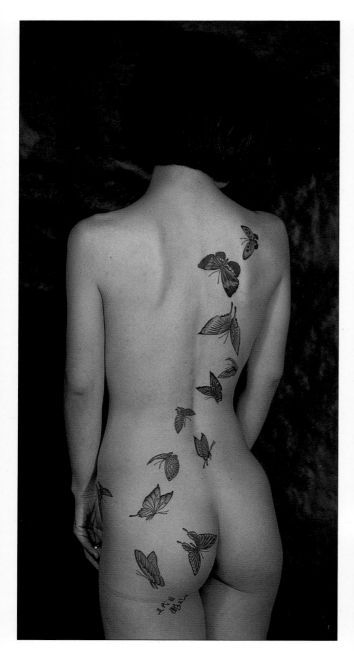

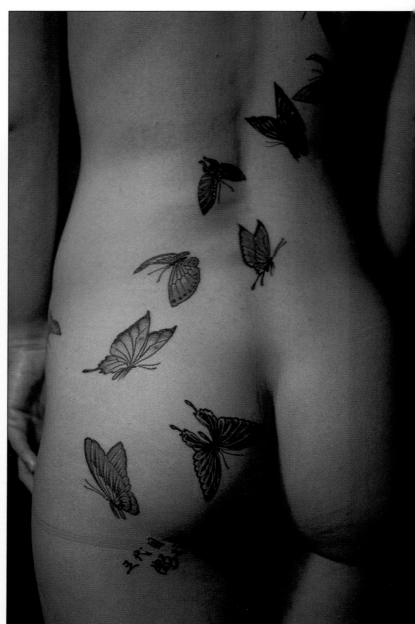

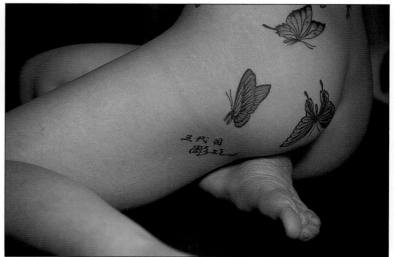

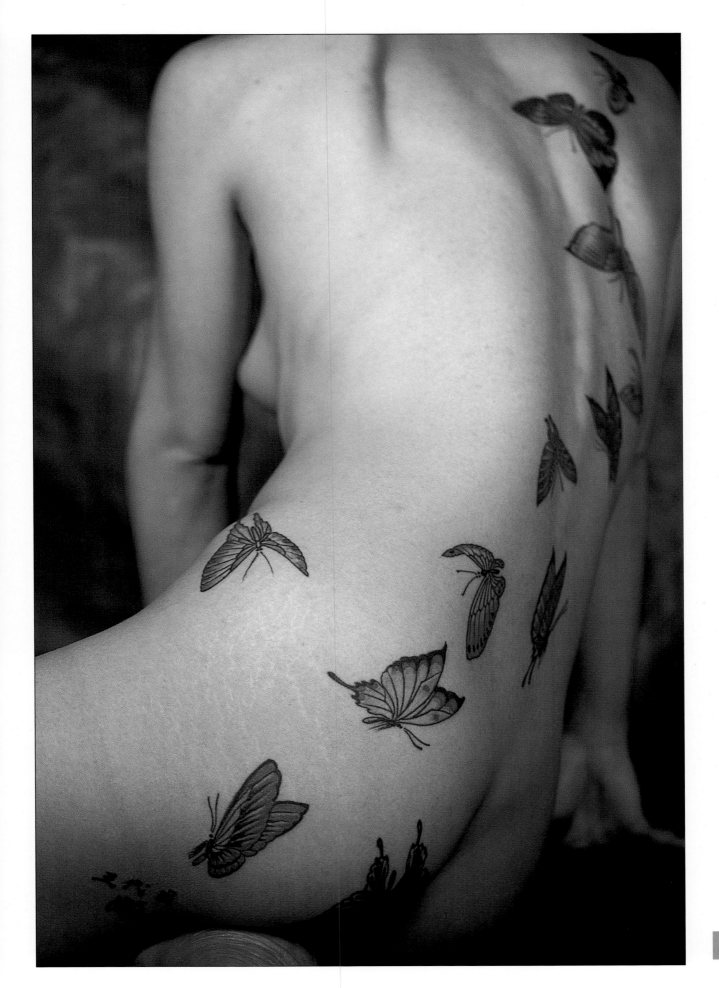

Anonymous

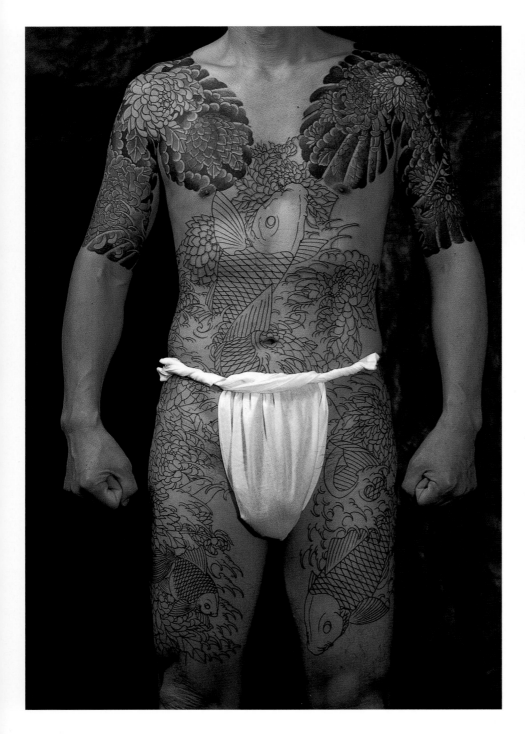

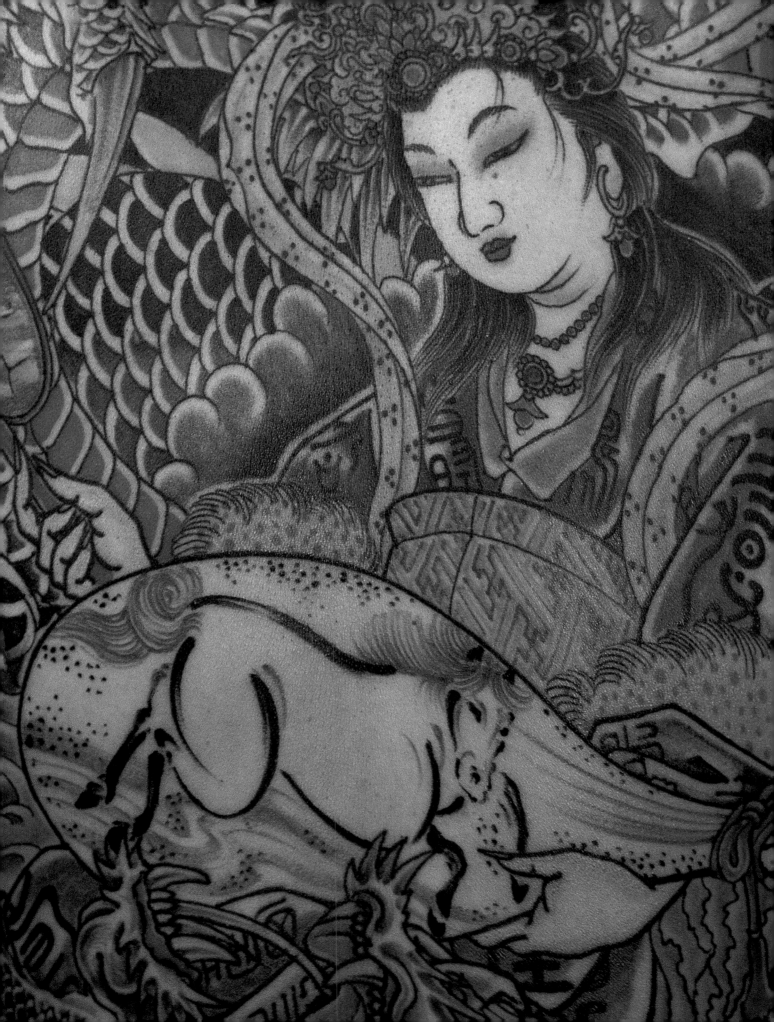

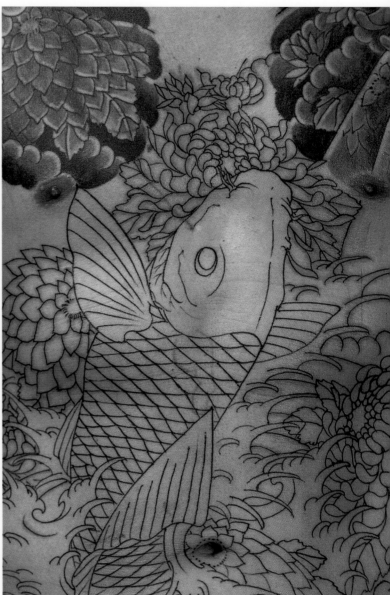

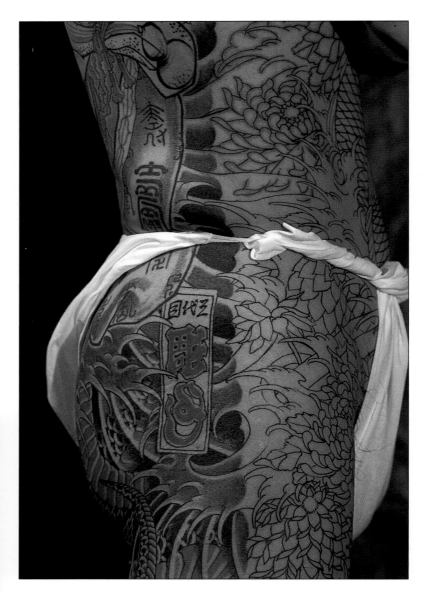

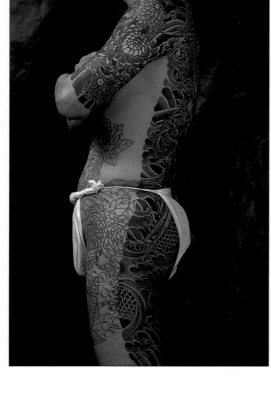

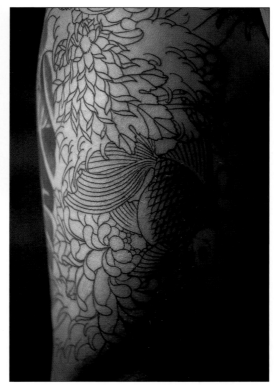

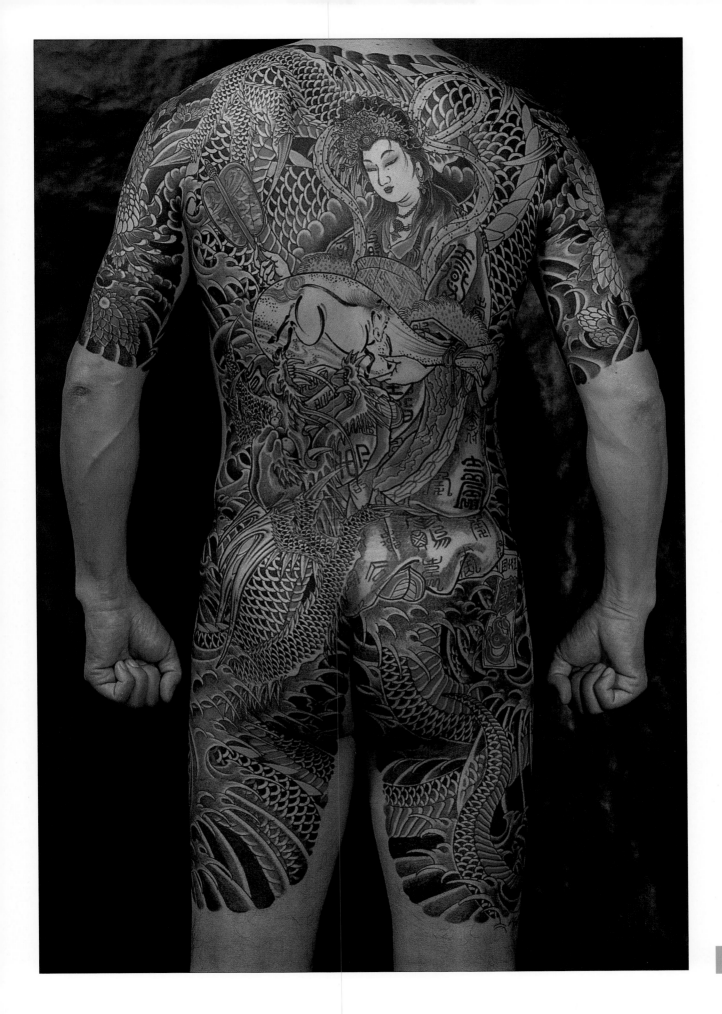

Mitsue Yamamoto

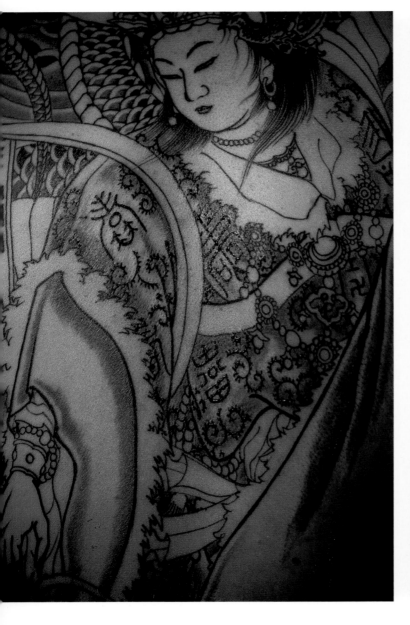

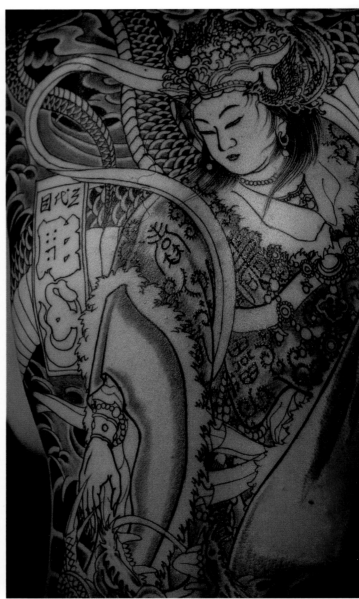

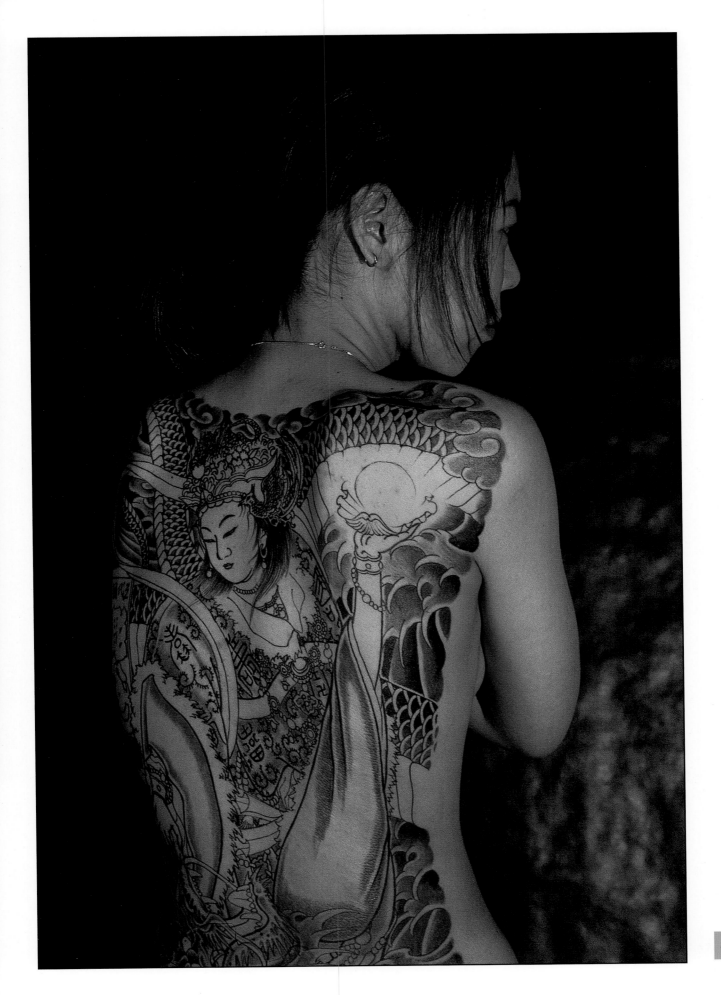

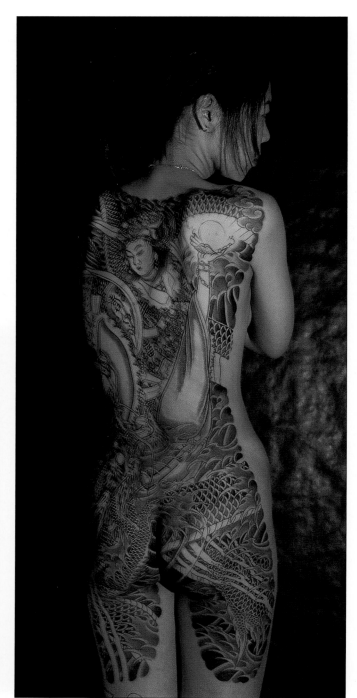

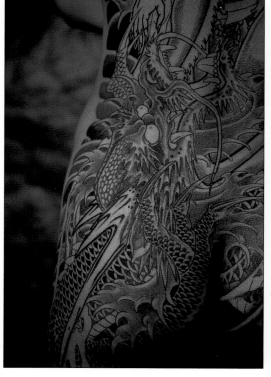

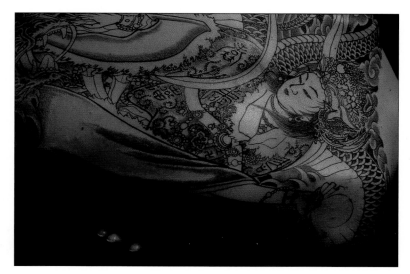

Katsumi Shimizu

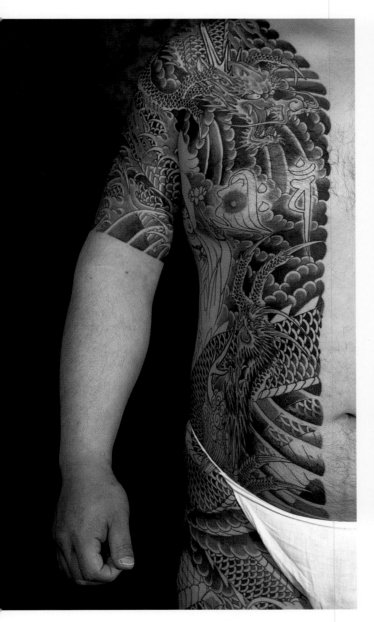
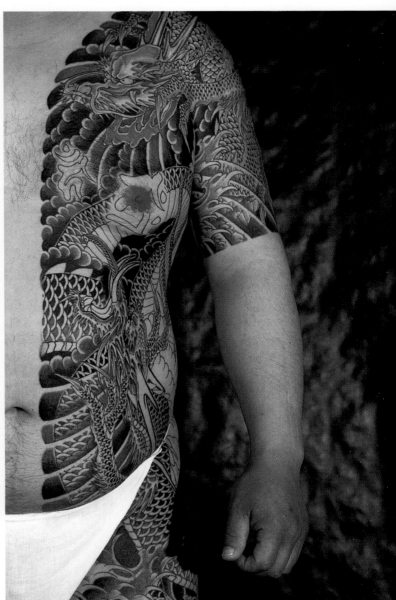

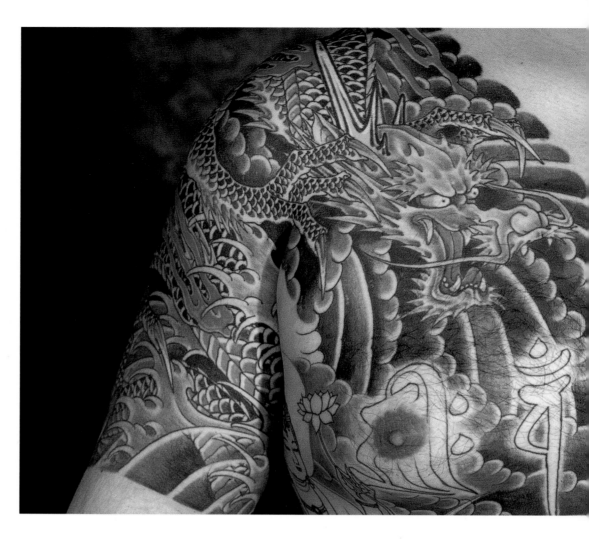

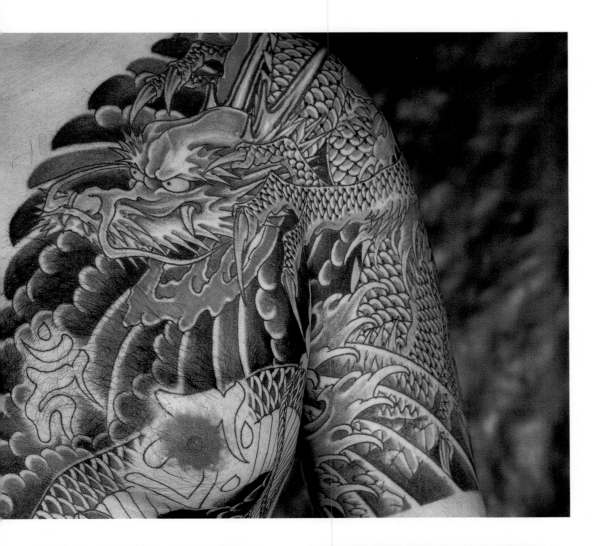

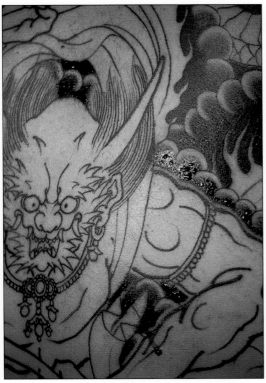

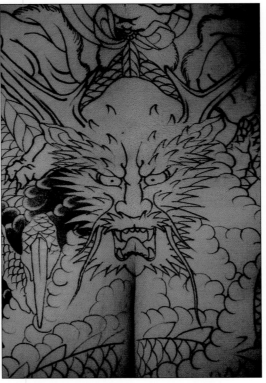

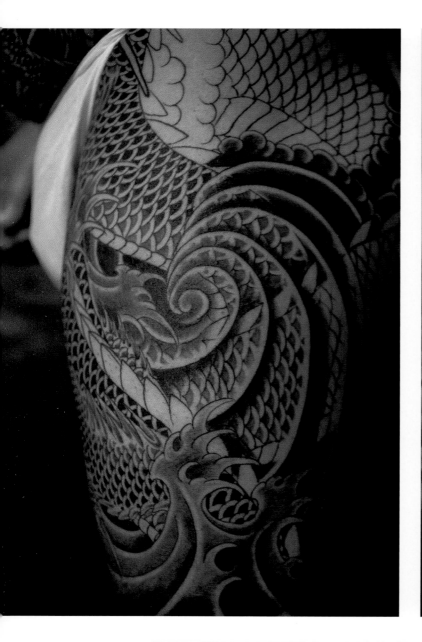
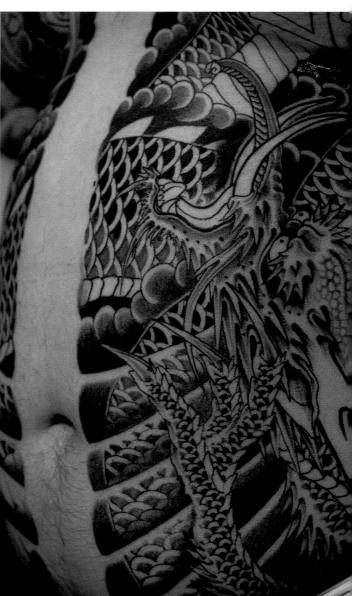
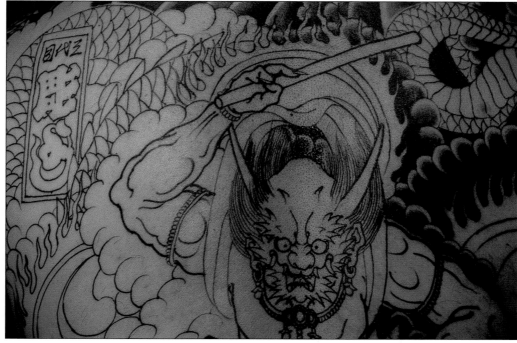

Kohnoshin Harada

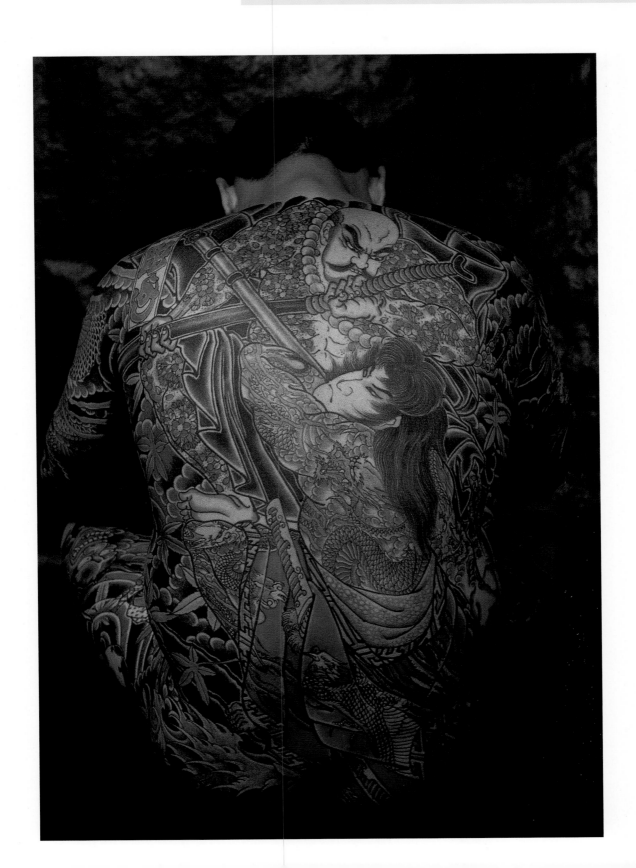

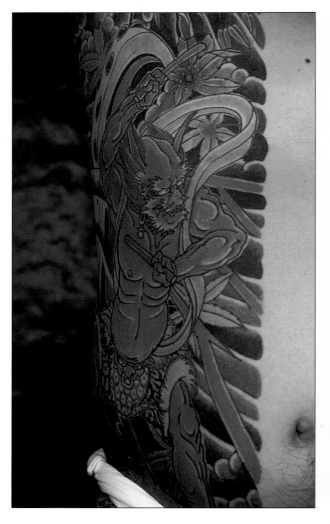
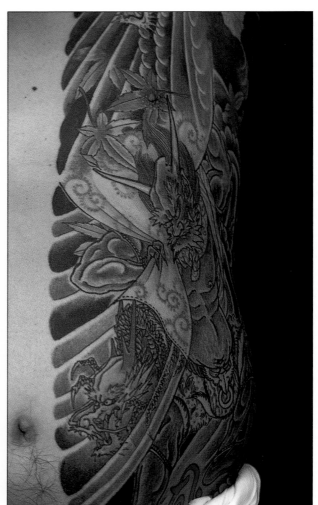
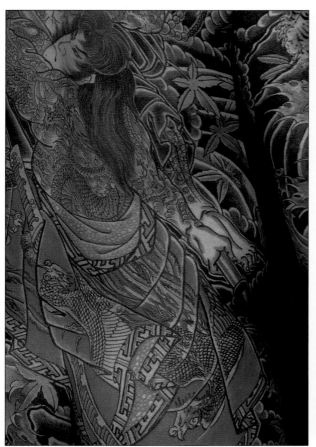
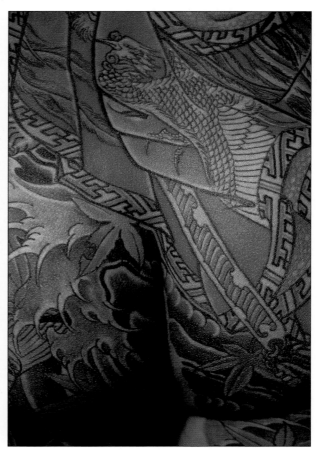

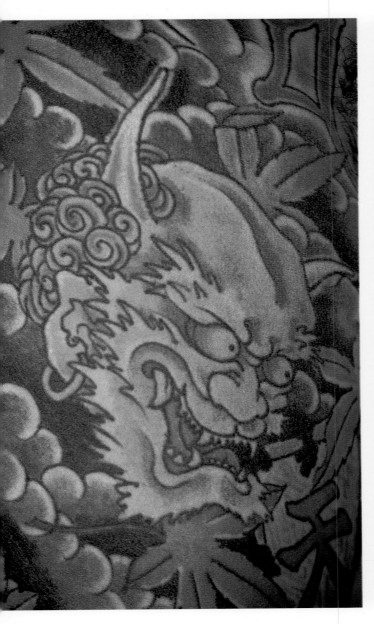

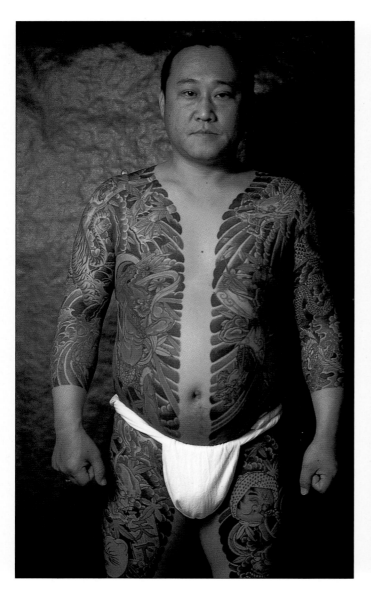
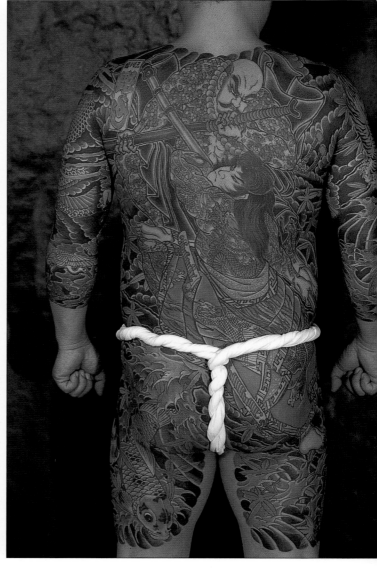

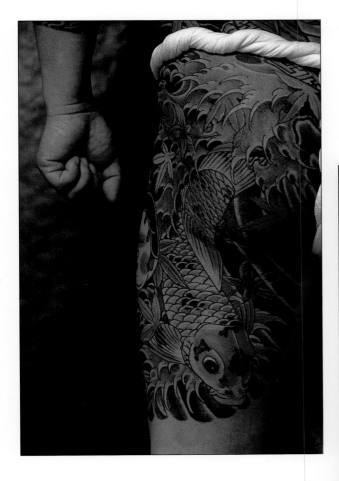

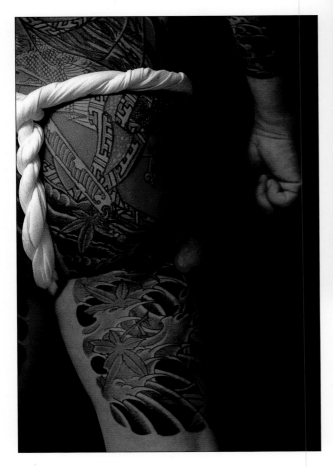

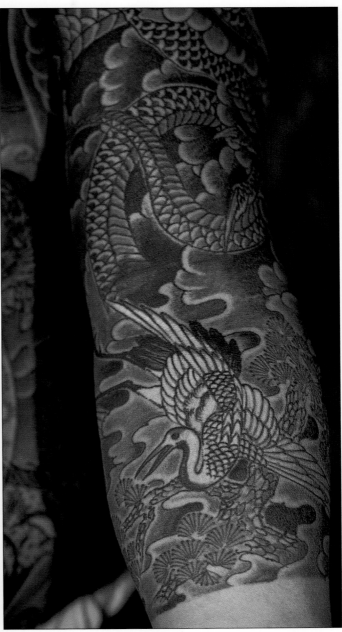

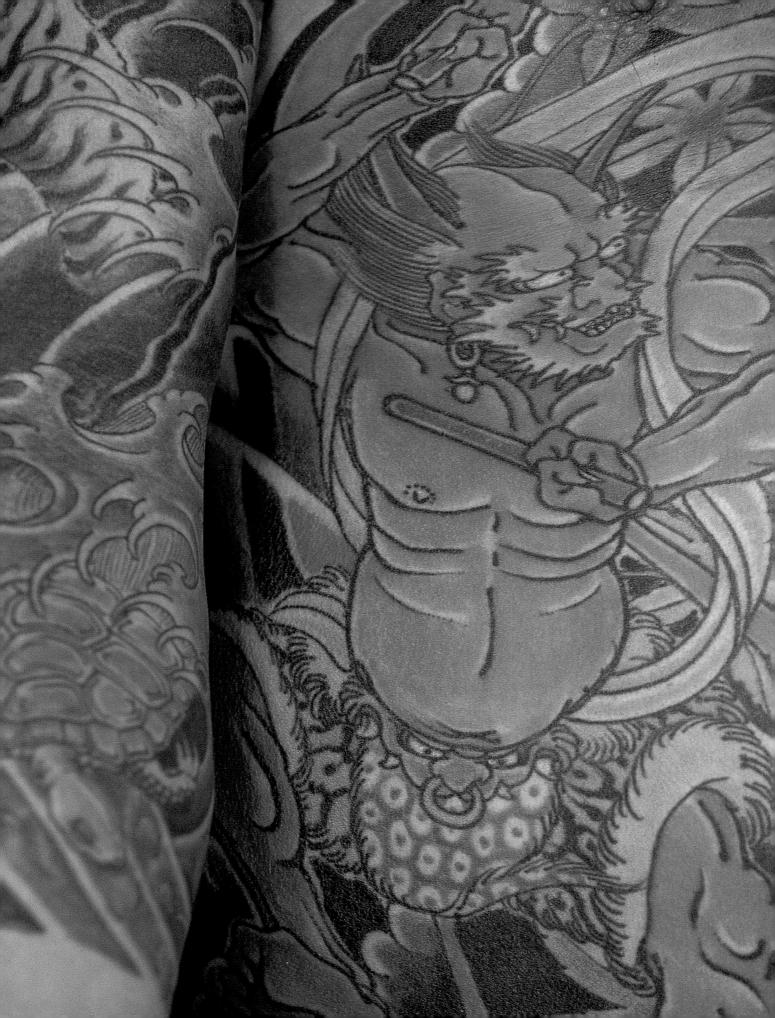

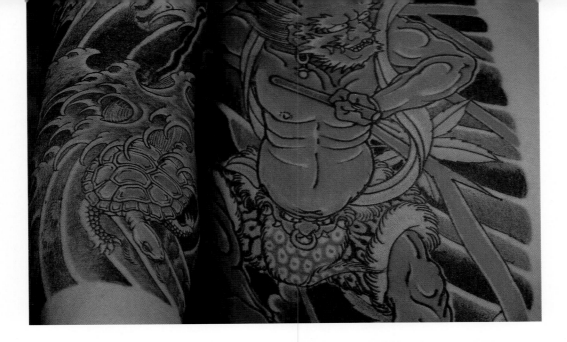

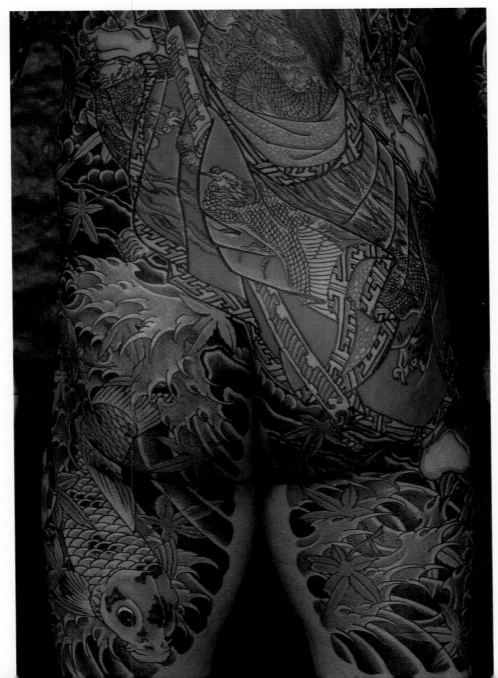

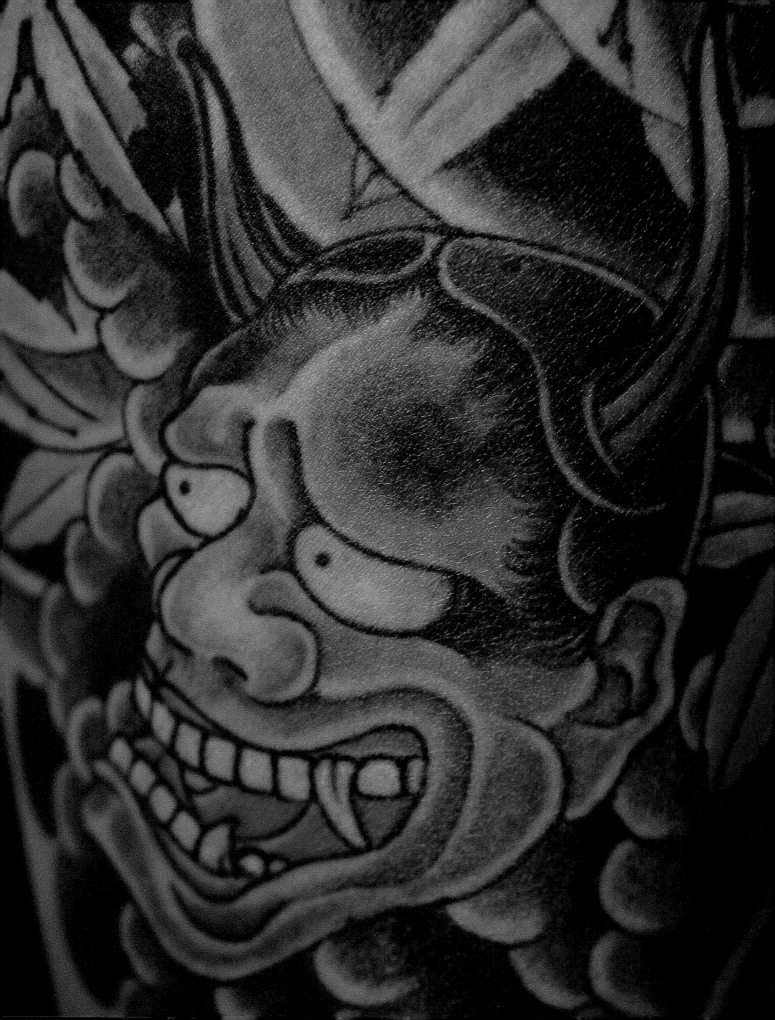

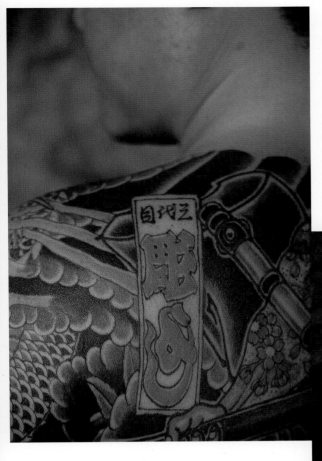

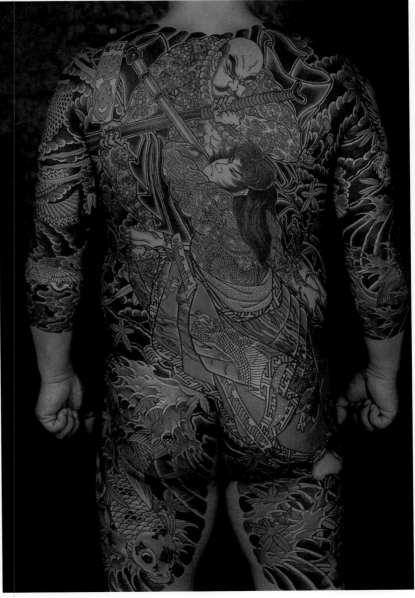

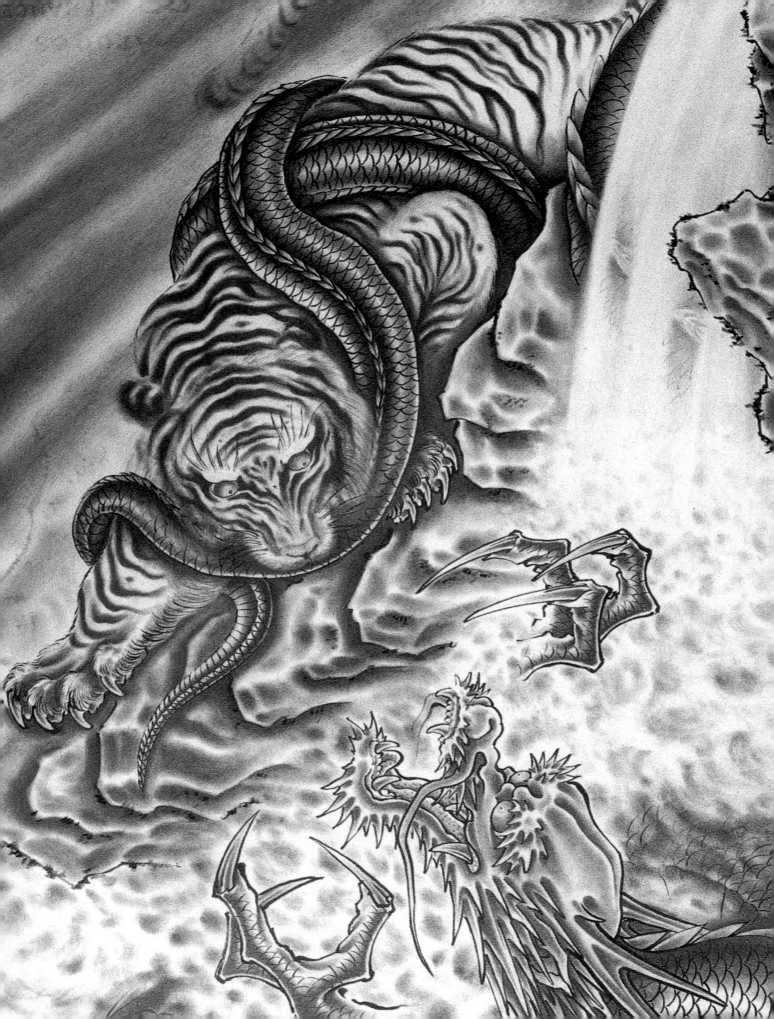

Chapter Three

The world of Japanese tattooing is a veiled one, in part by its own will. The intensely private nature of the tattoo in Japan is in some ways specific to this nation; tattoos are often concealed, and are rarely (if ever) displayed in public. On occasion, a conservative business suit will actually conceal a far more flamboyant tattoo body suit. The tattoo is still not highly regarded by the more conservative parts of Japanese society, and is socially condemned to a degree that is by and large unparalleled in the West. The diligent following of the tattooed, and the elaborate and extreme degrees to which these individuals are tattooed, is thus something of a enigmatic puzzle. In a society where the public display of tattoos is considered taboo, the logic of the tattoo takes on a more private motivation.

The shadowy nature of this world finds many of its roots in the historically troubled relationship between Japanese tattooing and the Japanese government. As with the related art of *ukiyo*-e, tattoo arts have long held an antagonistic relation with the national authorities. The national government for many years instituted a series of "anti-tattoo" movements, actions that forced the already relatively private realm of tattooing further underground, and continues to do so today.

Ironically, despite their history of anti-tattoo prejudice, one of the government's first interactions with the tattoo was the government's employment of the tattoo practice in order to brand and punish criminals. Practiced during the Kambun (1661-1673) and Tenna (1681-1684) periods, tattooing as a form of punishment was fully reinstated during the mid-Edo period, in 1720. Tattooists, then and now, were eager to differentiate between the rather grisly nature of the tattoo as employed by the government, and that of the tattoo

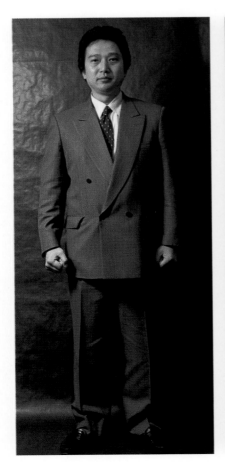
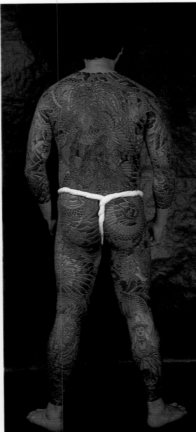
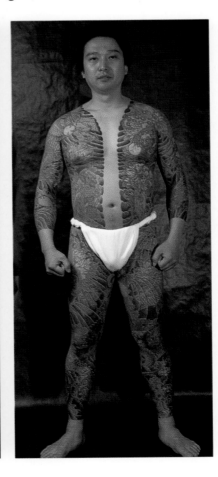

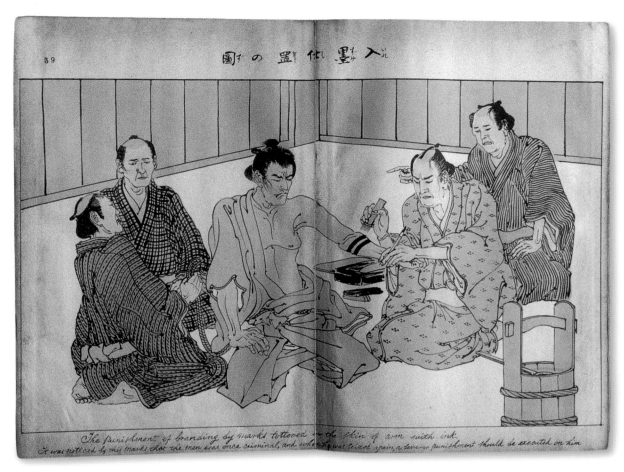

入墨仕置の圖

The punishment of branding by marks tattooed in the skin of arm with ink.
It was noticed by this marks that the man was once criminal, and when he was seized again, a severer punishment should be executed on him

Woodblock print depicting the practice of *Irezumi*, tattoos used by the government to mark criminals. Courtesy of the Yokohama Tattoo Museum.

as an art form. Hideo Gosha, a well-known Japanese film director, writes: "Horimono (artistic tattoos) are a 'living traditional art in Japan' and should not be confused with Irezumi (tattoos as punishment). Irezumi is a carved seal which officials tattooed on criminals as punishment and evokes the image of an ex-convict. Horimono too consists of the injection of inks into the skin, but is a decorative luxury performed on the human skin voluntarily, a pure painting, of which one is proud for life."[1]

Despite the clear distinction between *horimono* and *irezumi,* the word *irezumi* was stigmatized for quite some time. This has faded in recent years, and *irezumi,* which is now used as a synonym for *horimono*, is often used to specify the Japanese style of tattoo work. It should be noted that members of the older generation, Horiyoshi III included, still do not use or condone the term. However, as the stigma fades with the youth generation, the tattoo is beginning to overcome one of the more severe blows it received from the government, damage all the more severe due to its indirect (and unintentional) nature. This particular action on the part of the government subtly, but deeply, troubled the tattoo's status as a potentially viable form of art, and the repercussions

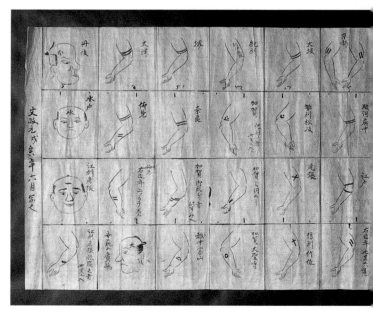

Chart defining markings used by the government for *Irezumi*. Courtesy of the Yokohama Tattoo Museum.

of this debasing use of the tattoo have only recently faded from view.

The government soon began to *consciously* attack the tattoo world, in a series of legislative decisions that held as their objective the eradication of the tattoo arts. In 1789, a massive reform movement included among its mandates the outlawing of tattoos, in regulation of the "morals and manners" of the time. However, by 1801, under a new government administration, these reforms by and large fell out of place, and the popularity of tattooing was renewed with especial vigor. In 1811, tattooing was once again banned in response to the increasing popularity and visibility of the tattoo. This time, the measures were rather more extreme; tattooing was declared to be illegal, and the police raided the studios of the artists. Designs and tools were stolen from tattooers, and in the process countless historical relics and original works of art were destroyed.

Furthermore, both client and master were clearly implicated in the "crime"; one governmental notice read: "It should be noted that both the individual who is tattooed and the tattooist are violating the law and will have charges brought against them." This ban, like its earlier counterpart, did not persist for any extreme length of time; however, in many ways, the tattoo culture was damaged in irreparable ways. In 1840, a more lenient form of the 1811 ban was reinstated, and lasted for five years. In this environment of persistent persecution, artists and their clients were forced deeper underground, and the practice of both receiving and giving a tattoo became both criminal and dangerous.

The tattoo world enjoyed a respite from governmental persecution from (roughly) 1845-1872, but in 1872, under the Meiji government, tattooing once again became a punishable crime. These actions were conducted in an effort to reform the Japanese international public image and create in its place a Japan more fully tailored to the tastes of the Western world. Much to the chagrin of the government, the imagination of the very same foreigners they aimed to impress had been captured by the work of Japanese tattoo artists. The Japanese tattoo, carried to distant lands on the arms of sailors, was already garnering worldwide fame and acclaim. Finally, at the repeated requests of several members of the European royalty, tattoo artists were allowed to tattoo foreigners. In 1891, the Crown Prince of Russia (Nikolai II) received a tattoo while visiting Nagasaki. From Greece, the Crown Prince Georgios also sought a tattoo. However—and somewhat nonsensically—the practice of tattooing native Japanese remained illegal, and though the sentence for the "crime" varied from administration to administra-

tion, the art would be forced to continue ducking the law for many years.

With characteristic perseverance, the tattoo world not only survived, but actually thrived in the oppressive atmosphere created by the government. And in an ironic twist befitting the besieged history of the tattoo, the intense relationship between the master and client was only strengthened by the problems of legality surrounding the art. The diligence of the artist was of course tested as never before, but so was the commitment of the client. Client and master quite literally became partners in crime, both equally vulnerable to arrest. This tight relationship has continued to modern times, and its legacy has extended beyond the époque of stringent anti-tattoo laws. It was only in 1948 that the ban on tattooing was ended, and the tattoo world was liberated from governmental regulation.

Though anti-tattoo laws did subside, police persecution in more unofficial forms persisted. From the early 1980s, in efforts to combat the high-profile presence of the *Yakuza*—the Japanese Mafia—the public display of tattoos was often met with rigorous police questioning, and on occasion, harassment. Tattoos, especially bodysuits, were standard among the *Yakuza*, and even became part of the "initiation" process into this particular world. In the public imagination, tattoos were strongly associated with the *Yakuza*, and became imbued with a substantial amount of fear. In their book, *The Cult at the End of the World*, David E. Kaplan and Andrew Marshall write: "A brilliant tattoo stretched from his neck to his calf, the classic mark of a Japanese *yakuza*, or mobster. Simply rolling up his sleeve and baring part of the design was enough to get trucks moved, doors opened, and bills paid."[2]

This police persecution lay largely in the hope that the authorities would thus be able to lessen the power of the *Yakuza's* intimidation tactics, in addition to creating plausible grounds for the detainment of *Yakuza* members; in a sense, therefore, the tattoo was merely caught in the crossfire of a larger struggle. Though certain festivals and bathhouses were held exempt from the scope of this persecution, for the most part the public presence of the tattoo became more or less non-existent.

With the recent growth in popularity of Western style tattooing in Japan, small, one-point tattoos are seen with increasing frequency. However, the bodysuit is still an elusive phenomenon, save for in books and certain select festivals. Wearers of the Japanese tattoo, especially Yakuza, prefer to slip by unnoticed. Thus the Japanese tattoo remains a highly private matter, one that evades the reaches of the public sphere.

The practice of tattooing from a private studio, often one's home, was originally necessitated by the illegality of the art. However, like so many aspects of the tattoo, it has persisted to modern times, a legacy perpetrated by the private nature of the tattoo and its clientele. The environment created by the private studio is uniquely Japanese, and the polar opposite of an American tattoo parlor.

The business success of a Western studio relies on a high visibility factor. Though in Japan, the process of selecting a tattoo artist is often long and arduous, in the States, walk-ins are common, and the choice of this or that studio may be determined by as simple a factor as which studio first catches the client's eye. Bright neon signs and colorful posters usually adorn the American tattoo parlor, and inside, loud music and the buzzing of machines create an atmosphere akin to a nightclub. In contrast to Japan, where studios are located in central residential areas, American tattoo parlors are located in more industrial, exterior areas, largely by city orders.

The American tattoo parlor is also a highly social locale, and people can often be seen milling around outside. The behavior of the younger clientele provides almost the perfect contrast to the Japanese practice of concealing the tattoo; it is not uncommon for young clients, eager to show off freshly acquired tattoos, to prematurely remove bandages and strut about in tank tops—in the dead of winter. The average American tattoo client, having undergone the pain and the financial investment of the tattoo, seems to enjoy the thrill of display and the element of spectacle involved with the tattoo.

The Japanese home studio offers the complete antithesis to this. This difference is apparent from the outset, and from beginning to end, the experience of receiving a tattoo in Japan is radically unlike the Western experience. The dissimilarity, as I suggested earlier, begins with the very process of finding a tattoo artist. Though in recent years business cards and telephones have eliminated the need for letter writing, at one time this sort of an introduction was necessary merely in order to schedule an introductory meeting with a tattoo master.

After clearing this initial hurdle, even the process of finding a traditional Japanese tattoo studio can present a challenge in and of itself. My own personal experience of visiting the studio of Horiyoshi III began with something of an ordeal. Dropped off in front of a small block of houses, I was assured by the cab driver that Horiyoshi's studio was within this complex. Despite the small radius of the area indicated by the driver, I found myself wandering about for a good half an hour. Finally, exasperated and literally drenched with sweat, I caved in and called the studio for directions. I was directed to a cigarette stand where I was shown a map. I have to confess that I was rather relieved; after circling the area for what seemed to be an interminable length of time, I had nearly begun to despair of ever locating the studio.

Horiyoshi III's studio is located on the second story of a house, and is accessible only by a narrow stairway perpendicular to and facing away from the street. Ironically, I had walked by these stairs several times, pausing only briefly before once again resuming my search, reasoning to myself that a more flamboyant exterior would certainly mark the studio of one of the great Japanese tattoo masters. In reality, there are no signs from the outside, and nothing indicates the nature of the work that is performed within the walls of this building. Walk-ins are quite literally an impossibility, and only those with appointments and directions would succeed in locating this studio—and of course, on occasion even those with appointments and directions can

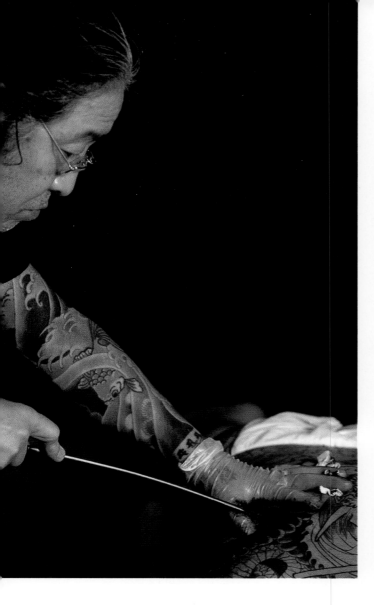

tattoo forms the essence of the Japanese tattoo. The completion of the full bodysuit demands an extended series of "sessions," usually taking place over the course of several years; for example, the short body suit, even with regular weekly sessions, would take approximately three to four years to complete. However, this depends on various factors, including the complexity of the design, the pain tolerance of the client, even the body and skin texture of the client's physique. Because of the intimate nature of the tattooing process, the life-long physical souvenir in the shape of the tattoo is often accompanied by a more intangible, but equally long-lived bond between the client and master.

The amount of physical pain involved in the Japanese tattooing process is perhaps difficult for the un-tattooed to fully understand. Gosha writes: "When I told (another tattooer) of my desire to become a tattooer he did not object but said, 'You should...be capable of comprehending the pains of those who have been tattooed . . .' Those who want to be tattooers without wearing a tattoo themselves feel very guilty. One can imagine well the pains of the person being tattooed if one has experienced the pain firsthand."[3] The pain of a single tattooing session—which can last for several hours—can persist for several days, and can carry with it on occasion some rather unpleasant side effects such as nausea or fainting. Though a master such as Horiyoshi III is able to work with remarkable speed and precision—I have yet to see any artist tattoo faster, either by hand or by machine—on the whole the traditional "hand poke" method of Japanese tattooing is considerably slower than that of the Western machine method. In addition, depending on the area of the body in which the tattoo is done, the hand-poke tattoo can be more painful to receive. When combined with the multiple-session nature of the Japanese tattoo, the specific nature of this willingly endured—even self-enforced—pain requires a remarkable level of commitment and determination on the part of the client. For those who are familiar with the tattooing process, it is difficult to see a bodysuit tattoo without conjuring the hours of pain mixed into the creation of these often exquisite images.

Ironically, this pain in some senses creates the foundation for the unique relation between the client and master. Choosing the master is rather like selecting a partner before engaging in a grueling marathon of pain—one which predicates entrusting one's body to another, with the final goal being a permanent and radical alteration of the skin. The unique nature of a pain that is willfully requested and received by the client, and willingly given by the master, creates an often irrevocable bond between

meet with difficulty! On subsequent visits, I was often sent to the cigarette stand in order to lead Americans to the studio.

In this secluded location, the interaction between client and master is usually one-on-one. Though with the increasing use of machines over recent years (ten years in the case of Horiyoshi III), a limited noise element has been introduced within this space, the Japanese studio is by and large a quiet space, far quieter than its Western counterpart. Though many artists outline by machine, they continue to faithfully shade by hand, a process that is almost completely silent. This quiet, reclusive den provides the backdrop for the foundation of the relationship between the client and master; a setting that befits the remarkable dimensions of the interactions that here take place.

The unique relationship between the client and master is one that gradually develops over time, and is hugely facilitated by the sheer pain and extraordinary duration of the traditional Japanese tattoo. Though "one-point," small tattoos are not uncommon per se, the artistry of the full bodysuit

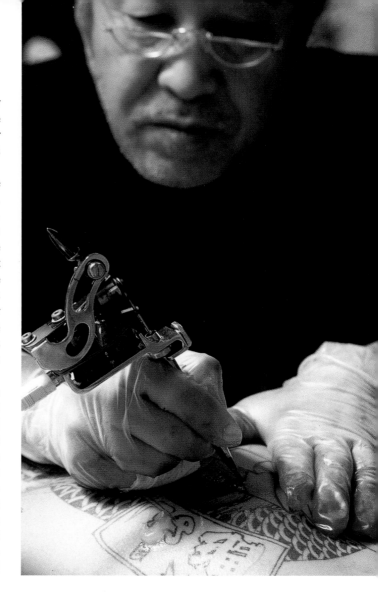

master and client. This deep trust almost inevitably demands an unshakeable sense of respect for the master. The decision to choose a certain master reveals an appreciation not only for the master's skill, but also for his artistic judgment.

The regimented, hierarchical social structure of Japan is one that penetrates the tattoo world, applying itself to the master and client relationship. Though the truly self-respecting master is drawn into valuing the client for a variety of reasons, the external displays of deference are far more evident in the case of the client's respect for the master. The master is addressed as *sensei*. This literally translates to "teacher," or "professor," but a more culturally inflected translation would more likely be along the lines of "maestro." As a form of address, it carries with it the same veneration implied by the English terms of "Doctor," or "Sir."

This display of respect is evident not only in the vocal manners of address, but permeates the physical mannerisms of the client. Customarily, prior to and following a session, the client makes an *ojigi* to the master—a deep bow to the floor, executed while kneeling, in which the forehead often comes within inches of the floor. Physically, it is a display of abjection that is probably unknown in modern American culture. However, in this particular cross-section of Japan this bow is infused with admiration and appreciation, and is willingly performed by the client. In many ways, it is a manifestation of an ideal

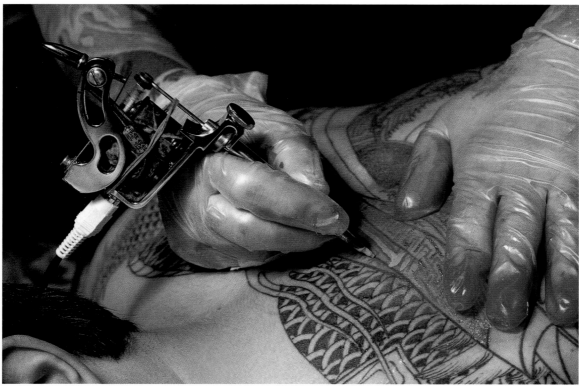

hierarchical relationship, one in which the dynamics of the structure are reinforced by both those above and below.

In some senses, this deep, almost self-effacing respect may seem incongruous with the highly masculine, "macho" image that characterizes a considerable portion of the tattoo clientele. However, it is often precisely these individuals that produce the most remarkable displays of deference and self-restraint. One incident in particular remains in my mind. Once, while visiting the studio of Horiyoshi III, my attention was caught by a tough-looking man with full sleeves in progress. Having just emerged from an extensive and physically draining session with the master, he was kneeling on the ground, cigarette in hand. Despite the fact that his body and mind must have been craving the calming effects of nicotine, he remained perfectly still, waiting patiently for Horiyoshi III to light his cigarette first. The amount of self-restraint involved in this relatively minor show of respect is such that it transforms this small gesture into a remarkable display of veneration and self-control.

The hierarchical structure of the Japanese tattoo world naturally places the tattoo master on a pedestal built over years of tradition. Strictly speaking, within the closed circuit of the tattoo microcosm, this pedestal arises out of the client's respect for the master's skills and artistry. However, the world of tattooing often opens up onto a more extensive field; in these cases, the motivation behind the client's deferential comportment may alter slightly.

Members of the lower echelons of the *Yakuza* often cower before the tattoo master in a pose expressing a formidable combination of both fear and respect. These younger *Yakuza* members are well aware that any insult to the master, real or imagined, can be read to translate directly to an insult to their superiors. The considerable regard a higher-ranking member shows the tattoo master is multiplied a thousand-fold in the younger members under his control. In certain cases, for a fledgling member to attempt to obtain an introductory meeting with the master who tattoos their superiors without first obtaining their permission would be considered a deep sign of disrespect.

One might quite reasonably demand how the respect of these high-ranking members is won in the first place. On the one hand, the *Yakuza* do in fact embody the samurai spirit in their own way; the overpowering hierarchical system of honor and deference is just one of the ways in which this spirit is manifested. The *Yakuza* also have a strong sense of pride and a strict appreciation of tradition. An exemplary case of this honor can be seen in the manner that the *Yakuza* defended Japanese businesses and neighborhoods from Korean and Chinese gangs during the turbulent years following World War II. Furthermore, some elements of the rebellious nature of the samurai can be seen in certain aspects of the underlying spirit of the *Yakuza*, one which includes a flagrant snubbing of the traditional forms of authority.

However, yet another level is added to these layers of paradox. There are many *Yakuza* families operating as criminal organizations freely employing the tactics of intimidation. To obtain the esteem of these individuals is no easy task, and certainly cannot be earned by the stereotypical displays of machismo or power. And it cannot be denied that dealings with the *Yakuza* can take a potentially sinister turn; stories abound of tattoo artists who have "disappeared" or were banned from work as a result of a messy falling-out with the crime syndicates.

Horiyoshi III is one master who has succeeded in obtaining the willing respect from all of his *Yakuza* clientele, from lowest to highest-ranking member. While this certainly is derived in part from an appreciation of the master's artistry, it also arises out of a deep regard for the remarkable and powerful personality of Horiyoshi III.

Horiyoshi III, in his chosen approach to this challenging clientele, reveals not only a character of exceptional integrity and strength, but also an unusually powerful psychological instinct. In the space of his small studio, Horiyoshi III creates a non-confrontational atmosphere, and (even more impressively) maintains this ambiance even as *Yakuza* members filter in and out. The honest, approachable demeanor of Horiyoshi III offers these members, who in almost every other moment of their life are forced to present a front of power and intimidation, a space to relax. Intimidation is absent here, largely because Horiyoshi III himself refuses to employ this tactic, but also because Horiyoshi III's own uniform respect to *all* his clients makes this approach seem more or less irrelevant.

Horiyoshi's own self-respect and integrity is partially what permits him to treat all who pass through his studio with deep consideration. That is to say, for Horiyoshi III, a personal sense of self-respect is not diminished, but rather is increased, by the display of respect for others. Certainly a relatively simple doctrine to understand, but one difficult to carry through. As a result, Horiyoshi III not only exudes a sense of restrained strength, but also, in freely giving his quiet esteem to his clients, induce his tougher clientele to drop the exhibitions of machismo which in other circles are all too often central to earning a position of good standing.

The sense of gratitude the client feels toward the master, can, in cases such as this one, be magnified into a deeper and more powerful emotion. Horiyoshi III is a figure easy to romanticize, in part because he embodies "traditional" values in a remarkably pure, even simple manner. For example, Horiyoshi III maintains low prices, despite the increasingly exorbitant fees charged by other tattooers. He does so in part because of the repeated sessions necessitated by the nature of the Japanese tattoo; in part because of his deep esteem for the client that willingly undergoes the pain and commitment of the tattoo; and in part because, as he puts it, "a working-class man works long hours for just one session."[4] Horiyoshi III respects his clients as much as they themselves esteem him, and it is because of this unique dual flow of emotion that the master and client relationship in this particular manifestation takes on a very special and very particular dimension. Obviously not all client-master relationships parallel those that Horiyoshi III holds with his clients, and I would like to emphasize here that Horiyoshi III represents an ideal that all tattoo artists would hopefully endeavor to attain not only artistically, but spiritually and morally.

In part, Horiyoshi III's regard for his clients is derived from his own memories of his experiences as a client, his own acknowledgment of the part of his own identity that is in many ways that of a client. The majority of tattoo artists are themselves tattooed, and are thus familiar with the position and pain of those on the other side of the needle. Horiyoshi III carries a full, long sleeve bodysuit, which extends into the armpits, as well as neck, head and palm tattoos. The true master is irresistibly drawn into respecting the client's endurance of the pain, and in some sense the master is constantly at once master and client. Every experience of tattooing another recollects the master's own experience as a client. Furthermore, the regard of the master for the client is one not only arising out of an understanding of the pain endured, but out of a respect for the artistic appreciation of the client.

It is Horiyoshi III's ability to respect his clients that leads to his unconcern for power or financial status, his ability to esteem the working-class client as much as the politically powerful client, and his indifference to financial motivations. Finally, it is his own sense of self-valuation that creates these characteristics—and it is these qualities that make him in many ways an uncannily true-to-life manifestation of the idealized and romanticized vision of the fair and virtuous feudal lord, a figure that inspires both trust and faith. This conception of the feudal lord is one that is drastically different in Japan, and stands in marked contrast to the potentially negative associations this same title might hold in the West. In this idealized image, the feudal lord is fiercely devoted to his retainers, and possesses an unbounded sense of honor and loyalty to those under his protection. In many ways nothing more than a utopic vision or dream that in fact was perhaps never a reality at all, this ideal of the feudal lord and his loyal samurai still holds sway over the Japanese imagination.

The bond role of "master" is thus based not only on the client's deference to the master, but also on the master's ability to respect both himself and his client. Finally, the true *master* such as Horiyoshi III can often find himself, perhaps unconsciously, fulfilling the idealized vision held by his clients; that is to say, his own identity is created by his clients. Thus the two are bound closer and closer together, and in an ideal situation, as that which takes place daily in Horiyoshi III's studio, hours of labor and pain run concentric with love and respect, snowballing into a permanent bond.

Thus far we have by and large considered the term master in terms of interpersonal relations, but it is only fitting in a book centered on tattoo art that we explore the overall resonance of the word "master". Master, as pertaining to a tattoo artist, is also a title earned by the attainment of a certain level of skill, obtained after years of diligent study, and as stated earlier, the client's regard for the master is as much a respect for his artistic skill as his overall moral and spiritual person. If the client trusts the master's artistic power, the master in many ways must place his trust in the client as well. Here, as at the level of personal dynamics, the display of deep personal regard and trust flows in both directions.

Most immediately obvious is the appreciation the client must feel for the master's artistic skill. Trust in this skill is crucial to this side of the equation as well; it is virtually impossible to submit oneself to being permanently marked by another without this trust. However, though it is perhaps less immediately obvious, in some senses the master's investment in his client equals, or even surpasses, that of the client in the master.

In the tattoo world, the master can ascend to artistic mastery only through the skins of his clients. Virtually every other artistic medium, with the possible exception of architecture or performance arts, permits the creation and production of art while remaining in complete isolation. The role of interpersonal relations in the generation of artistic inspiration is of course another question altogether; however, on a very literal level it is possible to produce a novel or a painting while remaining in a state of isolation. Physically, it is impossible to tattoo without a body to tattoo on.

Tattooing is not possible without the client, and it is not only their body, but their desire, endurance and overall love that makes the artistic creations of the master possible. Due to the symbiotic nature of client and master relations, the reciprocation not only of respect, but also of trust, is inevitable. The master's artistic legacy lies in the skins of his clients, individuals whose personal features such as skin color,

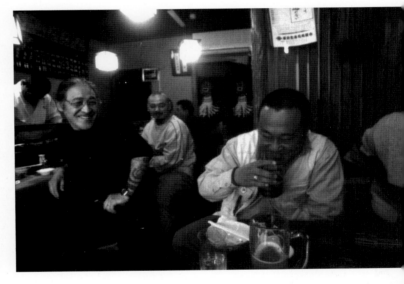

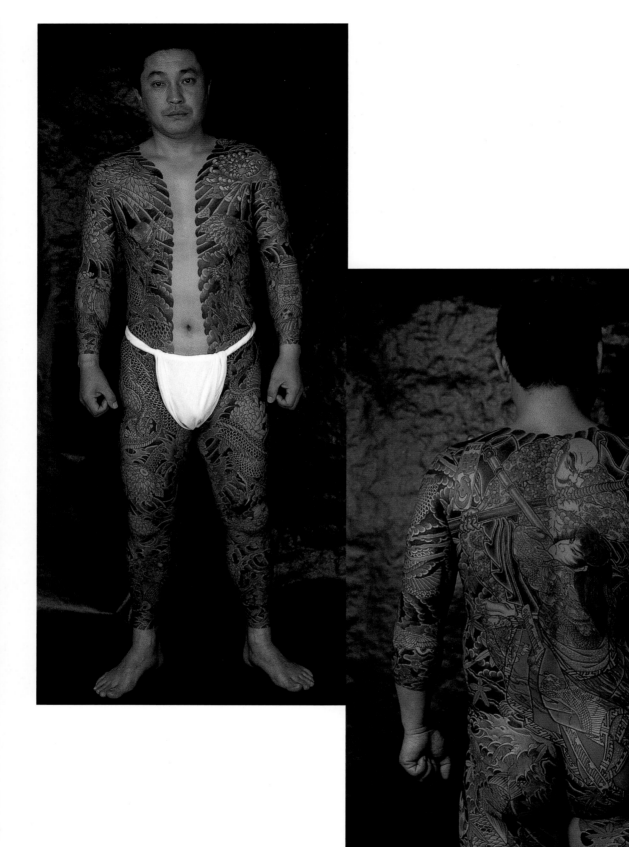

skin texture, and body shape (to name a few) dictate the work that transpires through the needles. The client's skin forms the canvas, the raw material of the work.

Furthermore, the master is forced to wait for extended periods of time between each session. After every session, the living canvas leaves, and every master undoubtedly must, if only subconsciously, wonder if he will ever see this particular work of art in progress again. Completion of a work of art depends not only on the artist's own determination, but on that of the client. The tattooer must trust the personal commitment of the client—and even with the assurance of this, other factors, such as accidental death, illness or imprisonment threaten the completion of what might be a potential masterpiece. And of course, every piece has a limited life span. Often small, snapshot photos, absurdly inadequate to the task of capturing the beauty of a tattoo, are all that remain following the death of a client. Even if the client's skin is flogged and donated to the skin museum in Tokyo, many qualities of the living work of art are lost, and the peak viewing period for the work of art will have passed.

Despite the almost frighteningly fleeting nature of this particular form of art, tattooers and clients alike persist in their pursuit of artistic mastery. The definition of artistic legacy therefore is redefined by the art of the tattoo. For these artists, the fact that the work of art existed at one point must be sufficient. Yet for the individual client, the work is forever, a temporal perspective that at once validates and the work of the master.

The client-master bond, in the specific form we are discussing here, rarely exists in the United States due to the short relations between tattooer and tattooee, the difficulty in finding an individual worthy of the many dimensions of the title master, and the vast cultural and sociological differences. However, in the Japanese culture, this bond is akin to one built of iron, and is forged tougher with every prick of the needles. This experience can be said to be truly eclipsed by only one other relationship. In the relationship between the master and the apprentice, the central elements of the master-client bond are pushed to their logical conclusion. It is here that the most striking parallels between tattoo culture and samurai ethics emerge, as the master molds and form the apprentice on a training course targeting the attainment of not only technical and intellectual knowledge, but also spiritual and emotional strength.

[1] Hideo Gosha, "The Marvel of the Works of Horiyoshi the Second" IN Japan's Tattoo Arts: Horiyoshi's World, Ed. Akimitsu Takagi, Katsunari Fukushi, D.E. Hardy with Japan Tattoo Institute (Tokyo: Ningen no Kagakusha, 1997), 64.
[2] David E. Kaplan & Andrew Marshall, The Cult at the End of the World (New York: Crown Publishers, 1996), 167.
[3] Gosha, 138.
[4] Interview with Artist.

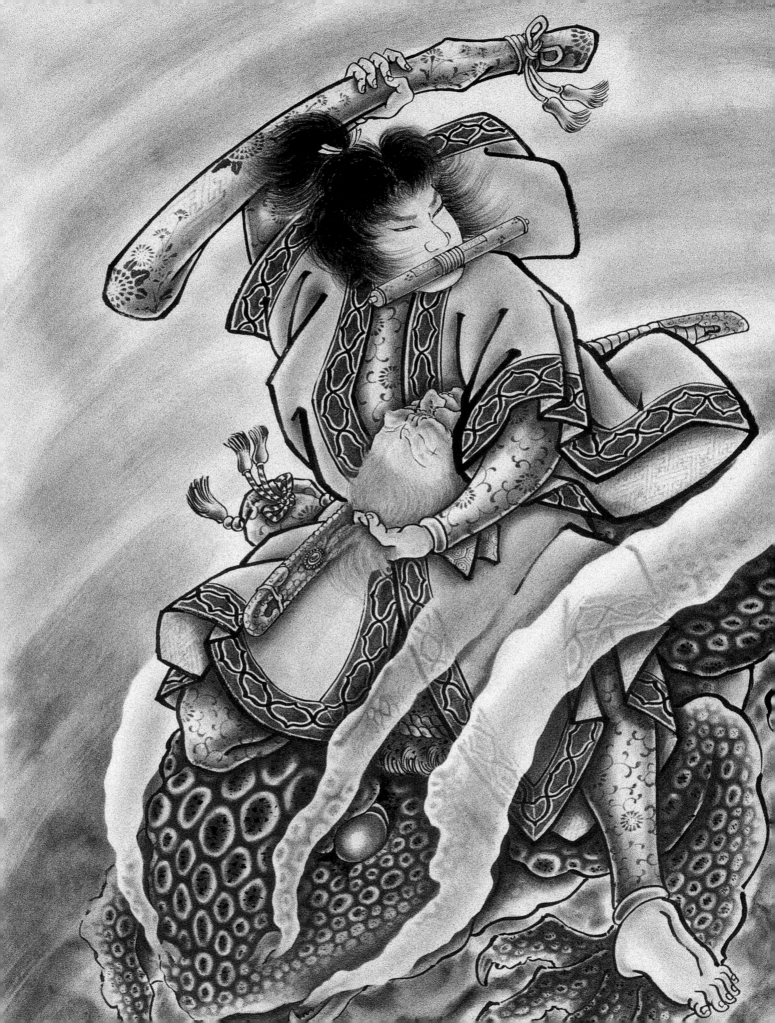

Chapter Four

Though the Japanese tattoo is in many ways a highly legitimate art form, like *ukiyo-e* art, it is simultaneously a craft carrying with it a long tradition and history. Many highly celebrated artists, including Horiyoshi III, continue in their effort to maintain the tattoo's original link with craftsmanship, while simultaneously and inexorably pushing at the artistic boundaries of the tattoo. This is not to imply a discrepancy between workmanship and artistry; at its best, the tattoo offers a seamless blending of both these aspects. Certainly there are highly ideological reasons for this choice to regard the tattoo as a craft; many artists take great pride in the proximity their craft holds to working-class people and origins. This sense of serving the people and the romanticized notion of a simple, working-class moral code is obviously echoed in *bushido*.

Musashi Miyamoto epitomizes the manner in which the ethics of craft, art, and the samurai spirit can be melded together. Although he is famed for his moral and physical strength as a warrior, Musashi was also both artist (he produced a number of *Sumi-e* paintings) and craftsman working in wood and metal mediums. In *The Book of Five Rings*, wherein he explains the workings of his principles and ethics, he writes:

> Let me explain military tactics by way of comparison with the craft of the artisan. I shall compare it with the carpenter because of the relationship with houses. We speak of the noble houses, the military houses...because we speak of schools, styles, and professions as houses, I shall employ the craft of the carpenter to explain military tactics...the same is true for the master carpenter as it if for a commander of a warrior house...to accomplish a task quickly and to perform it well is not to be haphazard about anything; to know where and when to use who and what; to know whether or not there is incentive; to give encouragement and to know limitations; these are what a master carpenter keeps in mind.
> The principles of *Heiho* are the same.[1]

Starting with what seems to be a purely linguistic similarity, Musashi skillfully reveals the fact that the fundamental similarities between the ethics behind artisan craft and warrior spirit extend beyond simple semantics. The principles of *bushido* are such that they apply to many facets of life, but are especially applicable to the notion of craft, to the creation of a utilitarian product that extends beyond pure aesthetics. The notion of efficiency, workmanship, and managerial discipline are more immediately linked to the workings of craft rather than the production of art. The Japanese tattoo in part associates itself to craft in order to preserve this alliance with the morals of samurai *bushido*.

One of the central manners in which the Japanese tattoo maintains its original bond with the warrior ethic of workmanship is through the apprenticeship learning structure, one that finds its origins in the world of skilled labor. Many craftsmen employed the practice of maintaining an apprenticeship position in order to teach and carry on the tradition of their craft. The practice of maintaining apprentices was often crucial to the survival of the master; in feudal times, the presence of the apprentice helped to secure the estate; on a less literal level, in many artisan families, taking on apprentices helped ensure the survival and continuing legacy of the family: "The largest, most successful, and long-lived artistic groupings...were organized along family lines and directed by individuals who combined artistic talent with entrepreneurial and managerial skills...In these workshops succession generally passed from father to son, but...a talented apprentice was sometimes adopted as heir to the family profession."[2]

Firmly in practice during the heyday of the samurai, the ideologies of these warriors can be seen in the dynamics between today's master and apprentice. Musashi's code of ethics, his *heiho*, is at once intensely philosophical as well as practical. *Heiho* teaches one to attain a spiritual strength of mind over body by learning, through diligent practice, the ways in which to use one's tool of choice, whether it is the sword, the tattoo needle, or the paintbrush. This philosophy teaches one the endurance to survive and triumph. In order to internalize this ethic, one must learn it not as a professional set of rules, but as a lifestyle, a personal set of beliefs. But he also emphasizes the importance of knowing

others; the way of the samurai is not a solipsistic lifestyle. According to *Heiho*, unless one knows others, not only will one never know the mind of the opponent, one can never truly know oneself. These various ideologies are embedded and interwoven in the training process a tattoo apprentice undergoes; I would now like to focus on the specific ways in which these thematic elements appear.

Because the Japanese tattoo is one of tradition, not merely the mental strength and the technical skill of the apprentice is tested, but also the intellectual grasp of the future artist. The young artist, while training for his or her future career, is constantly forced to cast one eye back toward the past. Fundamental to traditional tattooing is a thorough understanding of Japanese culture and history, and above all, an unquestionable mastery of every aspect of the imagery of Japanese art, throughout its lengthy history. As previously discussed, the images employed by the Japanese tattoo draw heavily from influences of Japanese artists from various historical periods. In order to vividly recreate and carry on the tradition of this imagery, the artist must properly understand the image—and understanding the image entails comprehending the political, social, intellectual and cultural history of the relevant period. Not surprisingly, the studio of Horiyoshi III is lined with bookcases, and books span the space from floor to ceiling. Books literally spill out from every nook and cranny.

The demands of this historical knowledge in many ways lead to an acknowledgment of the vital role tradition plays in the life and arts of Japan. The extensive research and study, necessitated by the importance of tradition, fosters this awareness in two ways; only the apprentice who possesses a fair amount of respect for tradition would be willing to undergo this rigorous course of study, one which, in turn strengthens and solidifies this particular appreciation of the past. The ability to recognize the lasting import of the past, within the context of a turbulent present and uncertain future is central to the warrior sense not only of tradition, but also of vindication and justice. It must be noted that the vast majority of samurai tales turn upon the samurai's relentless pursuit of the vindication of a dead master's honor, or, as in the story of *Taiko*, the attempt to carry to fruition, a dead lord's vision. Furthermore, this ability to understand and appreciate one's historical legacy helps one attain the Zen ideal of understanding the self not as an individual, but as a part of a larger whole, as a single member in a larger society or community of people. These intellectual demands lead to a philosophical lesson as one is made to contextualize one's notion of self.

The relation between master and apprentice is in one sense a more intense version of the relation between master and client, and a simple comparison of these two relationships reveals other ways in which the master-apprentice dynamic and the master-client relationship collude to reveal various manifestations of the warrior spirit. All these ethics and relationships emphasize the importance of learning through the body, through training and testing the strength of the body. Musashi stresses the importance of training the mind to dominate the body, writing: "you will learn the path of the long sword, your entire body will move at your will, and you will know the rhythm of the path with your spirit...the movements of your body and legs will be in coordination with your spirit."[3] In their introduction to *The Book of Five Rings*, Bradford J. Brown, Yuko Kashiwagi, William H. Barrett and Eisuke Sasagawa write: "the physical activity you do is the training for the body. There is a saying, *Ken-Zen Ichi Nyo* ("Body and Mind, Together")... first the technique is practiced so often it is internalized and 'forgotten,' and then one learns to use it. Mastering the technique is mind over body; discipline, hard work, forcing the body to accept the rules and the pain and the utter exhaustion of constant practice, until the body *learns*."[4] The very process of tattooing writes this lesson upon the body of both the apprentice and the client.

In a manner that parallels the endurance demanded by the client who undergoes the grueling Japanese bodysuit, the apprenticeship demands a remarkable combination of patience and determination. The first two years of such an apprenticeship might be spent grinding *sumi* ink, which is traditionally used for all black or gray coloration in the tattoo. Thus the apprentices spend these years acquainting themselves with the bare, elemental aspects of the most fundamental facets of the tattoo, in the process quite literally teaching the body "the utter exhaustion of constant practice." Furthermore, this ink should (ideally) be ground daily; the apprentice shoulders the more cumbersome tasks for his or her master such as running errands, cleaning the house, or performing whatever chores are necessary around the house, in addition to the already strenuous demands of their technical training and their more academic study. But this extends beyond mere physical or intellectual demands; for example, in the Horihito family, apprentices are required to shave their heads, to *physically* display the austerity of their spiritual devotion. Finally, in what might seem the most substantial sacrifice by American standards, members of the Horihito family turn in their earnings at the end of the day to their master. Though food, lodging, and

transportation are provided while they are within Horihito's studio, allowances for free spending are necessarily quite minimal.

Though the technical difficulty of tattooing—particularly hand tattooing—necessitates a long apprenticeship, the length of this training period is extended even further because of this concern with training the mind and spirit of the artist as well as developing the formal technique of the apprentice. The practice of grinding the ink is symbolic of the overall objective of the apprenticeship: that of developing in the apprentice a formidable knowledge of every element of the Japanese tattoo, from the most basic and apparently inconsequential aspects, to the most complex and artistic facets. Some apprenticeships can last as long as ten years. The arts of Japan place a special value on refinement, on perfection, and as Musashi writes: "Practicing a thousand days is said to be discipline, and practicing ten thousand days is said to be refining. This should be carefully studied."[5]

The years passed with a single master test the devotion and loyalty of the apprentice, much in the way the process of receiving a bodysuit reveals the client's devotion (or lack thereof). However, just as the apprentice and client thus reveal a considerable investment in his relation with his master, the apprentice creates a legacy for the master (in the same manner that the client's body constitutes a piece of the master's artistic identity and name). The ideal apprentice represents the master's ideals, artistic styles, and personal strength, and guarantees the continuation of the master's artistic identity into the next generation. This question of legacy and inheritance is clearly the fundamental base of tradition, and provides the course through which tradition is maintained. It is also central to Musashi's philosophy; he writes: "The 'spirit of direct communication' is to learn the true path of *Niten Ichiryu* (the School of Two Swords) and to pass it on. It is important to practice diligently and to make this *Heiho* a part of yourself. This is oral tradition."[6]

This legacy can be one that is not merely spiritual or artistic. Since the beginning of power structures and legacies, the role of the family has been crucial to maintaining the stability of tradition and cultural inheritance. The importance of family in *ukiyo-e* schools and houses has already been mentioned; tattoo culture is also intimately concerned with the ethic of the family. In the case of an exemplary apprentice, the master may choose to grant the apprentice his title, thereby ensuring the survival of not only his artistic legacy, but also his name. To receive the title of the master would in essence be the highest accomplishment an apprentice could strive for. The inheritance of the title can occur in one of two ways, each representing itself in two different title forms. For example, the title of one of Horiyoshi III's apprentices, Horihito, represents a lineage in title, in that Horiyoshi III permitted Horihito to affix the later part of his (personal) first name, Yoshihito, to the "hori" prefix indicating the individual's identity as a tattoo master; thus "Hori" and "hito" are combined to create Horihito's official title, and to indicate his link with Horiyoshi. One famous example such a title transition would be Yoshitoshi, who acquired the "Yoshi" from the later part of his famed master's title, Kuniyoshi.

Another manner of indicating a title lineage is illustrated in the history of Horiyoshi III's own title. Horiyoshi III's master, Yoshitsugu Muramatsu, tattooed as Horiyoshi of Yokohama, had two apprentices: his own son and Yoshihito Nakano. He named them, respectively, Horiyoshi II and Horiyoshi III. Thus in this case, the "Yoshi" of "Yoshihito" is not related to the "yoshi" of "Horiyoshi III." The son of Horiyoshi III, at present fifteen years old and training full time under the tutelage of his famed father, will eventually assume the title of Horiyoshi IV. Horiyoshi III's son will therefore take a title that follows the particular form of titular lineage lying behind his father's name (as opposed to that reflected in the titles of artists such as Horihito or Yoshitoshi). In this manner, a dynastic legacy of sorts is created, and maintained through generations.

Portrait of Yoshitsugu Muramatsu, Shodai Horiyoshi, hanging in the studio of Horiyoshi III.

In many ways, training an apprentice is not entirely unlike raising a child, a point reinforced by the notion of inheriting a "title" or a family name. Horiyoshi III's behavior is akin to that of a caring father; strikingly, Kuniyoshi, like Horiyoshi III, trained his own children (in this case his two daughters, Yoshijo and Tori) as apprentices. Horiyoshi III acts on the simple notion that the apprentice must be nurtured rather than abused. Frowning on physical abuse, or the attainment of respect through intimidation tactics, Horiyoshi III's method of kindness and generosity echoes the teaching techniques of Kuniyoshi, who is described as "a good teacher and kind master,"[7] "known for his generosity towards his family and his pupils."[8] This sense of a nuclear family is best captured by the traditional practice of *heyazumi*, a live-in apprenticeship. Like many other traditions, this one is also a byproduct of feudal times.

The practice of *heyazumi* is still utilized by the Horiyoshi III family, and its "offspring" family of Horihito—though obviously for different reasons than those motivating their feudal counterparts. In fact, it is this "twenty-four hour" apprenticeship format that helps instill the strength of character that marks these families.

Heyazumi provides a unique learning environment, one wherein learning is not limited to the hours spent in the studio, but instead continues throughout the day—and thus the life—of the apprentice. The apprentice is constantly a student, and this identity subsumes all others. The role of "tattoo apprentice" literally becomes all consuming, testing not only the devotion of the apprentice, but also the capacity the apprentice holds to carry the lessons of the tattoo traditions to all aspects of his or her life. *Heyazumi* instills within the apprentice an awareness that the spirit of a true tattoo master is one that cannot merely be acquired by diligent hours spent in the studio.

The apprentice, through the process of *heyazumi*, can even begin to approach the status of son or daughter. In addition to the invaluable training, attention, and care that is focused on the apprentice, room and board are provided without charge; Horiyoshi III, from early on in his career, lived with his master Horiyoshi I. The apprentice will often reciprocate this generosity; as mentioned earlier, just as a loyal child might pass his earnings on to the family, the earnings of a young apprentice often go directly to his or her master, outside of a small "allowance."

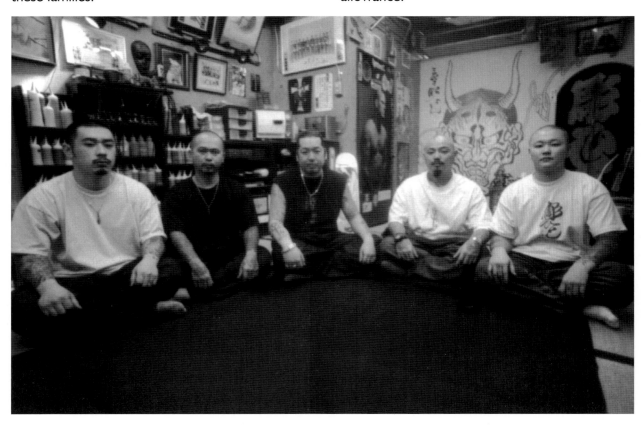

The Horihito Family. Shodai Horihito is seated in the center. The apprentices, from left to right, are Horiaki (the newest addition to the family subsequent to the writing of this text), Horihachi, Horimei, and Horitaro. Horishichi is absent from this photo.

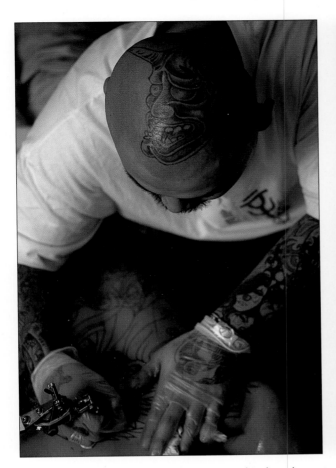

Horimei of the Horihito Family. The tattoo on his shaved head is by Horihito.

Kazuyoshi Nakano, future Horiyoshi IV

Horihito currently houses three apprentices. His former apprentice, Horishichi, has returned to his hometown of Atsugi to open his own studio; he has earned entry into the Horihito family, and his own studio is an extension of that family. Horihito's three current *heyazumi* apprentices, in order of seniority, are Horimei, Horitaro, and Horihachi. All live at Horihito's home, and willingly adhere to the strict guidelines set by the Horiyoshi III family. Beyond the shaved head all apprentices must bear, complete sobriety at all times is demanded, and, as mentioned earlier, each apprentice also performs a set of daily tasks. Even more, these apprentices, all in their twenties, must sacrifice, or at least place on hold, the pursuit of their own previous social circle or set of social activities to take on those of their master.

Despite the many sacrifices required of the apprentices, the final aspiration is a tattoo family that operates like a true, natural family. Much is demanded of the tattoo master as well. In order to merit the title, "master," he must show a self-restraint and discipline in *all* aspects of his life, not merely within the context of the studio. The master's personal life also falls under constant scrutiny and observation, and is offered up to the apprentice as a model for emulation. If the apprentice sacrifices his "public" life in order to adopt the closed life of the apprentice,

the master's private life in some ways becomes open to the eyes of a "public" of sorts. The master must epitomize Musashi's doctrine that *heiho* is not a professional mantra, but rather, a way of life and a personal philosophy.

In essence, the process of *heyazumi* combines elements of a father-son relationship with that of the master-apprentice relation, in a manner that heightens the dynamics of respect and honor that fill this relationship. Because there is an element of instilled distance that is not generally present in the father-son dynamic, the constant and unqualified display of respect (I am not speaking of a general "feeling" of respect, which can be manifested in a million ways) is present in a way that it is not in many modern family relationships. On the other hand, because of the intimacy of the *heyazumi*, the ties of affection between the master and apprentice often take on a warmer tint than might otherwise be observed in a more strictly "professional" master and apprentice structure. Furthermore, the commitment, both emotional and temporal, on the part of the master, is such that the master's investment in his apprentice, both as an artist and as a future master, is increased. The apprentice will carry the name of the master, and thus must be capable of sustaining a legacy that is both spiritual and artistic.

The respect shown toward master is thus doubled, even trebled, by the respect that is often shown to a father, and the ties of loyalty shown to the master—and the ties of loyalty the master shows the apprentice—are drawn much tighter. And of course, in the case of Horiyoshi III and his natural son, the future Horiyoshi IV, the apprentice *is* quite literally the son of the master.

In overseeing the training of every young apprentice, Horiyoshi III is careful to strictly observe the dictates of tradition. Exceptions are almost never made, and even in his effort to simultaneously raise his son and train him as an apprentice, Horiyoshi III refuses to compromise the stringent nature of the demands that are made upon his young apprentice.

In the studio and all professional situations, Kazuyoshi addresses his father, Horiyoshi III, as "*shisho,*" or master. Just as with any other apprentice, Kazuyoshi must *earn* and endeavor to merit his place within the Horiyoshi III family. Horiyoshi III has carefully ingrained in Kazuyoshi a remarkable indifference to his father's status; in all my interactions with the Horiyoshi family, I have never seen Kazuyoshi show even the slightest sign of any unseemly awareness of his father's stature. From a strictly professional perspective, Kazuyoshi is Horiyoshi III's apprentice before he is his son, and it is this distinction that permits Horiyoshi III to groom Kazuyoshi as an apprentice.

Clients have already begun to book appointments with the future Horiyoshi IV, such is the anticipation built around Kazuyoshi's emergence professionally. At least in terms of his professional training, Horiyoshi III chooses to prepare his son for the pressures that will fall upon him simply *because* he is the son of Horiyoshi III. He trains Kazuyoshi exactly as though he were not his son, but merely an exceptionally gifted apprentice. To train Kazuyoshi's *spirit* to face the expectations that have been built up by the tattoo world, Horiyoshi III follows tradition relentlessly, refusing to be in any way lenient upon his own son.

Because Horiyoshi III uses extreme care in the selection and training of *deshi* (apprentices), he has earned the uniform respect of his young pupils. And again, as discussed in the previous chapter on the master and the client, it is in many ways Horiyoshi III's personal character that allows for this form of training. His self-respect never demands submission or ostentatious displays of respect from his apprentices; as a result, this respect is sincerely felt.

Though I had had ample opportunity to observe the remarkable practices of Horiyoshi III, I had assumed that this was specific to the individual char-

acter of the man. However, upon closer interaction with Horiyoshi III's former apprentice Horihito, and the Horihito family—an offspring family of the Horiyoshi III family—as a whole, I realized that these ideals and modes of training had been preserved in the transition from tattoo generation to tattoo generation. I quickly revised my former appraisal; if anything, this characteristic pervaded both the Horiyoshi III family and its offspring families, and this legacy formed one of the most important products of the master-apprentice practice.

Horihito, who heads the Horihito family in Kawasaki, is himself a member of the Horiyoshi family, providing one of the more simple manners in which these tattoo families are linked and related. Through my relation with Horiyoshi III, and the (comparatively brief) time I have spent with Horihito, I was made aware of the manner in which the sublime tattoo work these families produce is matched by an equally remarkable strength of character.

This coupling of artistry and character is a product created by the continuing practice of the apprenticeship. Horiyoshi III and Horihito offer the ideal example not only of the complex relationship between the master and apprentice, but also of the rewards of this practice. Therefore, I refer to these two artists *not* as a "typical" or representative example of the master and apprentice interaction, but rather as an ideal fulfilled. Their observance of tradition and their own personal integrity (one that cannot be attained merely by mimicking the movements of tradition) make them excellent "case studies" of the infusion of this samurai essence in the art and practice of the Japanese tattoo.

I first met Horihito while on an assignment from Horiyoshi III. Knowing of an interview I had just completed with the renowned Hong Kong tattoo artist Pinky Yun, Horiyoshi III requested that I write an article introducing Horihito and his work to the US tattoo community. Initially, I approached the assignment as precisely that; I endeavored to record the "facts" of Horihito's life and work. Concerned with the more factual aspects of the similarities between Horiyoshi III and Horihito (such as artistic choices, tattooing techniques) I initially overlooked a more powerful—and for me personally, more fascinating—current of similarity running between the two men.

Ironically, the similarity between Horihito and Horiyoshi III is essentially based on difference. The shared sense of honor and respect is centered upon the relationship of master and apprentice, and thus turns upon the differentiation between a master and an apprentice. Musashi, even as he outlines a doctrine to be followed by the apprentice, emphasizes

the importance of self-reliance: "having become enlightened to the principles of *Heiho*, I apply it to various arts and skills, and have not need of any teacher or master."[9] The final goal of any apprenticeship and any process of learning or training is this independence. Crucially, it is Horihito's complete internalization of the ethics as outlined in the *Heiho* and his respect for Horiyoshi that allows him to be a "true" master himself, and thus align himself, even elevate himself, toward the remarkable stature of his own master. The attainment of this position depends upon a nearly self-effasive respect for tradition (and thus the master), and in order to inherit this legacy, one must finally understand the value of the past.

I certainly did not instantly grasp the manner in which these subtle paradoxes were constructed. When considering my interactions with both these families, there is no single event that specifically stands out in my memory; rather, it was the observation of a collection of countless small actions, ingrained to the point that they were exerted naturally, without any thought, hesitation, or effort.

However, it must be admitted that the respect, even adoration Horihito holds for his master is made manifest in an immediate, physical manner. Even on the briefest of visits to Horihito's studio, one would rapidly realize that the studio forms an almost shrine-like representation of the master.

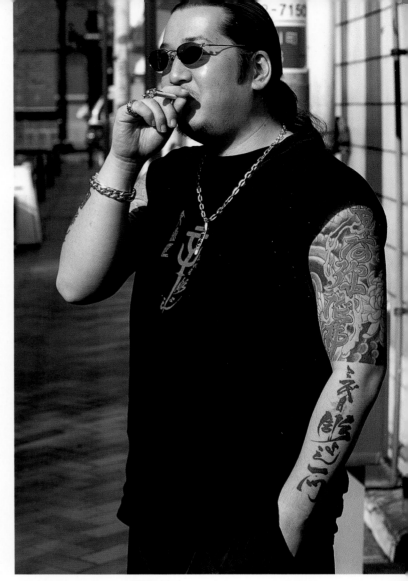

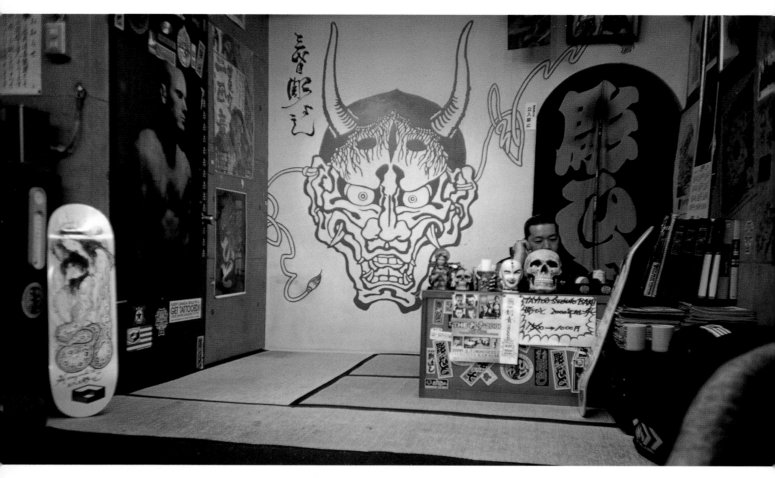

Prominently displaying photos and artwork samples of Horiyoshi III, at first glance the studio might seem to be that of Horiyoshi III's rather than that of Horihito. However, Horihito's loyalty to Horiyoshi III can be observed even prior to entering his studio; on his forearm is a tattoo with an inscription reading "Horiyoshi III family." Horihito tattooed the inscription himself, an act which functions as a more global metaphor for the apprentice's self-induced respect for his master.

These outer, more physical shows of respect are in fact *not* merely "show." Horihito's deference to Horiyoshi III can be observed in his actions and his words. As a loyal apprentice, Horihito constantly considers the importance of his words and actions to the reputation and honor of Horiyoshi III. Throughout the interview, for example, whenever a point that might be even slightly ambiguous or potentially controversial, Horihito would simply refer me to Horiyoshi III. In other words, Horihito quietly and calmly acquiesced his own opinion and commentary in favor of that of his master, and I can say with confidence that Horihito would never voice any opinion that might run counter to that of Horiyoshi III in even the slightest regard.

The realities characterizing the vast majority of tattoo families are rather more prosaic, and many family units are organized according to financial motivations. In most Japanese tattoo family units, it is, by tradition, customary for a compulsory monetary payment to be made to the master. Though this sort of financial offering technically a respectful tribute and a concrete display of gratitude, there are also motivations for this custom that do not find their base in sentiment. Some tattoo families will take on members merely in order to collect this monthly tributary payment.

Horiyoshi III and Horihito families also operate on this tribute system. However, the motivation behind this runs more along the lines of deference to custom, rather than those of financial greed. Indeed, the highly select nature of the Horiyoshi III family has led to an unusually small immediate family, consisting of only two members, Horihito and Horinami, despite the fact that countless tattooists aspire to be made part of the family. It is self-evident that the organization of Horiyoshi III's family is not dictated by monetary motivations. And within this particular family, it is clear that in the use of the term "tribute payment," the emphasis falls more upon "tribute" than "payment."

The master can aid the apprentice's financial status in numerous ways. Immediately following the

apprenticeship, the master will (ideally) facilitate the newly trained artist's entry into the trade, and on the whole can establish him or her in the direction of obtaining a stable career for life. For example, Horiyoshi III's request that I interview Horihito reflects his continued interest and concern for his former apprentice's career.

Secondly, by gaining entry into a given family, the new member acquires the right to advertise his or her membership within the family. This sort of affiliation is perhaps the best form of advertisement available, and is one that has lucrative financial pay-offs. Though Horihito certainly affixes "Horiyoshi III family" to his own name out of a deep sense of pride, it is also a savvy career move. The association can "make" a tattooist's career, by affecting both his or her status as an artist as well as his or her clientele.

Horihito, who waited and trained patiently to become a member for seven years, is well aware of the double-edged nature of this membership. It is at once a source of infinite personal pride, at once a source that is to be widely advertised, and even, to a certain degree, exploited. In part, association with a family *must* be used to forward a Japanese tattooist's career, simply because virtually every tattooer is a member in some family; "non-association" would be more or less a form of career suicide. But the primary meanings associated with the word "family"—such as respect, loyalty—will perhaps always be first in Horihito's mind, rather than these professional considerations.

The word "family" is thus one that holds deeper and broader meaning within the realm of the Japanese tattoo. If the family once was the stronghold of tradition and respect within Japanese families, the feudal spirit of tattoo families uses this link not only to foster lasting relationships between master and apprentice, but also to create a chain-linked legacy of inheritance, preserving the multi-faceted tradition of the craft.

[1]Musashi Miyamoto, The Book of Five Rings, 14-5
[2]Guth, 41.
[3]Miyamoto, 57.
[4]Introduction to The Book of Five Rings, xxvii.
[5]Miyamoto, 58.
[6]Miyamoto, 56.
[7]Basil W. Robinson, Kuniyoshi (London: Victoria and Albert Museum, 1961)24.
[8]Inge Klompmakers, Of Brigands and Bravery (Leiden: Hotei Publishing, 1998) 10.
[9]Miyamoto, 6.

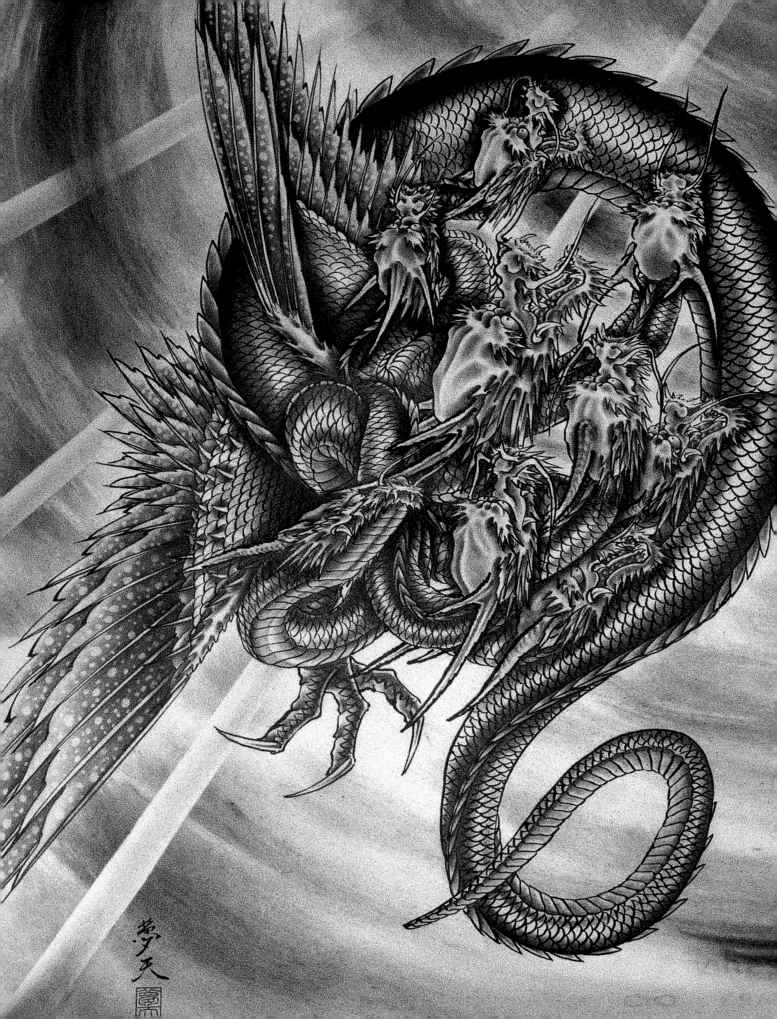

Conclusion

With the new generation, the practice of *heyazumi* as discussed in the previous chapter is quickly fading. Even the word itself is more or less meaningless to many young tattoo artists. Just as the machine has replaced the "hand-poke" method for reasons of time and labor efficiency, the careful selection and lengthy training demanded by the *heyazumi* practice is being replaced by hasty, financially motivated apprenticeships.

The problems facing a tattooist such as Horiyoshi III, who wishes to remain firmly rooted in the tradition of his craft, while forwarding his art by taking advantage of new innovations and techniques, are subtle and manifold. He fully understands that blindly following the dictates of tradition would do not only himself, but also the future of his art, a grave disservice.

In *One Hundred Demons*, Horiyoshi III describes the dilemma he experiences daily as follows: "For the background shading (in these prints) I broke with tradition. Observance of tradition is definitely important but it is important to open doors to further development. Still, I can't escape an ever-so-slight feeling of spitting in the face of a tradition that I respect and continue to rely on . . ."[1] His art struggles to maintain a careful balance between "observance of tradition" and "further development."

In order to approach this balance, Horiyoshi III has developed a personal "mantra," an artistic code or sorts, *Shu-Ha-Ri*. He explains this ideology as follows:

Shu: To succeed a tradition
Ha: To embellish with new concepts and techniques
Ri: To further develop these concepts, in the
 process creating one's own world

In some ways, the final component of *Shu-Ha-Ri* seems to be the crucial determining factor of the entire project. In attempting to build "one's own world," an endeavor that has always defined artistic creation, the artist must develop an unerring sense of what the balance between *shu* and *ha* might be. In the case of Horiyoshi III, one of few tattoo artists persistently seeking to perfect this balance, he quite literally creates an artistic product which is unlike any other.

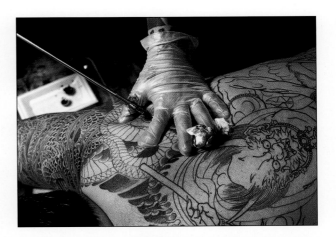

The determination to respect the traditions of the past is thus redefined; Horiyoshi III does not so much seek a literal repetition of the traditions of the past so much as he attempts to serve the vision developed by his masters before him. Using whatever new tools might be on hand to do so, Horiyoshi III remains remarkably faithful to his masters.

Horiyoshi III wonderfully demonstrates an ideal melding of the past and the present, and in doing so, creates a plausible future for the tattoo. However, on a more global level, the concepts of tradition, and indeed, the very definition of tattooing itself, are being tested as never before. If anything, Horiyoshi III provides the rare exception, and in part manages to do so by isolating himself and his craft from over-exposure to external elements. As mentioned earlier, Horiyoshi III's studio is something of an isolated haven, both literally and metaphorically.

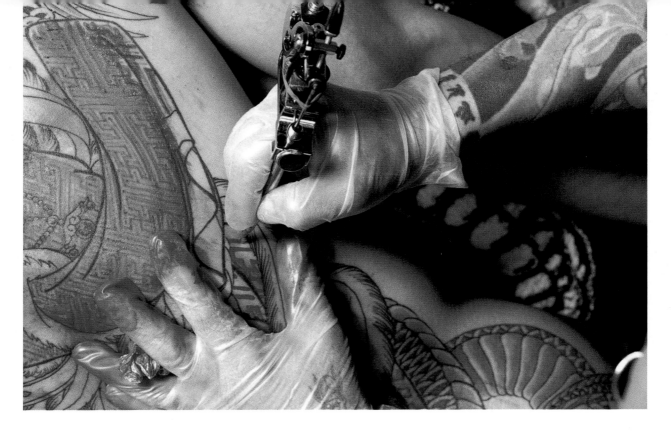

In contrast to this conscious artistic and cultural isolation, the development of world communication has produced a "global shrinkage" which has generated much discussion and speculation. Not only cultural differences, but cultural identities themselves are being altered and reshaped. Certainly the contrast between Japanese and American culture, though still considerable, is not nearly so extreme as it was perhaps only a century ago. Tattooing is not exempt from this global cultural reconfiguration; elements of the Japanese tattoo increasingly surface in Western tattooing, and the pop-culture influenced Japanese youth are eagerly embracing the current popularity of the American "one-point" tattoo.

Dialogue within the international tattoo community has had an ongoing existence, and did not by any means begin with the recent communication explosion. Originally sailors acted as a sort of primitive communication vessel, and on the arms of these men there formed a literal collage of various tattoo techniques and designs, a multi-cultural collection showcasing the history of the tattoo. Unconsciously acting as a traveling, living museum of sorts, these men carried the tattoo in all its forms to all corners of the world.

Many tattoo artists were eager to found an international discourse network, and in an excellent publication of American tattoo artist Sailor Jerry's letters and correspondence, appropriately titled *American Tattoo Master* (edited and published by Don Ed Hardy) these attempts are made wonderfully clear. In Sailor Jerry's correspondence with Japanese

tattoo masters such as Horihide and Horikin, the desire for an open channel of communication and exchange is explicitly expressed. In essence, Sailor Jerry and these Japanese tattoo artists were attempting to create an informal trade agreement of sorts; Jerry was interested in acquiring Asian designs, while Japanese tattooers were drawn to American machines and ink. Needless to say, this initial exchange has altered the face of tattooing in both countries, and many tattooists today (including Horiyoshi III) are simultaneously excited and troubled by the continuing repercussions of this first trade.

Though Japanese tattooists initially sought the technical advancement associated with the machine, ironically, American tattooers have always been drawn to the mystique of the hand tattoo, and remain so today. This cross-cultural envy and exchange permits tattooers to create a more "complete" vision of the global face of tattooing. For example, hand tattooists (whether of Japanese or Pacific Island origin) are highly prominent at Western tattoo conventions. These artists are almost always fully booked with clients, and their public tattoo sessions inevitably draw a crowd of spectators. The dual-edged attraction this technique holds is composed of the awe inspired by the virtuostic technique involved as well as the draw of the historic, the interest in the *global* roots and background of all tattooing.

Similarly, there exists a corresponding fascination for the West on the part of the Japanese. Today, tattoo studios geared entirely toward the one-point method abound in Tokyo, and are in fact more

visually prominent than traditional studios. The flashier exteriors of the Western one-point tattoo studios have accompanied the arrival of one-point technique in Japan, while in contrast, traditional Japanese studios have continued to opt for a less ostentatious, more covert existence.

However, there seems to exist a new emerging identity for the tattoo studio, both in the West and in Japan, a cross-cultural mix that destabilizes the binary expressed above. A new, "hybrid" species of studio seems to be evolving, one that captures elements of both the traditional Japanese studio and the Western studio. At one point during his career, Don Ed Hardy operated a private, appointment-only studio, located on an upper floor of a building. Though he has since abandoned this practice, it remains an interesting point of comparison with the Japanese tattoo studio. Like the Japanese studio, Hardy's set-up conceals the studio, quite literally elevating it from the level of casual "walk-in" sessions. The private aspect of the tattoo, not only for the client, but also for the tattooer, is thus emphasized. Consciously or unconsciously,

these artists are encouraging the American tattoo clientele to consider the art of the tattoo more seriously. In addition, the "one-man" nature of these studios induce the client to become familiar with the individual work of these artists, rather than on the vague notion of "tattoo art."

In a larger studio, with multiple artists, this sort of exclusivity is more difficult to maintain; indeed, even within independent artists, only the truly exceptional will be capable of thus safe-guarding their artistic privacy and integrity. However, a studio such as *Primal Urge* succeeded in creating what might be deemed a hybrid studio of sorts. Despite the fact that multiple artists worked out of a single studio (which rarely occurs in traditional Japanese studios), private rooms were provided for the artists, and virtually every tattoo executed in this studio was custom drawn. Though the "flash"-oriented street shop remains the dominating species in the tattoo scene, studios such as *Primal Urge* are vividly demonstrating the potential success for studios focusing not merely on attaining business, but on promoting the artistic standards of the tattoo. Interestingly, the individual personality and artistic identity of each artist is in many ways crucial to creating this standard, and this individuality is both reflected and developed by the privacy granted to the artist within the studio. As tattoo artists begin to garner name-recognition even outside of the tattoo world, the opportunity of acquiring a more select clientele and the occasion to work under private, self-controlled conditions becomes increasingly plausible. In essence, we are witnessing a transition from the tattoo as an art form that is

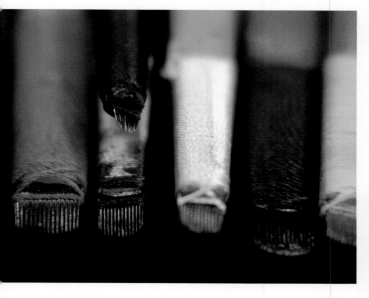

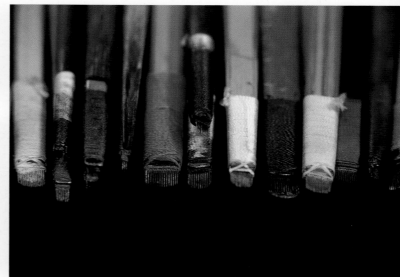

Close up of Horiyoshi III's hand tattoo tool. The stainless steel construction allows for the needles to be autoclaved for each client.

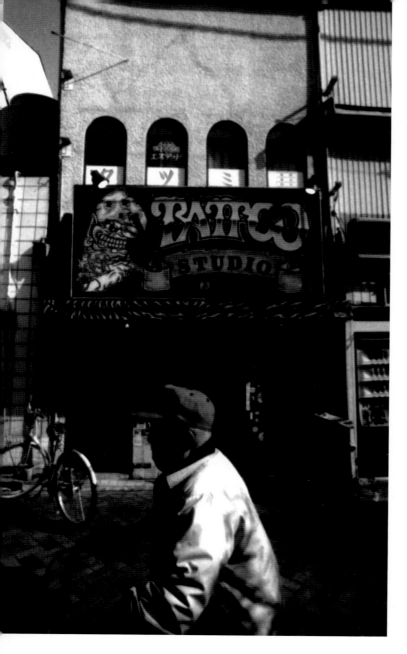

English, no less—one quite reasonably would expect to find within a Western-style studio. However, the curtained doors peel back to reveal *tatami* mat floors (traditional Japanese style, woven straw floor panels), and the quiet atmosphere indicates the silent nature of the hand-tattooing that takes place in this studio.

The basis of this juxtaposition of American and Japanese cultures has causes both external and internal to the actual studio itself. On the one hand, the flashy exterior of the studio was necessitated by the perimeters of a leasing permit that would not tolerate a tattoo studio bearing the external markers of a "traditional Japanese establishment." The desire to "update" and westernize the appearances of Japanese streets thus imposes itself upon the tradition Japanese tattooing struggles to maintain. However, the terms of tattoo tradition are being renegotiated from the inside as well. The younger members of Horihito's family are of part of the new youth generation of Japanese, and their own tastes are highly influenced by contemporary American culture. In spite of the traditional *tatami* mats, the walls of the studio are decorated with the paraphernalia of modern pop culture. For example, on one occasion I was startled to look up from the *tatami* to the wall, only to be greeted by a poster of the iconic American hip-hop star Tupac Shakur.

If the infiltration of American culture into the tattoo studio, one of the remaining strongholds of tradition in Japanese culture, may seem to be less than wholly positive—and I have to admit that my own feelings here can only be described as ambivalent—the current pop culture popularity of the tattoo has greatly altered Japanese public opinion of the tattoo. As American teenagers embrace the (formerly) underground tattoo world of the States, Japanese culture has begun to open up to their own formidable tattoo culture. However, it should be noted that the Japanese culture continues to stigmatize the full-body suit, particularly because of its long-standing association with the *Yakuza,* and it is the Western one-point tattoo that is truly gaining popularity and acceptance.

As Japanese tattooers execute one-point tattoos in Western-style studios, it becomes increasingly difficult to define the "Japanese tattoo." The collapse of cultural barriers necessitates a redefinition of the Japanese tattoo. The surging popularity of Japanese imagery is such that Western artists tattoo dragons and *koi* (carp) on a daily basis. However, this sort of tattooing defines itself along lines that are very different from the work performed by the Horiyoshi III and the Horihito families.

Though an exceptional Western tattooer may create a Japanese-style tattoo that will rival the

relatively undiscriminating in its choice of client or design, to one wherein the artist is better able to control these variables. Tattooing becomes less of a strictly monetary occupation, to one more focused on artistic liberty and expression.

Nor are these changes in the tattoo studio occurring only in the States; the Japanese studio is evolving in a manner that corresponds with and parallels these alterations in the West. The chamelonesque nature of current Japanese youth culture is reflected in the ever-changing, ever-evolving face of the Japanese tattoo studio. The increasingly powerful influence of Western (particularly American) culture finds an expression even in highly "traditional" studios. For example, Horihito's studio provides a series of often startling contrasts of East and West. The exterior of the studio seems to declare an allegiance to Western studios; decorated with a large, brightly colored sign declaring "Tattoo"—written in

technical and imagic work of a traditional Japanese tattoo master, the Japanese tattoo is not merely an exercise in art and craft, but also a vehicle for the history and culture of a nation. Horiyoshi III conceives of the Japanese tattoo as a complex and technically challenging art, which simultaneously demands a head-spinning amount of intellectual, cultural, and historical knowledge. While a Western tattooer certainly could master the *technical* demands of the Japanese tattoo (though it must be said that at present, very few Western tattooers are capable of mastering, for example, the techniques of hand tattooing), to attain the cultural and artistic knowledge of Japanese history that a master such as Horiyoshi III possesses is a task that would be daunting even to the most dedicated and talented of Western artists.

On a very literal level, the proper execution of Japanese images demands the acquisition of this bulk of knowledge. Rules and regulations abound in this imagery; these traditions dictate imagic decisions such as the use of a certain flower in association with a certain deity, details that may seem tiresome, even irrelevant, but in fact form the base of the traditional Japanese tattoo. This attention to detail is a trademark of Japanese culture, and is not truly present to the same degree in American culture. Other traditional practices and crafts, such as the Japanese tea ceremony or the art of Japanese flower arrangement, demand the same excruciatingly precise attention to detail and tradition.

This attention to detail is ultimately a surface manifestation of an attention to tradition itself. Every imagic detail carries with it a veritable chapter of Japanese cultural history, weaving a living record of the nation's traditions. Needless to say, this deference to tradition is only one layer in a complex code of honor and respect—itself yet another marker of the Japan's cultural heritage. In contrast, American tattooing tends to provide a vivid expression of the *current* status of pop culture; these tattoos wonderfully act as an index measuring and recording the social evolution of our nation. Clearly both these forms of "recording" are valid, but function in direct counterpoint, one to the other. The youthful spirit of American tattooing runs counter to the often frustratingly strict, tradition-observing nature of Japanese tattooing. It is this space of cultural difference—both globally and within the tattoo world—that makes it difficult for authentic Japanese tattoos to be performed by artists other than traditionally trained Japanese masters.

Nor is this difference merely one that is "ethnic" in nature; Horiyoshi III often notes the lack of understanding in many Japanese tattooists themselves. The exuberant style of the American tattoo is increasingly affecting young Japanese tattooers, and as noted earlier, lengthy apprenticeships are fast becoming a phenomenon of the past. Thus the population of artists capable of continuing the tradition of the Japanese tattoo is rapidly shrinking.

The future of the Japanese tattooing, once besieged by its own government, now faces an entirely different set of problems, those caused by the collapse of cultural barriers. Nonetheless, the strength of the master and apprentice bond—where it still exists—seems as though it may ensure the continued survival and success of the Japanese tattoo. The Horihito family provides a perfect example of a younger generation tattoo family successfully maintaining the essence of Japanese tattooing while simultaneously adapting to the current global multi-cultural environment. Operating out of a studio providing a (relatively) peaceful compromise between Japanese

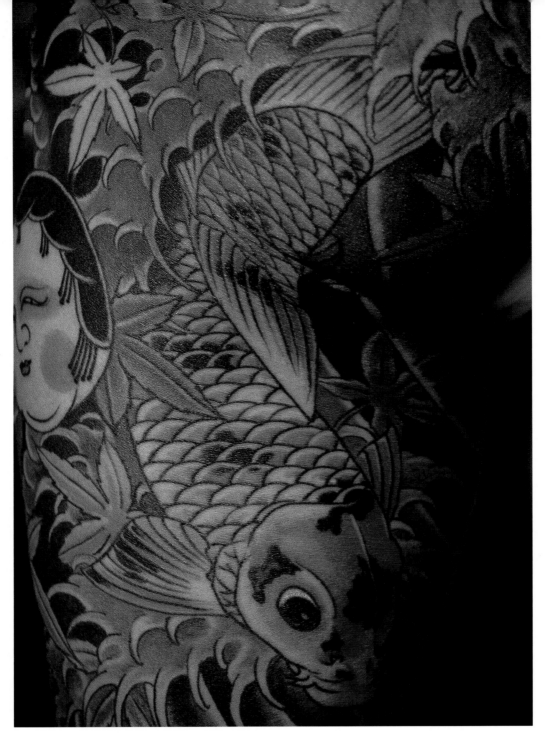

and Western practices, Horihito firmly believes in the value of tradition. In an interview, Horihito, with a touching display of pride, stated firmly, "In our hearts and minds is the Japanese tattoo." The hand tattooing and *heyazumi* process practiced by the Horihito family confirms these words. An artist such as Horihito has clearly inherited the sensibilities of his master; what is even more encouraging is the fact that Horihito has instilled this sense in his apprentices, ensuring the continuation of the Japanese tattoo morality for at least another generation.

However, it seems as though the solution to the fundamental problem might, ironically enough, finally be situated in the source of the predicament itself.

Because of the now global presence of the Japanese tattoo, the audience for the art is far larger, and via the new technologies and markets that are emerging, Horiyoshi III's art has spread quite literally across the globe. As a result, he can now draw disciples from all corners of the world rather than only from Japan. These young tattooists possess a powerful interest in *all* aspects of the Japanese tattoo, and on occasion can possess the discipline and enthusiasm demanded by the training process. Horiyoshi III is often able to single out young tattooers that are promising in many ways; these young tattooers often possess a radically different tattoo background than the traditional apprentice, and may have received

Western-style tattoos and training before turning to the Japanese tattoo. However, once having found their way, the devotion of these young artists is such that this population might potentially provide a new breed of Japanese tattoo devotees.

Furthermore, these new practitioners often focus on the *ideals* pertaining to certain aspects of the cultural tradition which natives are more likely to bypass, perhaps because they are more fully familiar with the prosaic realities of the daily culture, the manners in which traditions have been metamorphosed over the years. In my own case, I realize, of course, that I can be prone to romanticizing aspects of the culture and tradition, but also believe that this idealism has aided me in my study of the practice of the tattoo. What began as a stereotypically teenage, angst-ridden search for the culture of the "motherland" has been redirected and transformed into what I hope is a fruitful awareness of the traditions of past generations. Ironically, those who are most prone to romanticization and are also those who are most likely to preserve the traditions of the Japanese tattoo history.

During the course of a correspondence with a young German tattoo student of Horiyoshi III, I was pleasantly surprised to discover that we had many points in common, despite the radical differences in our background. He observed a general loss of honor in his own country following the catastrophe of World War II, and admitted that part of his fascination with the Japanese culture was his sense that "honor" remained a term that held meaning in that culture. While this sentiment is clearly akin to my own overly romanticized sense of Japanese culture, our mutual acquaintance with Horiyoshi III has doubled this idealism.

We are both in many ways representative of an entire global youth generation in search of new role models, ideals perhaps situated in the past, but nonetheless functional in modern-day society. Just as the Edo-period working-class population looked to the iconography of past heroes for inspiration, in a rapidly evolving world, the next generation may be said to be doing much the same thing. In the United Sates, we can observe a similar phenomenon, a parallel sense of nostalgia and romanticization of the past. This is particularly evident in tattoo culture; renewed interest in tattoo masters of the past, as well as the resurgence of "old school," traditional designs, indicates this heightened awareness of the past. Though it must be noted that all this is coupled by its antithesis, a radical bent and desire for the future, it does seem valid to claim that in this phenomenon, one can locate not merely a desire for a return to traditional designs, but also a more general longing for visual images representing a cultural legacy and sense of inheritance. Old navy designs, for example, are naturally crucial to the specific history of American tattooing, but also represent the more general cultural history of the US Navy and sailor community. Thus a single tattoo captures an époque in American social history, and today these tattoos have become an integral part of modern-day tattoo culture, worn by many who have themselves never been in the service. A client once confided her plans of acquiring a popular military tattoo which reads "Death before Dishonor." Though this particular notion of honor is all but extinct in contemporary culture, she had chosen this design in order to pay homage to her grandfather, a personal working-class hero to the woman.

The resurgence of nostalgia is one that seems to be taking place in response to a generational disillusionment and millennial angst, and is one that does not seem likely to quickly subside. As seen in the example given above, many young people are striving to endow words such as "honor" with renewed meaning. This global nostalgia, coupled with a new, more global following and a powerful cultural inheritance (as seen in the master-apprentice relations of Horiyoshi III and Horihito), all seem to guarantee the Japanese tattoo a place in the future. It is a pairing of the old with the new, the culturally specific with the global, a finely tuned mixture that manages to reconcile these crucial conflicts. The key elements of the warrior spirit—devotion, honor, and discipline—are being redefined in a manner that promises to preserve the traditions of the Japanese tattoo, even as this age-old art enters a new era.

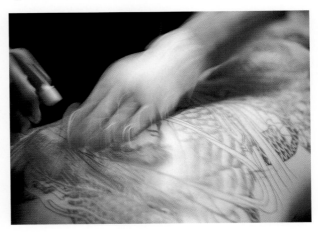

[1]Horiyoshi III, One Hundred Demons of Horiyoshi III, (Tokyo: Japan Publishing Co., 1998) Afterword.

Appendix I.

Horiyoshi Family of Yokohama

As discussed throughout the text, Japanese tattooers are often organized into hierarchical family structures. This "family tree" traces the Horiyoshi III lineage from his master, Horiyoshi. In the Japanese tattoo world, the founder of a family is referred to as *shodai*, a term of respect meaning "the first." In this case, Muramatsu Yoshitsugu, is referred to as Shodai Horiyoshi. All names in this section are presented in Japanese format, family name first.

Shodai Horiyoshi
Muramatsu Yoshitsugu
Yokohama
Deceased

apprentice

son
Ni-Daime Horiyoshi
Muramatsu Yoshiyuki
Yokohama
Retired

apprentice

Shodai Daimonbori
Kuwahara Hachiro
Omiya
Deceased

apprentice

Shodai Horiichi
Terada Isokazu
Nagoya

apprentice

San-Daime Horiyoshi
Nakano Yoshihito
Yokohama

apprentice

Ni-Daime Daimonbori
name unknown
Omiya
Retired

apprentice

Shodai Horinami
Suzuki Sayoko
Utsunomiya

younger brother

son
Future Yon-Daime Horiyoshi
Nakano Kazuyoshi
Yokohama

apprentice

Shodai Horihito
Kurokawa Kimiaki
Kawasaki

San-Daime Daimonbori
name unknown
Omiya

apprentice

Horishichi
Hirata Yasushi
Atsugi

apprentice

Horimei
Hirano Yuji
Kawasaki

apprentice

Horitaro
Saito Yuki
Kawasaki

apprentice

Horihachi
Nakajima Hirobumi
Kawasaki

apprentice

Horiaki
Ito Teruhiko
Kawasaki

Relatior

Title
Name
City

Unless otherwise specified all tattoo artists are active

Shodai Horiyoshi, Muramatsu, Yoshitsugu

Horiyoshi III, Nakano, Yoshihito

Horiyoshi III's spouse, Nakano, Mayumi

135

Horihito

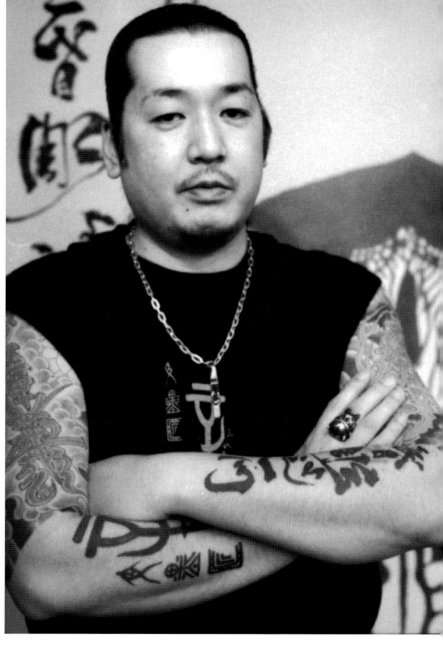

Nakano, Mayumi

Horinami

Horinami

Horinami

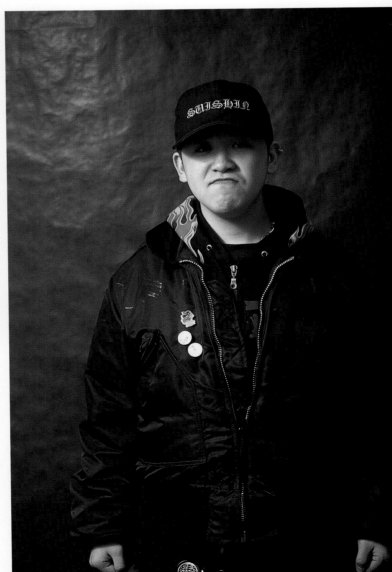

Future Horiyoshi IV,
Nakano, Kazuyoshi

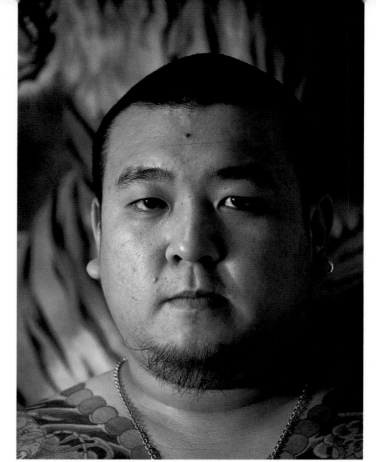

Horishichi

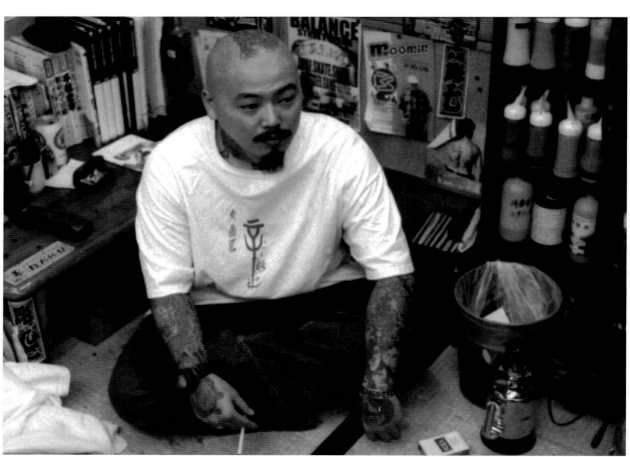

Horimei

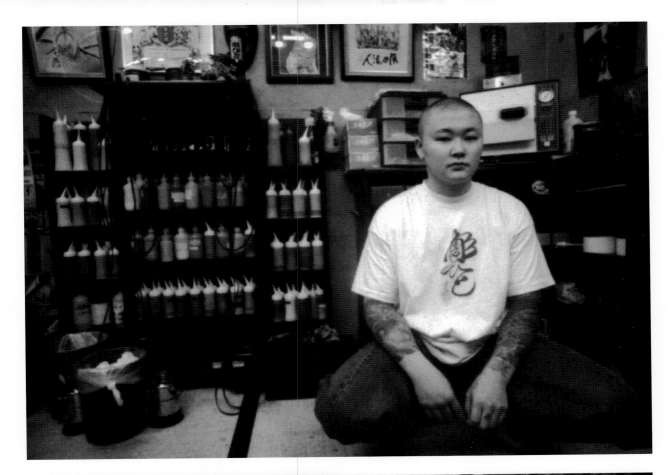

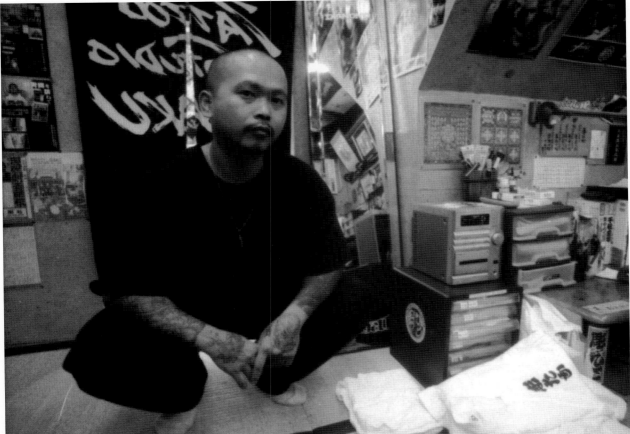

Top: Horitaro

Above: Horihachi

Left: Horinami

Below: Horiaki

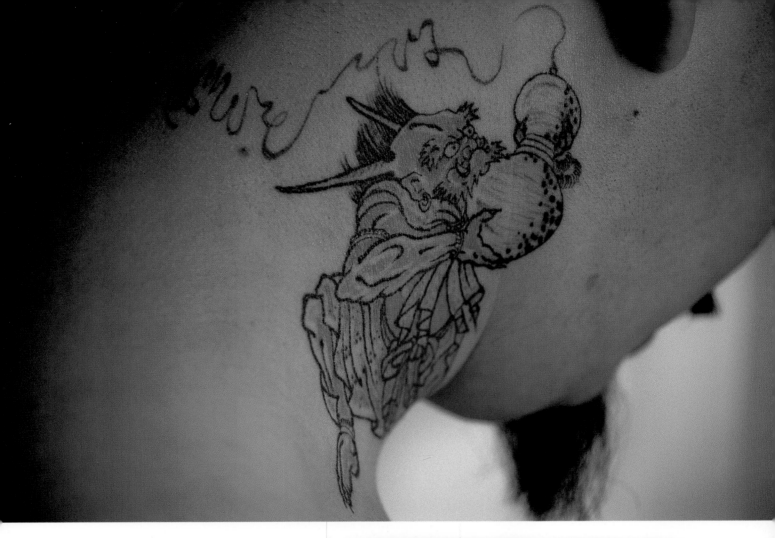

Above: Horimei's neck, tattooed by Horihito, bearing the inscription: Horihito Family.

Right: Ozuma, Kaname. A friend and artistic colleague of Horiyoshi III who frequently uses Horiyoshi III's tattoo clients for models and artistic inspiration.

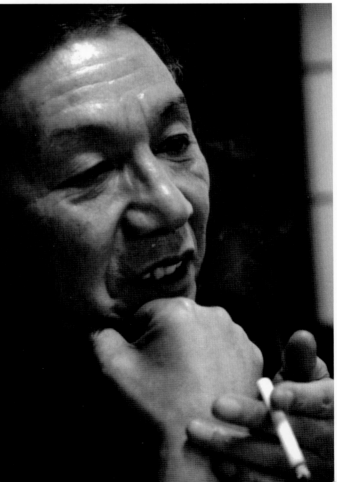

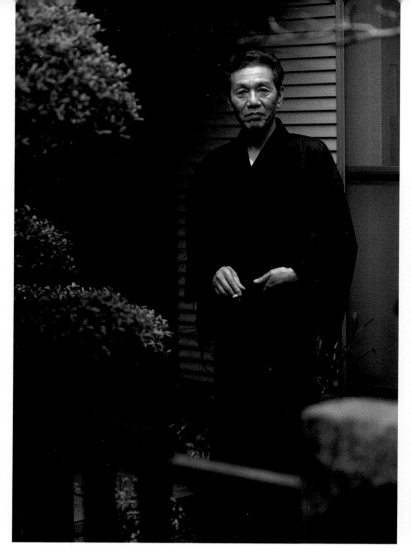

Ozuma, Kaname

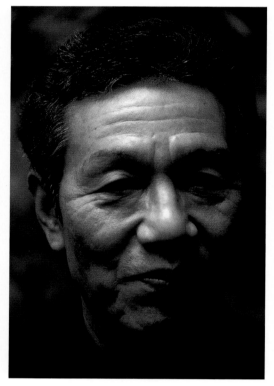

Ozuma, Kaname

Horinami and Ozuma, Kaname. Horinami has modeled
for three paintings by Mr. Ozuma.

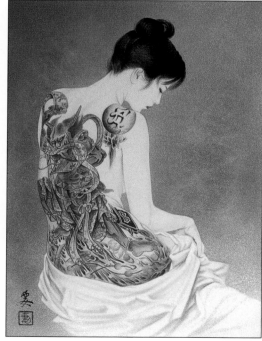

Painting by Ozuma, Kaname of Ito, Miho.

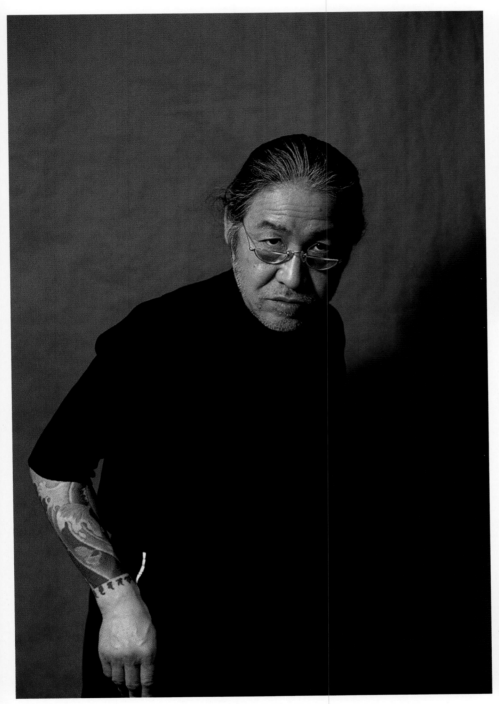

Horiyoshi III

The alley where Horiyoshi III's studio is located.

The residential building housing Horiyoshi III's studio.

Appendix II
Glossaries

General Glossary

Body suit: Stylistic element of the tattoo in which nearly the entire body is covered, excepting the face, neck, hands and feet. This is a fairly loose term and does not specify the type of tattoo art nor the degree of coverage.

Confucianism: Chinese belief system, based on the teachings of Confucius, emphasizing loyalty to one's master and filial piety. Confucianism was one of the many Chinese influences on Japanese society.

Edo era: Period of time running from 1603 to 1868.

Flash: Pre-drawn tattoo designs available to clients for either direct application as a tattoo design, or as a source of suggestion for another tattoo.

Hand tattooing: A general tattoo term for any tattooing executed without the use of a machine.

Kansei era: Period of time running from 1789-1801

Kyoho era: Period of time running from 1716 to 1736

Linework: Tattoo term for the actual lines of a piece before (or without) any shading or coloration.

Meiji era: Period of time running from 1868 to 1912.

One point: Contemporary slang term used in Japan to describe western style tattoos.

One Hundred Views of Mount Fuji: Famed *ukiyo-e* series by Hokusai Katsushika

Temmei era: Period from 1781-89.

Tenpo reforms: Governmental programs of the 1840s, whose effects included regulations against the publishing industry.

Yamatoe revival: An artistic movement taking place from the late 1700s until the mid 1800s with an emphasis on the revivification of classic Japanese themes and artistic style.

Zen Buddhism: Form of Buddhism with an emphasis on meditation, discipline, and intuition.

Japanese Terms

Bijinga: A genre of woodblock print art depicting "beautiful women," often from, but not limited to those from the pleasure quarters of the floating world.

Bushido: Samurai code of ethics.

Deshi: Apprentice.

Edo: Old name for Tokyo city, where the Tokugawa Shogunate based their government.

Hashira-e: Pillar print.

Heian: Period of time in Japan from 794-1185, during which the earliest preserved prints were created.

Heyazumi: Live-in apprenticeship.

Jidai: Era or period of time.

Kohai: Junior, in terms of age or prestige.

Manga: Pictures or sketches often characterized by humor or exaggeration. In reference to woodblock art, the term is often in reference to the fifteen volumes of sketchbooks, titled *Hokusai Manga*, published by Hokusai.

Musha-e: Warrior *ukiyo* prints

Niten Ichiryu: Musashi Miyamoto's school of swordsmanship, "The School of Two Swords."

Ojigi: A bow to the floor executed while kneeling.

Samurai: Warriors retained by lords during feudal times. These warriors would receive stipends in return for their services, and occupied a high rank in the Japanese class system.

Senpai: Senior.

Sensei: Teacher.

Shisho: Master.

Shodai: The founder of a lineage; in the context of the Japanese tattoo, the founder of a tattoo family.

Shokunin: Artisan or craftsman; in recent times this word has become synonymous with "working class."

Shunga: Erotic *ukiyo* prints.

Suikoden: A Chinese classic rewritten in Japanese by Bakin that was immensely popular in Japan. The exploits of these "water margin" bandits, many of whom were tattooed, were rendered pictorially by Kuniyoshi in 1827-1830. Kuniyoshi, who executed these designs in *ukiyo-e* form, was met with great success and added to the popularity of the stories. These prints are still in use as tattoo design, reference and inspiration.

Sumi: Water and charcoal based ink used for brush and tattoo art.

Tatami: Straw mats often found in traditional Japanese houses as floor covering.

Ukiyo: The floating world.

Ukiyo-e: Pictures of the floating world. The suffix "-e" means print or picture.

kame-no-koh "turtle back"

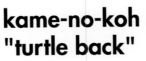

The stylization of the Japanese bodysuit is one that is unique. While many artistic references and folklore draw their influence from China, the body-suit formats are a purely Japanese invention. Terminology and tattoo styles may vary slightly by era and artist. The information below has been supplied by Horiyoshi III. Illustrations by Justin.

Sujibori: outline
Bokashi: shading
 Akebono bokashi: gradation shading
 Umazumi bokashi: gray shading
 Hon bokashi: black shading
Mikiri: background
 Butsugiri: straight-line *mikiri*
 Botan mikiri: scalloped *mikiri*
 Matsuba-mikiri: pine needle shaped *mikiri*
 Akebono mikiri: gradation *mikiri*
Nukibori: back tattoo without *mikiri*
Gakubori: tattoo with *mikiri*
Tebori: hand tattooing

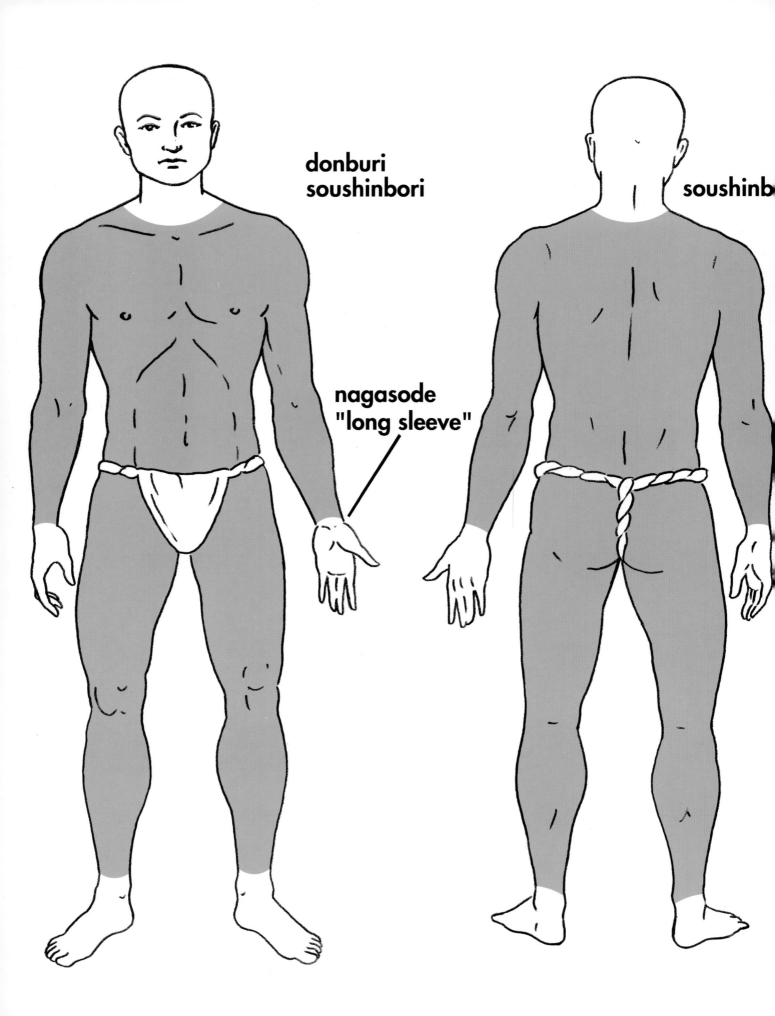

donburi
soushinbori

soushinb[ori]

nagasode
"long sleeve"

tsubushi

koban gata

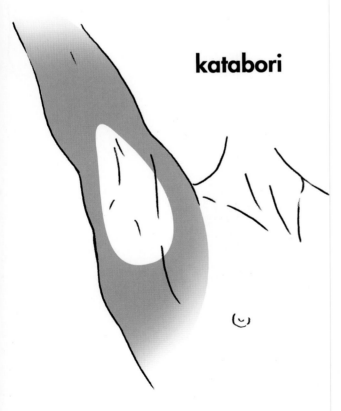

katabori

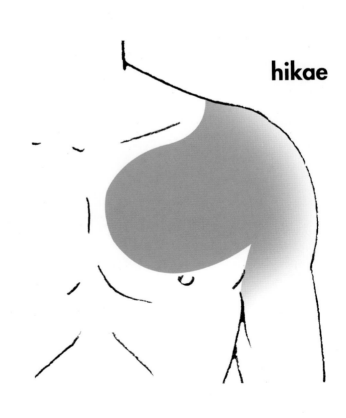

hikae

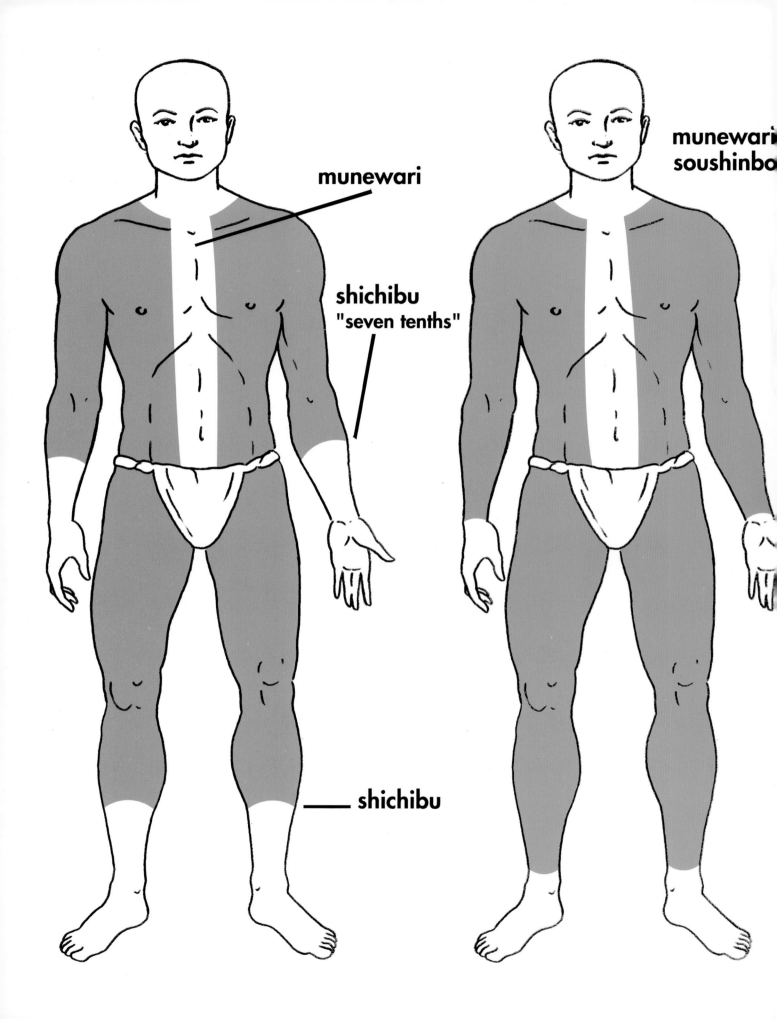

munewari

shichibu
"seven tenths"

shichibu

munewari
soushinbo

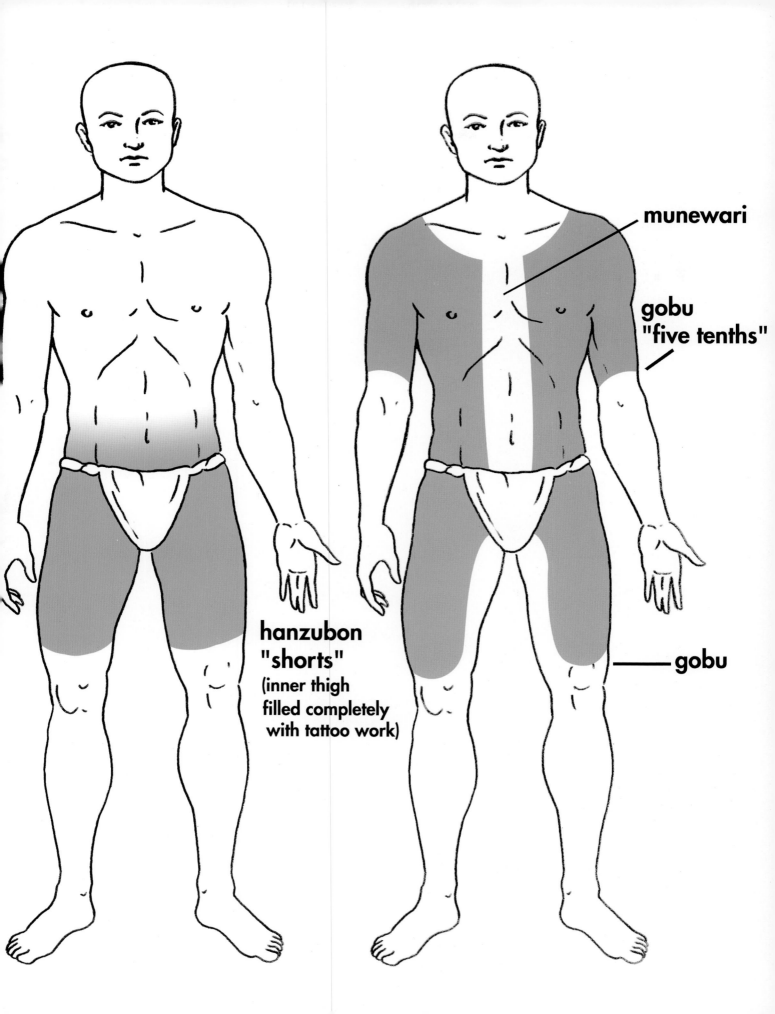

munewari

gobu
"five tenths"

gobu

hanzubon
"shorts"
(inner thigh
filled completely
with tattoo work)

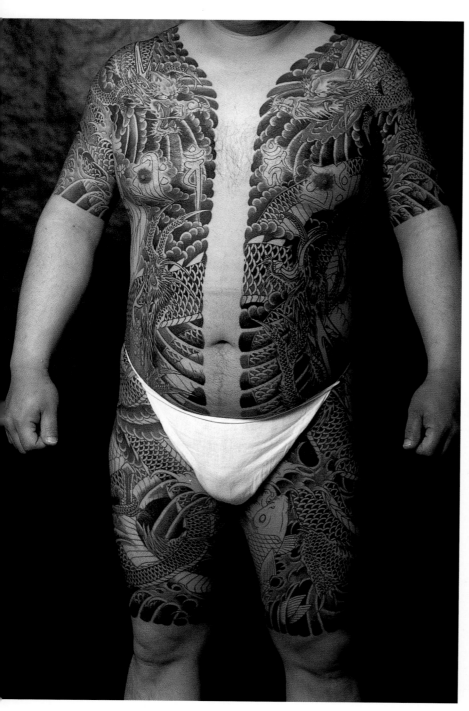

This is a perfect example of the *munewari* (split chest) bodysuit. The tattoo work stops above the elbow in *gobu* (five tenths) fashion. The tattoo work on the leg stops above the knee, also in *gobu* fashion. Since the inner thighs are tattooed as well, the *hanzubon* (short pants) style is also represented.

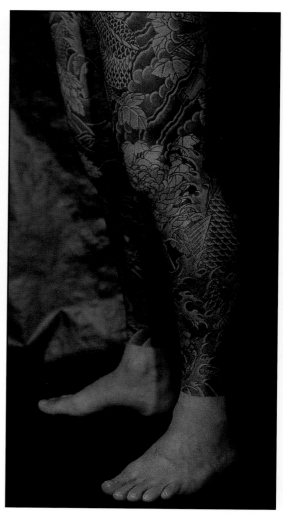

These legs are tattooed in the *soushin* (full length) style.

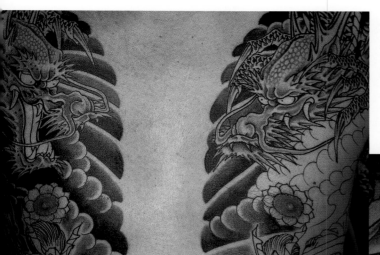

Close up of the *munewari* style. The scalloped edges of the tattoo work are of the *botan mikiri* style of bordering.

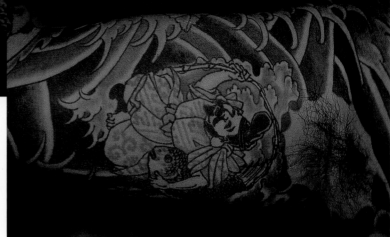

An example of the *koban-gata* underarm style.

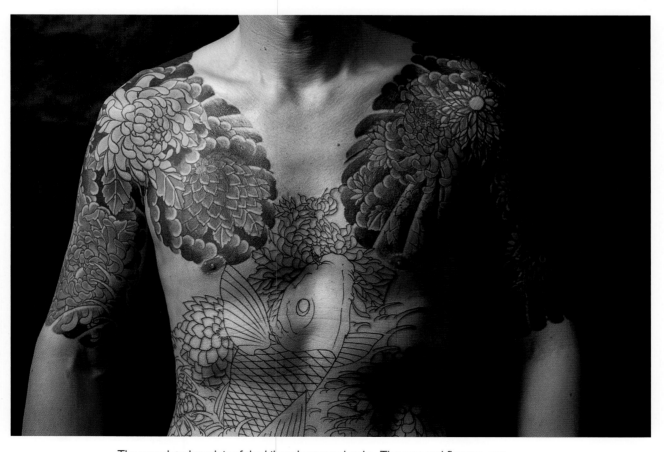

The completed work is of the *hikae* chest panel style. The carp and flowers, currently in *sujibori* stage, will transform his tattoo into a *donburi* upon completion.

Appendix III.

The Yokohama Tattoo Museum

In an effort to preserve and further study the history of tattooing on a global scale, in 1999 Horiyoshi III established The Yokohama Tattoo Museum. Initially conceived with the goal of sharing a collection of personal acquisitions, it has materialized into a three-story building complete with a tattoo studio on the third level. The two-story museum showcases every aspect of tattooing, past through present, and has proved to be an invaluable resource in the production of this book. It exemplifies Horiyoshi III's concern for the future of tattooing, and emphasizes this future's reliance on the knowledge of past generations.

Yokohama Tattoo Museum
Imai Building 1-11-7
Hiranuma Nishi-ku
Yokohama-shi
Kanagawa 222-0023 Japan

Telephone: 045-323-1073

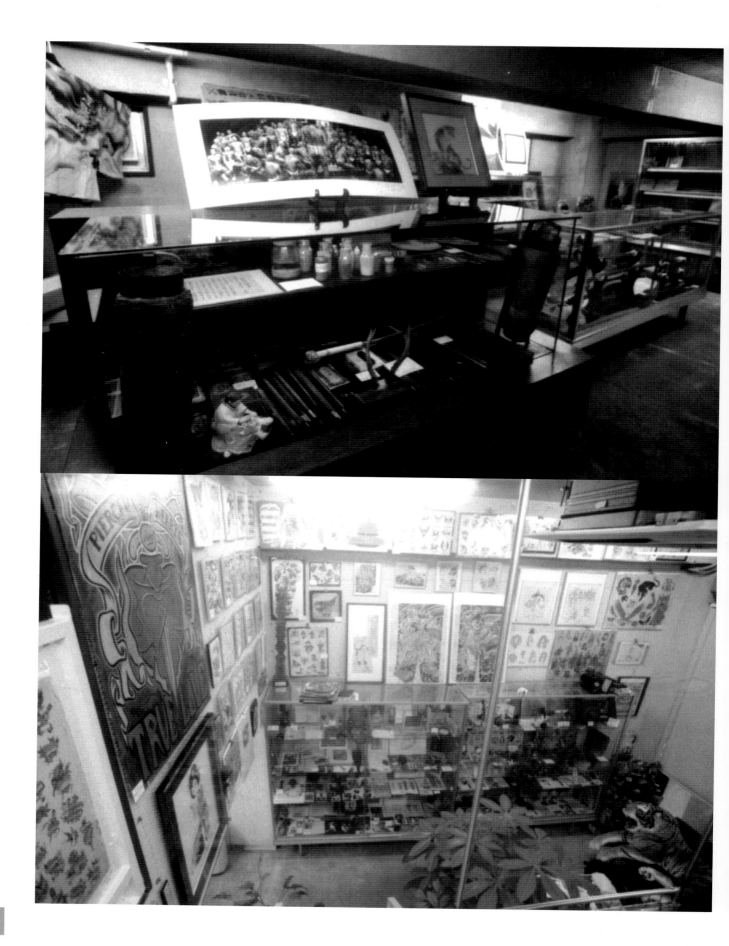

Appendix IV.

Artist Biographies

Ito, Jakuchu (1716-1800) Originally from a Kyoto Merchant family, Ito was a highly independent artist famed for his eccentricity.

Katsukawa, Shun'ei (1762-1819) One of Shunsho Katsukawa's most noted students.

Katsukawa, Shunsho (1726-1792) Founder of the Katsukawa school. A well-rounded artist, he was most renowned for his work portraying sumo wrestlers and kabuki actors.

Katsushika, Hokusai (1760-1849) Began his artistic studies with the Katsukawa School, then continued with other masters. Hokusai continued producing art up until his death. Arguably the most prolific *ukiyo-e* artist of the Edo period, his *manga* continue to influence tattoo artists of today.

Kitagawa, Utamaro (1753-1856) Known for his *bijinga* portrayals of women. Initially a student of Sekien Toriyama, Kitagawa broke away to establish an independent career that was eventually managed by Juzaburo Tsutaya. Tsutaya was considered by many to be the most important publisher of the 1780s and 90s.

Nagasawa, Rosetsu (1754-1799) Born into a low-ranking samurai family, he began his studies with Okyo Maruyama. Also known for his eccentricity.

Okumura, Masanobu (1686-1764) Of extreme importance to the *Ukiyo-e* genre, credited with the invention of the dual and tri-colored print and *hashira-e*. Founder of the Okumura School.

Soga, Shohaku (1730-1781) Began his studies with the Kano school but eventually chose to align himself with the Soga school, composed of individuals pursuing both monastic and artistic careers. Known as eccentrics, these monks would often paint while inebriated.

Reizei, Tamechika (1823-1864) A student of Totsugen Tanaka and part of the Yamatoe revival during the late eighteenth century.

Tanaka, Totsugen (1760-1823) Studied in the Kano and Tosa schools. Commissioned to work on Kyoto Palace, a project leading to the opportunity to study the Heian and Kamakura styles. The renditions by Tanaka and his students, adaptations of classic Japanese themes, became central to the Yamatoe revival.

Ukita, Ukkei (1795-1859) Like Tamechika, a student of Tanaka and thus part of the Yamatoe revival. Ukita's work often harbored political overtones and he was eventually arrested and executed for his beliefs.

Utagawa Kuniyoshi (1797-1861) First studied with his father, then began studies with Shun'ei Katsukawa before concluding his studies with Toyokuni Utagawa. Kuniyoshi, alongside Hiroshige and Kunisada, immortalized the Utagawa School. He is best known for his illustration of the *Suikoden* tales, a series of prints that propelled him to fame and is to this day used for tattoo reference and inspiration.

Bibliography

Asano, Shugo and Nobuyuki Yoshida. *Kuniyoshi: Ukiyo-e o yomu*. Tokyo: Asahi-Shinbun-sha, 1997.

Cawthorne, Nigel. *The Art of Japanese Prints*. London: Hamlyn, 1997.

Delay, Nelly. *Japan: The Fleeting Spirit*. Trans. Lorna Dale. London: Thames & Hudson, Ltd., 1999.

Fahr-Becker, Gabriele, ed. *Japanese Prints*. Trans. Michael Scuffil. Köln: Taschen, 1999.

Foundation Siebold Council, ed. *Kuniyoshi Exhibition Catalogue*. Tokyo: Foundation Siebold Council, 1992.

Guth, Christine. *The Japanese Art of the Edo Period*. London: Orion, 1996.

Hardy, Ed, ed. *Pierced Hearts and True Love*. Honolulu: Hardy Marks Publications, 1995.

Hardy, Donald Edward. *Sailor Jerry Collins: American Tattoo Master, In His Own Words*. Honolulu: Hardy Marks Publications, 1994.

Hardy, D.E. ed. *Tattootime Number 1: New Tribalism*. Honolulu: Hardy Marks Publications, 1988.

Hardy, D.E., ed. *Tattootime Number 2: Tattoo Magic*. Honolulu: Hardy Marks Publications, 1988.

Hardy, D.E., ed. *Tattootime Number 3: Music and Sea Tattoos*. Honolulu: Hardy Marks Publications, 1988.

Hardy, D.E., ed. *Tattootime Number 4: Life and Death Tattoos*. Honolulu: Hardy Marks Publications, 1988.

Hardy, D.E., ed. *Tattootime Number 5: Art From the Heart*. Honolulu: Hardy Marks Publications, 1991.

Hillier, J. *Japanese Colour Prints*. London: Phaidon, 1991.

Japan Tattoo Institute, ed. *Horihide's World*. Tokyo: Keibunsha, 1989.

Japan Tattoo Institute, ed. *Horiyoshi's World*. Tokyo, Ningen no Kagakusha, 1997.

Kaplan, David E., and Andrew Marshall. *The Cult at the End of the World*. New York: Random House, 1996.

Keyes, Roger. *The Male Journey in Japanese Prints*. Berkeley and Los Angeles: University of California Press, 1989.

Klompmakers, Inge. *Of Brigands and Bravery: Kuniyoshi's Heroes of the Suikoden*. Leiden: Hotei, 1998.

Kobayashi, Tadashi. *Ukiyo-e: an Introduction to Japanese Woodblock Prints*. Trans. Mark A. Harbison. Tokyo, New York and London: Kodansha, 1997.

Munsterberg, Hugo. *The Japanese Print: A Historical Guide*. New York and Tokyo: Weatherhill, 1998.

Nagata, Seiji. *Hokusai: Genius of the Japanese Ukiyo-e*. Tokyo, New York, London: Kodansha, 1995.

Nakano, Yoshihito. *100 Demons of Horiyoshi III*. Tokyo: Nippon Shuppansha, 1998.

Nakayama, Mikio. *World of Kabuki Pictures*. Tokyo: Tokyo Shoseki Ltd. 1995

Nihon Keizai Shinbun-sha. *Hokusaiten Exhibition Catalogue*. Tokyo: Nihon Keizai Shinbun-sha, 1967.

Price, Lorna, ed. *Hokusai and Hiroshige: Great Japanese Prints from the James A. Michener Collection, Honolulu Academy of Arts*. San Francisco: Asian Art Museum of San Francisco, 1998.

Shindo, Shigeru. *Kunisada*. Tokyo: Graphic-sha Publishing Co., 1993.

Singer, Robert T. *Edo: Art in Japan 1615-1868*. Washington: National Gallery of Art, 1998.

Stevenson, John. *Yoshitoshi's One Hundred Aspects of the Moon* Boulder: Avery Press, 1992.

Terano, Tansai. <u>*Hyaku ryu ga cho*</u>. Tokyo: Iwasaki Bijutsu-sha, 1987.

Tokugawa Art Museum. *Shogun: the Shogun Age Exhibition*. Tokyo: Shogun Age Exhibition Executive Committee, 1983.

Ueda, Akinari. *World of Moonlight and Rain*. Tokyo: University of Tokyo Press, 1971.

Yamaguchi, Keizaburo. *History of Ukiyo-e*. Tokyo: San-Ichi Shobo, 1995.

Yoshida, Susugu. *Dictionary of How to See Ukiyo-e*. Tokyo: Keisuisha, 1971.

Yoshikawa, Eiji. *Musashi*. Trans. Charles S. Terry. Tokyo, New York, London: Kodansha, 1981.

Yoshikawa, Eiji. *Taiko*. Trans. William Scott Wilson. Tokyo, New York , London: Kodan sha, 1992.

Index

Due to the frequency of references, members of the Yokohama Horiyoshi Family, Horiyoshi III Family, and the Horihito Family have been omitted from the index.